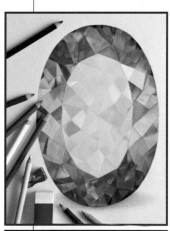

YOU CAN DRAW!
SIMPLE TECHNIQUES FOR
REALISTIC DRAWINGS

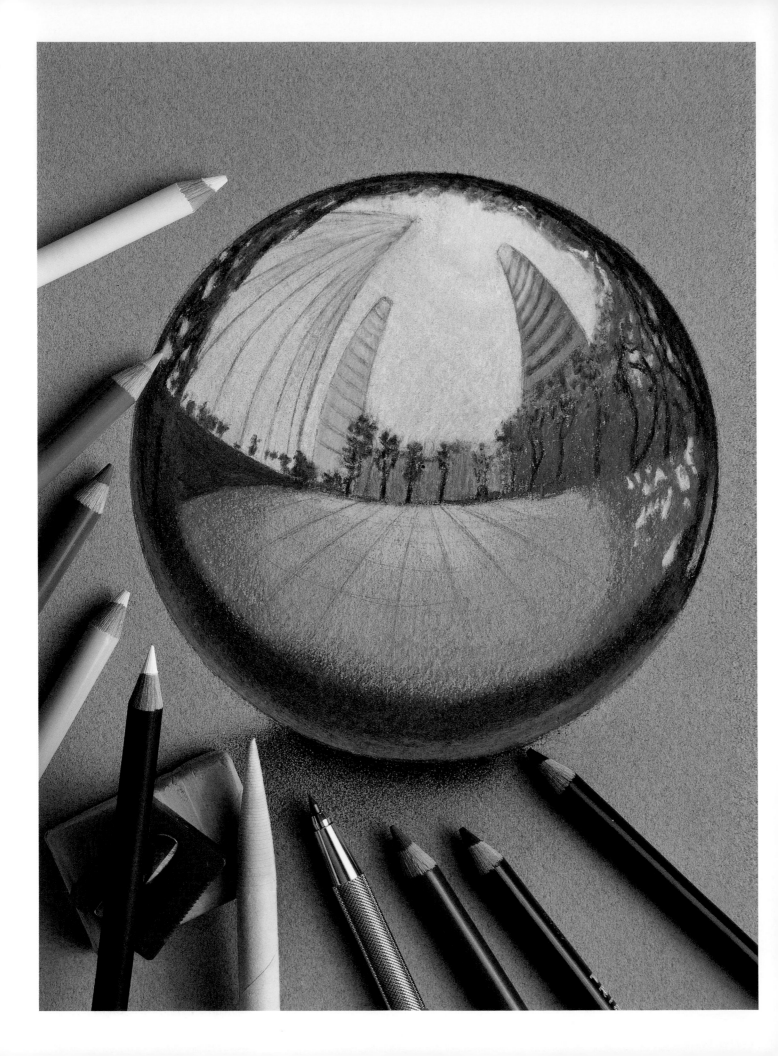

GEMSTONES • METALS • HARD SURFACES • CRYSTAL AND GLASS • WATER • FLOWERS

YOU CAN DRAW!
SIMPLE TECHNIQUES FOR REALISTIC DRAWINGS

LEONARDO PEREZNIETO

 sixth&springbooks NEW YORK

sixth&springbooks
104 West 27th Street, New York, NY 10001 | sixthandspringbooks.com

Library of Congress, Cataloging-in-Publication Data
Pereznieto, Leonardo, 1969-
 You Can Draw! : Simple Techniques for Realistic
Drawings / by Leonardo Pereznieto. – First Edition.
 pages cm
 ISBN 978-1-936096-96-1 (paperback)
 1. Color drawing – Technique. 2. Texture (Art) I. Title.
 NC758.P47 2015
 741.2--dc23
 2015007374

7 9 10 8 6

First Edition

PRINTED IN CHINA

Managing Editor: Laura Cooke

Editor: Martha K. Moran

Art Director: Diane Lamphron

Editorial Assistant: Sarah Thieneman

Page Designer: Areta Buk

Copy Editor: Vevlyn Wright

Still-life Photography: Marcus Tullis

Vice President: Trisha Malcolm

Publisher: Caroline Kilmer

Production Manager: David Joinnides

President: Art Joinnides

Chairman: Jay Stein

LEONARDO PEREZNIETO'S work has been exhibited internationally in prominent museums and galleries in cities including Florence, London, Paris, Seoul, Los Angeles, and New York. He also regularly conducts workshops and lectures around the world. His popular YouTube channel, Fine Art-Tips, releases a new art instruction video every Tuesday to more than 500,000 subscribers. He lives in Mexico.

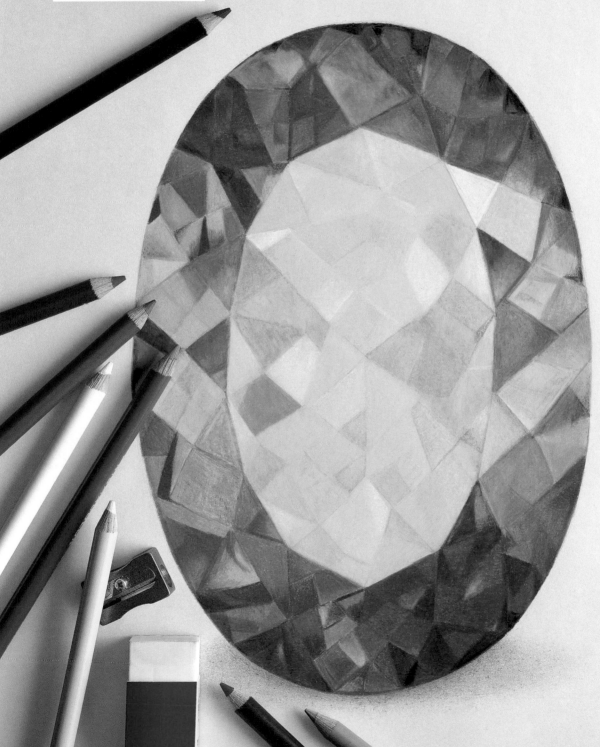

CONTENTS

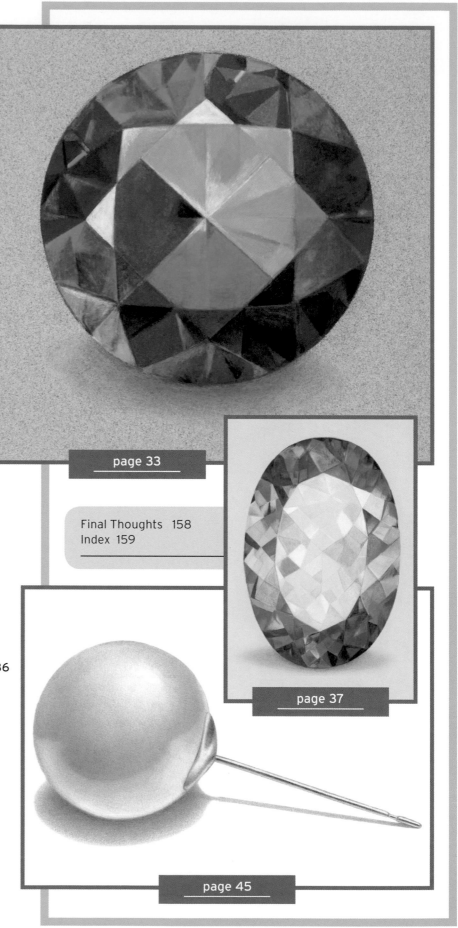

page 33

page 37

page 45

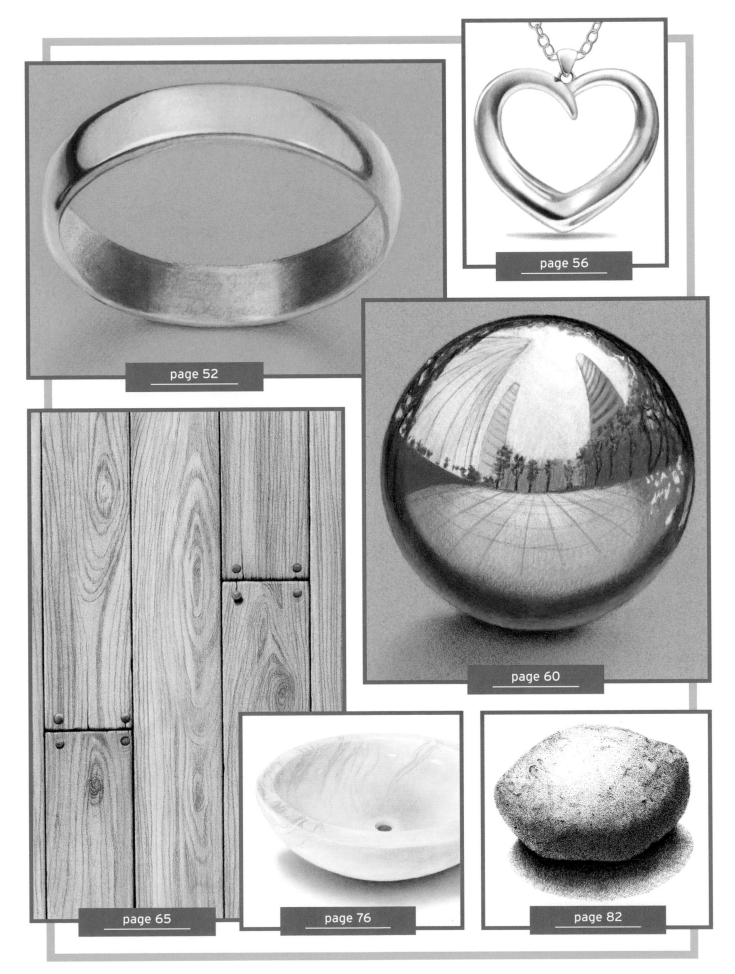

page 52

page 56

page 60

page 65

page 76

page 82

7

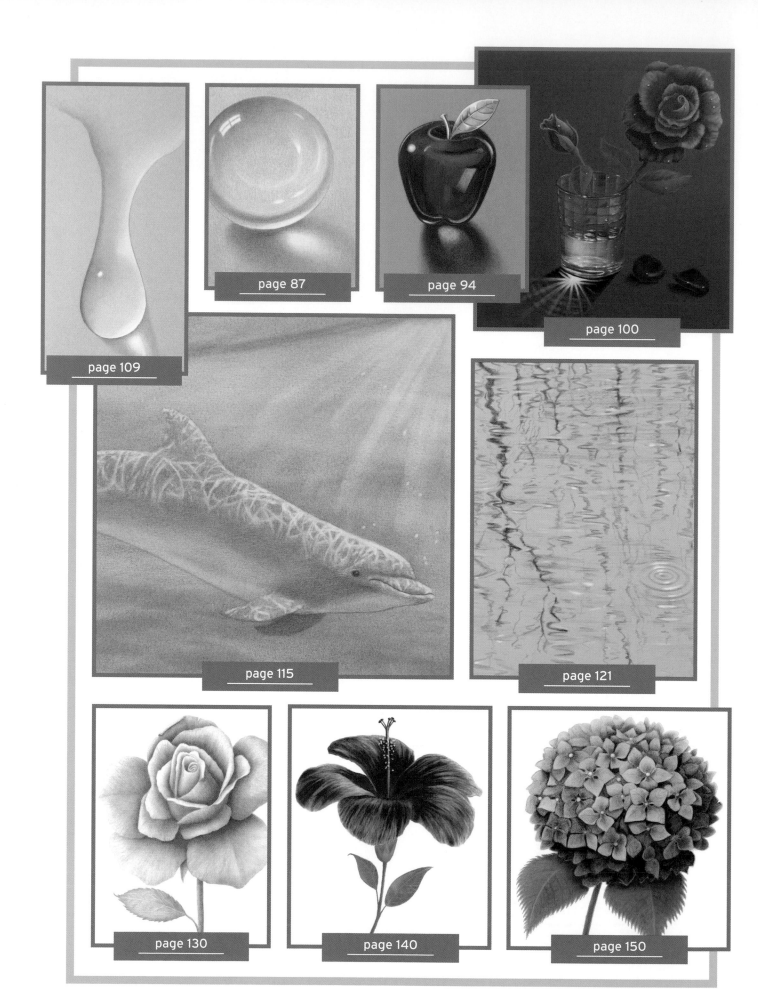

page 87

page 94

page 100

page 109

page 115

page 121

page 130

page 140

page 150

We all draw because we love it.

The more techniques you master and the better you become, the more you enjoy it.

Sometimes I hear from aspiring artists that they don't want to learn specific techniques, as it would deter their creativity and prevent them from developing their own style. This is, of course, nonsense. You have to know the basics of drawing and master the techniques first. Only by being armed with these tools will you be able to create anything you want with freedom and joy, and you will develop your own style as a consequence.

This is, in fact, the intention of *You Can Draw! Simple Techniques for Realistic Drawings* – to broaden your arsenal of skills with simple but amazing techniques. Doing so will allow you to appreciate the act of drawing even more. You'll also produce breathtaking effects that will surprise your public.

This book doesn't teach you how to draw every surface, texture, or element on Earth. Rather, it is filled with a variety of visual examples and ideas which I hope can spark your own talent in seeing, interpreting, and rendering your own creations. You may read this book in sequence from beginning to end, or you may skip to the chapters that will help you resolve a specific drawing.

I've put the chapters together in a way that is simple enough for the novice to follow but includes advanced techniques to improve the work of professional artists – and everyone in between. If you are a beginner, know that it's never too late to start. By learning the right techniques and with hard work and dedication, you may soon draw like a pro. And if you already are a pro, the featured techniques will allow you to take your drawings to a whole new level.

I intend for *You Can Draw! Simple Techniques for Realistic Drawings* to be helpful, useful, and to therefore live with you in your studio or working space and not be forgotten on a bookshelf. I hope that it will soon be dirty, worn, and filled with folded and marked pages you will refer to again and again. It is not a book to be kept pristine.

Enjoy this book. Use it well. And more important, enjoy the process of creating each and every one of your drawings. That is, after all, the true pleasure of being an artist.

Materials

There are two sides, or viewpoints, on the subject of materials and specifically about having them or lacking them. People tell me all the time, "I can't draw like you because I don't have your materials." That sort of comment makes me cringe because, in my opinion, not having the best materials is no excuse for a bad work of art.
On the other hand, having good materials does make it easier, and you should strive to have better materials as you progress.

Drawing Pencils

You should always use artists' pencils for drawing, not the pencil you wrote with at school. Those are inferior and not meant for drawing. Low-quality pencils can leave an uneven tone.

Graphite pencils

Drawing pencils (graphite pencils) are graded according to the hardness of their leads, which basically are considered hard or soft.

The **hard leads (H)** leave less graphite on the paper and therefore produce lighter marks. The different hard pencils are labeled with an "H" (for "Hardness") preceded by a number. The higher the number, the harder the lead and the range starts at H, then 2H, 3H, up to 9H. The 9H hardly leaves a mark and is not commonly used for drawing.

The **soft leads (B)** leave more graphite on the paper and produce denser marks. The range of pencils is labeled with a "B" preceded by a number. The B stands for "Blackness," as these leads draw darker marks. The range goes from B all the way up to 9B; the higher the number, the softer the lead and the darker the mark.

> **LEAD HARDNESS/SOFTNESS BY NUMBERS**
>
> • B LEADS:
> The higher the number, the softer the lead.
> • H LEADS:
> The higher the number, the harder the lead.

In the **middle of hard and soft leads** is the **HB**. As far as hardness, it is the equivalent to the standard American No. 2 pencil. While it is in the middle of the hard-soft range, it's considered reasonably hard for drawing purposes because artists use mainly the soft leads.

Between the H and the HB there is an additional one, the **F**. "F" stands for **Fine Point**. Since it is relatively hard, it stays sharp. (Or so they say.)

So the whole spectrum of graphite pencils, from hardest (far left) to softest (far right), goes like this:
9H, 8H, 7H, 6H, 5H, 4H, 3H, 2H, H, F, HB, 2B, 3B, 4B, 5B, 6B, 7B, 8B, 9B

Pencils from 6H to 6B are commonly available in most art stores. The ones at both ends are a little bit more specialized and sometimes not as readily available. However, the larger art stores usually stock them.

Pencil Starter Set

If you don't want to get the entire range of pencils at once, this is the set that I recommend: 3H, H, HB, 3B, 6B. With these five leads you should be fine and over time you can expand.

With which pencil number should you start, let's say, for sketching your drawing? It's hard to say as they behave in different ways depending on who is using them and on what surface you are drawing. Some people are heavy-handed and to comfortably leave a fair mark would use an H while you and I might use an HB. A light-handed person might get the same result with a 2B.

There are many brands that carry quality artist grade graphite pencils, including Berol Turquoise, Conté à Paris, and Derwent.

Pencils and different papers

The same pencil leaves different intensity of marks depending on the paper as well. A grainy paper, with texture, tends to "bite" and retain more graphite and therefore hold a darker mark than a smooth paper. So, when you draw on smooth paper you will find yourself drawing with softer pencils to get your usual result.

Lead Holders

Lead holders have a clutch-release system that extrudes the lead. In most models the lead is loose inside the holder. You push the back button to release the desired length. (Be careful that gravity doesn't cause the whole lead to fall out of the holder). The lead is held in place by a three- or four-part vise.

You can get different grades of leads in the holders (on the same scale as that of the wooden graphite pencils). They come in different calibers of thickness but the most common for general drawing is the 2mm lead, which is the same caliber as the wooded pencils. (The 7B, 8B, and 9B leads are usually not available in 2mm lead holders as they are so soft that they break easily).

As far as drawing, lead holders are equivalent to graphite pencils. It is not that you would draw better or worse using one or the other, but in my opinion, lead holders do have some advantages:

- With the push of a button you can instantly have as long a lead as you like; lead is never too short (when one lead wears out, you put a new one in the same holder);
- It is very easy to sharpen them to an extremely fine point;
- They usually have a clip on the upper part so you can secure it in your breast pocket or your jacket;
- Because the lead is stored completely inside the holder, it doesn't break and doesn't stain your clothing as pencils do;
- No trees were cut to produce it;
- I love the feel, especially of the ones made of metal, which are heavier. (Most today are made of plastic and weigh about the the same as wooden pencils).

For ease of use I have a set of different colored holders and I always keep the same leads in them so I know that I have a 3H in the grey, an H in the black, a 3B in the red, and a 6B in the yellow, and I can pick the right one at a glance.

The brand of the lead holders is not very important. What matters is the lead you put inside, although I have to say, quality lead holders feel nice. Leads that I recommend are Eagle Turquoise, Faber-Castell and Staedtler Mars.

Mechanical Pencils

Mechanical pencils are similar to the lead holders but they are made for holding leads of a smaller caliber. The smallest common lead is the .35mm, followed by the .5mm, .7mm, and .9mm. The range of softness to hardness is less wide than in pencils and lead holders. It usually goes from 4H (hardest) to a 2B lead (softest). They have a more elaborate push mechanism that advances the pencil lead in increments and that prevents it from dropping out.

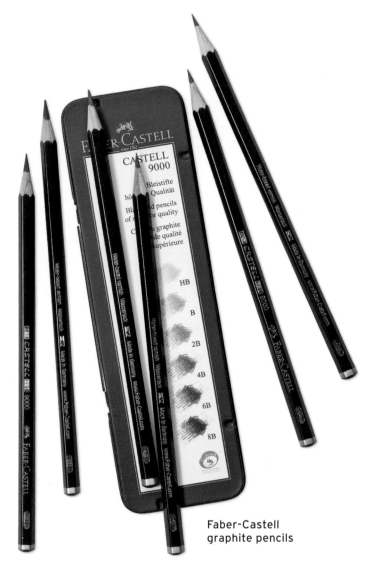

Faber-Castell
graphite pencils

These pencils are very practical and have an advantage over the other two types: The leads are so thin that you never have to sharpen them. As you use them they just get shorter. With a click on the back you get more lead, always sharp. I love them.

These days, this is the tool that I use the most. The only time that I forgo them in favor of the old trusty lead holder is when I need a softer lead such as a 6B. Also when I need to shade a fairly large surface and I prefer to use the 2mm lead rather than thin ones.

When the drawing instructions say to use a "pencil," it doesn't matter if it is a wooden graphite pencil, a lead holder, or a mechanical pencil. What is important is the softness of the lead. If you draw with an HB lead, it can be a wooden pencil or otherwise.

THERE IS SOME VARIATION OF HARDNESS AMONG DIFFERENT PENCIL BRANDS.
A 2B of one brand might be harder than a 3B of a different brand. For consistency, I recommend purchasing all pencils from the same brand.

Mechanical pencil and lead

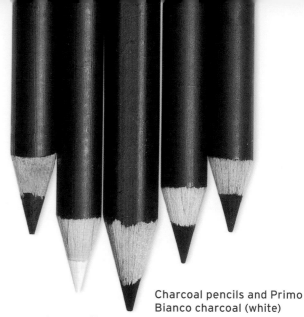

Charcoal pencils and Primo Bianco charcoal (white)

Charcoal Pencils

The carbon-rich residue of incompletely burned wood, vegetable matter or bone is called charcoal. The charcoal used by artists is made by burning wood in a chamber with no air. Charcoal powder is compressed and mixed with a binder to form the drawing medium, which is then set inside a wood pencil. They generally range from 6B (softest) to HB (hardest).

Charcoal is more abrasive than graphite and it is not as smooth. It does not easily adhere to surfaces so it smudges easily.

You can use graphite and charcoal pencils in the same drawing. While the graphite is great for small detail, it never gives you a black as black as the one produced by charcoal. Additionally, if you push a graphite lead too much to get a very dark tone, it becomes shiny and reflects light, which can be annoying. If you need black in a drawing you can better achieve it with charcoal.

Make sure to use fixative on any finished charcoal since it smudges and smears so easily.

Some good brands are Ritmo, General Pencil Company's Primo Euro Blend, as well as Derwent and Prismacolor Premier.

White Charcoal

I use Primo Bianco charcoal to get bright highlights as it is the whitest of the whites I have tested; it gives a brighter white than the white of the color pencils set.

Primo Bianco is dry, not oily, and therefore it does not hold on greasy surfaces. If you use it with color pencils, first lay down the highlights with this white charcoal and then use the color pencils on top of it, not the other way around.

Faber-Castell
Oil Pastels

Oil Pastels

You may sometimes want to add a highlight on a surface that you have filled with color pencils. Because the pencil medium is oily or waxy, the white charcoal won't hold on them (and sometimes not even the white of the color pencils give you the desired result). In these cases, you can use an oil pastel stick. With it you can produce a nice white or colored highlight on the layer of color that is already laid in. Faber-Castell has a good set, and you can usually find them in single color sticks.

Prismacolor color pencils, set of 72

Assorted Faber-Castell color pencils

Prismacolor Colorless blending pencils

Color Pencils

Most color pencils are made with an oil base such as the Faber-Castell or with a wax base like the Prismacolor Premier. Color pencils contain varying proportions of pigments and binding agents.

The quality of colored pencils may vary widely. Artists' grade pencils have a higher concentration of quality pigments than student-grade ones. Consequently, their light-fastness (resistance to fading in sunlight), core durability, and break resistance is higher. Good quality pencils also allow you to layer and mix better. The Prismacolor Premier pencils are wax-based and softer. In my opinion they mix more easily and their colors are slightly brighter.

The oil-based Faber-Castell pencils are firmer, which is great for fine detail. Their sharpened leads last longer (as do the pencils themselves), they break less, and they blend well. I use both brands and it is a matter of personal taste which one is better. (Note, you can use them together.)

To combine the colors you can use a colorless "blender," which looks like a color pencil, but has no pigment. After you have lain in layers of two or more colors, you can go over them with the colorless blender using a strong rubbing motion. This is called "burnishing."

You can also melt and mix the colors by applying mineral spirits on them. Please see the "Mineral Spirits" heading in the "Color Pencil Techniques" section on page 23.

Because of their oil or wax base, color pencils are hard to erase.

Use a lot of care when handling and storing color pencils because if they fall, the lead may crack internally and then it is almost impossible to sharpen them as they keep breaking on every attempt.

Markers

Drawing with markers is exciting. They are simple to use and, because the ink is fluid, the marks are smoother than with other mediums. Drawing with ink used to be a bit messy but with the invention of markers it has become clean and practical.

We will be using Prismacolor Premier Fine Markers for the "Rock" drawing project on page 82. They are labeled as archival, acid-free premium pigmented inks that prevent work from deteriorating over time. However, I wouldn't place the finished drawing in direct sunlight because it could fade over time. They dry quickly and are water resistant. The fine point is ideal for minute detail.

page 82

Fine and Very Fine markers

Erasers

One usually thinks of erasers as tools to get rid of unwanted flaws and mistakes, but they are actually great drawing tools, too. Erasers can be used to pull lights (reflections), to lighten an area, or to create texture effects. There are several types of erasers for drawing, each with its own useful properties.

Kneaded eraser

The eraser that I use the most, by far, is the kneaded eraser. It is made of pliable material that resembles putty or gum. It absorbs or "picks up" graphite and charcoal particles. It does not wear smaller nor leave behind eraser waste, thus it lasts much longer than other erasers. Eventually, it gets dark and sticky, and that's when it's time to replace it.

A kneaded eraser has several advantages over regular erasers.

• It can be shaped by hand for precision erasing, creating highlights, or performing detailing work, all without smearing. (If you try to pull a light or lighten the tone within an area shaded with graphite or charcoal using a regular eraser, you'd smear the drawing and make a mess.)
• You can make a flat area with your trusty kneaded eraser by gently tapping on the surface. The graphite or charcoal will stick to the eraser, without smudging. You should knead the eraser to get a clean section for every tap.

• Because it is soft, it causes the least damage to the paper, out of any type of eraser. So I also normally use it to make corrections and to erase lines.

Their only limitation is that they are no good for completely erasing a dark, in-depth mark. For that job you'd need a vinyl eraser.

My favorite kneaded eraser is the Prismacolor.

Vinyl Eraser

Vinyl erasers (sometimes called plastic erasers) are made of soft vinyl. They erase very well. They are efficient at erasing graphite or charcoal and they even erase India ink. They are tough on drawing surfaces, however, and if you don't use them carefully they can tear the paper. My favorite is the Faber-Castell Magic-Rub.

Eraser Pen

Eraser pens are like lead holders but they encase a vinyl eraser in the shaft instead of a lead. They exist in different calibers (thicknesses), and vinyl refills are widely available and inexpensive. ,

Some handy ones are the Pentel Clic Retractable, the Paper Mate Tuff Stuff Eraser Stick (which is very fine) and the Tombow MONO Zero Eraser Round Tip, which is really great for erasing fine detail, as it is the thinnest of all retractable erasers.

Kneaded eraser

Thick and thin retractable eraser pens

Vinyl eraser

Fine blending brush, for smaller details

1-inch blending brush, for larger areas

Blending Tools

Blending is a process of merging different shades together, so that each transitions smoothly into the next, creating a soft and realistic tone. There are several blending tools you can use; all brands work equally well.

Stump

A stump is a blending tool for graphite, charcoal and pastel. It is a cylinder tapered at both ends, made out of tightly wound, soft paper. You can produce soft gradations and half tones with this tool. It can also be used to apply the medium directly for softer effects. They are sold in a wide range of sizes and diameters to fit your needs.

A clean side of the stump should be used to smudge lighter areas, otherwise you would smear darker blotches into it. However, unless they are damaged beyond repair, you should save your dirty stumps for later use, as they are great to smudge dark areas.

They can be cleaned by lightly rubbing the tip on fine sandpaper.

Tortillions

Tortillions resemble blending stumps but the paper is not wrapped as tightly and they are pointed only on one end. Like stumps, they are used to smudge and blend a drawing but because of their different consistency, they produce a different effect. Generally speaking, stumps tend to be larger and therefore used for wider areas, while the more slender tortillions are used for finer detail.

Smudging with the fingers is not advisable, as body oil left on the paper can create marks or inconsistencies in further applications of the medium.

Chamois

A chamois is a piece of soft leather. It is great for evenly smudging large areas. You can fold it like a napkin and use a flat part of it, or you can roll it around your index finger for better control. Go over the graphite or medium with light circular motions, or straight lines that go all across the area you intend to smudge. You can get better quality (and strength) ones at art stores and cheaper ones at auto parts stores. The latter will work, although they tend to get damaged more easily.

Brushes

You can blend and smudge with a brush, and give a tone to a whole area using one with graphite (or charcoal) powder. The size of the brush will depend on the area

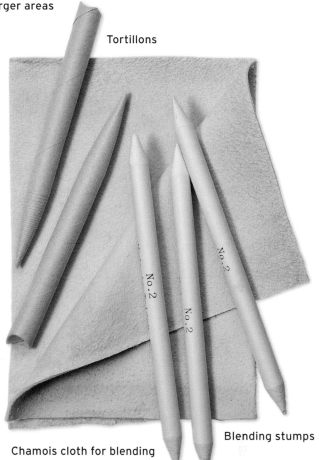

Tortillons

Chamois cloth for blending

Blending stumps

you want to cover. For toning a letter-size page I use a flat 1-inch brush, while for blending a small detail I use a really fine brush.

I have used many brushes for blending and I cannot say yet which one is the perfect one, as each gives different effects. Sometimes, I prefer flat ones as I feel they can be better controlled, but at times I prefer a round brush, which seems to "paint" more evenly.

They should be soft because the hard strands leave graphite (or charcoal) marks behind, but not so soft they don't smudge well. My favorites are the synthetic ones made for acrylic paint, with a medium to soft feel.

My advice is that you test different types to find the ones with which you feel most comfortable.

Felt Pad

I sometimes use felt pads as blending tools. These are the thick pads often called "furniture gliders" that are sold in hardware stores to place under furniture and accessories so they don't scratch surfaces, or on which to move heavy objects. They come in different sizes, circular or square. I mostly use the circular ones that are about two inches in diameter, although they all work.

After you apply graphite or charcoal to a surface, gently smudge it with the felt pad. You can use small even circular motions, as well as long straight motions, across all the paper, from left to right, right to left, top to bottom, etc. If you do it in different directions all the way from one side of the paper to the other they give a pretty even finish, though it's rougher than the effect achieved by the chamois, as felt pads lift and move less medium than a chamois.

Sharpening tools

(Please also refer to the section on sharpening techniques for more information on their use).
It makes a big difference whether you work with a sharp lead or a dull one, so your sharpening materials are essential for good results in your work. There are different ways to sharpen, depending on the specific tool and the effect you want to achieve.

Blades

When it comes to drawing, graphite pencils are usually sharpened with a blade because, typically, artists like a longer, more exposed lead than an electric or hand sharpener can give. You can further refine the sharpening with a sand paper pad. Obviously you need to be very careful when using a blade so as to avoid any possible injury.

Blades (used together with sandpaper pads) are also my favorite tools for sharpening charcoal pencils, which break easily in other devises.

Electric sharpeners

Electric sharpeners can be handy and sharpen very quickly and effortlessly. You need to use them with care though, so they don't eat up too much of the pencil. I do not recommend using an electric sharpener for color pencils because the leads tend to break in them and their blades can jam a bit with the soft material.

Hand sharpener

This is the regular little pencil sharpener in every child's pencil case. In my opinion they are the best for sharpening color pencils. But make sure you use a high-quality device, because they are sharper.

When using my color pencils I often just need a trim at the tip. It may be just slightly blunt, and with the hand sharpener I can give it just enough turn, let's say, a half a turn, to get exactly the point I want. With an electric sharpener this is impossible because the moment you stick it in it gives tens of turns.

When you feel that the sharpener is not working as well or is breaking leads it's time to switch the blade, or to get a new one.

Both Prismacolor and Faber-Castell make good sharpeners. They come with two holes of different sizes and a casing that holds the waste. The larger orifice is the one used for color pencils, the smaller produces a longer exposed lead, which may break.

Sharpeners for 2mm leads

There are two types of sharpeners for the 2mm leads in lead holders: Lead pointers, which look like a miniature hand sharpener, and the rotary barrel sharpeners. They both are efficient. The smaller lead pointers are extremely inexpensive. The rotary devices, which have a rotating barrel that sharpens the lead and collects the dust, are fast and easily get your lead to a needlepoint. You can also sharpen 2mm leads with sandpaper pads.

Sandpaper pads

Sandpaper pads are designed for shaping or sharpening leads. They have a wooden base and sheets of fine sandpaper on top. They easily refresh a point on the pencil between sharpenings. When a sheet gets too dirty, peel it off to expose a new piece of sandpaper.

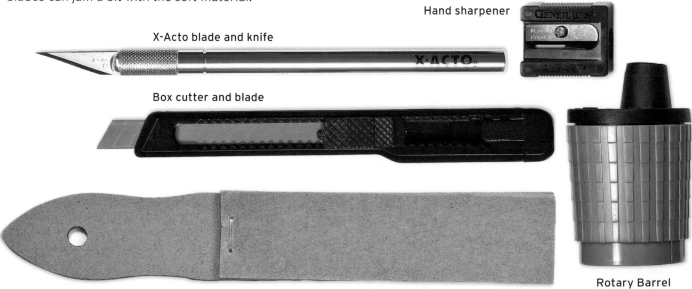

Hand sharpener

X-Acto blade and knife

Box cutter and blade

Sandpaper pad

Rotary Barrel Sharpener

page 33

page 76

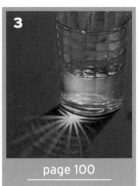

page 100

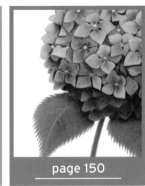

page 150

SOME PAPER SAMPLES
1 Light gray cardboard
2 Fabriano sketching paper, 56 lb., fine grain, white
3 Blue cardboard
4 Arches water-color paper, 140 lbs., hot-press

Paper

The paper you chose might be the most important element of all the materials on this list and it is a crucial factor in helping you achieve the results you're looking for.

Cotton papers

Cotton papers, made from the longest cotton fibers, are generally considered the highest quality. They are referred to as 100% cotton rag and can handle heavy erasing and strokes without tearing or showing wear.

It is important to choose the right paper for your project. The grain of the paper can work for you or against you. If you want to achieve a super smooth, metallic finish and you are using a rough surface, you will be fighting against the nature of the paper. On the other hand a well-chosen texture can greatly help you. If you are drawing realistic skin, a paper with a fine grain can give the realistic finish by itself compared to a totally smooth paper, which would give you an unrealistic effect.

You also have to take into account the tonality of your drawing – how dark is it going to be? Papers with more grain have more "tooth" to bite with and hold more of the lead, so your mark looks darker. Smooth papers have little tooth and your marks will be lighter.

Fine detail and smooth finishes are easier to achieve with smoother papers. I recommend that the paper always has at least a little grain, even if fine, because it lets you work more effectively and the result is more artistic than with completely smooth paper.

Types of paper

There are basically three types of paper which are hand-made: hot-press, cold-press, and rough.

Hot-press paper is smoother. It comes in various weights. Smooth paper is best for fine detail work as well as softer blending, but it is often not the choice of many artists when drawing with pastel or charcoal because it doesn't have enough tooth to hold them.

Cold-press and rough paper each have a coarser finish. Papers with more grain are generally the best for pastel and charcoal drawings, unless you aim for a really smooth, hyper-realistic look.

Using an **acid-free archival paper** will help your drawings last for many decades.

I recommend having **newsprint or lower grade pads** handy so as not to use your good paper when sketching and practicing. Use your quality paper for your final drawings.

The paper's weight will generally determine its thickness and density. This factor is more important for painting techniques such as watercolor, than for drawing, since watercolor paper needs to hold water and dry slowly.

However, drawing paper should be thick enough to give you a good surface that holds the material, that it won't be damaged by erasing, and that is sturdy enough so it does not fold. Using a heavier weight, such as 90 lb. or more, should allow room for repeated erasing.

Sometimes, I use toned illustration boards, which also have great surfaces for drawing. The tone of the paper, wisely chosen, can greatly help your drawing. For example, if you draw a bird flying in the sky you could chose a blue paper, which would instantly give the right background and feel. Toned paper, as opposed to white, also allows you to draw very distinctive highlights with white or light colors.

Papers labeled "drawing" tend to be thicker and usually of a better quality than the ones labeled "sketch." However, I have found some **sketch papers** that are plenty good for drawing such as the Fabriano sketching paper, fine grain, 56 lb. It is smooth enough to be able to do small details but has enough tooth to hold the medium well. The 94 lb. Fabriano drawing paper is even better. It is has a similar feel but it is thicker. I love it.

Another excellent paper for graphite and charcoal is the Arches 140 lb. hot-pressed watercolor paper. I usually use the backside of it, which is smoother. Canson and Strathmore also have a wide selection of quality papers.

Fixative

Fixative for drawings usually comes in spray bottles. It is used to protect your drawing and keep the medium from smudging. There are "working fixatives," which reduce smudging while they let you keep drawing on them and "non-workable fixatives," which are used for final drawings. They give a permanent protective coating. Fixatives come in a matte or glossy finish.

Photo References

I absolutely love drawing from life, and do it as much as I can – and I recommend that you do, too. I think in most cases it delivers the best results (and develops your drawing skills the most). Why? First, obviously, you are looking at three dimensions, so you can better interpret form and depth than with a two-dimensional photograph.

But there's another advantage: When you draw from life, you can pick many "best" moments. For example, with a live model, you draw all the visible muscles and bones with the existing light and shadow, and then, all of a sudden she slightly tenses a leg and for a moment you can see a muscle that was not visible before. She takes a deep breath and you see more of her rib cage, and then she looks and her eyes sparkle and lightly smile. You capture those brief moments as well. It is nearly impossible to get the result you achieve in a live-drawing session from a photograph, which is just a single instant. It is the collection of different moments that makes the best drawing.

Sometimes, shooting reference photos is helpful. If I can't hire a model for an extended time, I book a session and take many photos in slightly different illuminations, poses and expressions. Then I pick the overall best one for my main reference, but work with many of them to improve and enrich the drawing.

There are times when reference photos are outright necessary, like when you want to draw a charging African elephant. (It's not like you will go out and find one, then work on making him angry enough to come at you while you sit in front of him drawing.) Or if you want to draw an underwater dolphin, you surely wouldn't go underwater with your paper and pencil!

There are times when reference photos are better than drawing from life, like a macro photo of a suspended water drop about to hit a petal (or for practically any subject in motion, really).

When I use reference photos from books, magazines or Internet searches, I almost never use just one. I find several, usually five or six, and I take the best details from each, making my own version of the subject in my drawing. Maybe I take the shape and pose of a dolphin from one, but the light pattern hitting on his back from another. The beams of light entering the water from yet another. I may do the detail of the face looking at a fourth picture. If drawing a galloping horse, I'd use a few pictures of horses galloping, but I'd also use horse anatomy diagrams to better inform and depict the bone and muscle structure, even if they are not visible in the reference photos.

In summary, I recommend you draw from life whenever possible, or, if using reference photos, use the best elements of several (along with your imagination) for your own composition. This way the final result will be better than any of the photos themselves. ■

Lack of expensive tools is no excuse for a poor work of art.

A Cuban painter I met, a true master, who created astonishing landscape paintings told me how he used to go around scouring for old, recycled pieces of paper of different kinds that people would donate to him. (Drawing paper was not available at that time in his country.) He would gather all the paper, iron the wrinkles out as best as he could, tape all that together into a larger piece and then he would go on, with his make-shift oil paints and archaic brushes, to create an unbelievable masterpiece.

One evening, while walking down through Times Square in New York City, I saw a Japanese sculptor, an old man, on the sidewalk. A customer would sit in front of him as a model. The old man would grab a lump of clay and with just one tool – an old, short wooden stick (which long ago probably belonged to a popsicle) – would make a true portrait in relief, in about 15 or 20 minutes. Unbelievable.

Rodin used to go down to the riverbank, dig some wet mud, and with that created his historic sculptures. (Okay, granted, he lived close to the Senna River, and the mud from the river bank in that area is pretty good for modeling.)

I have seen young guys draw with a cheap ballpoint pen on copy-machine paper and make gorgeous drawings.

In any event, if you ever attend one of my workshops, please never tell me that you can't draw because you don't have good materials, because that is just not true. I will never accept that as an excuse for a bad work of art.

Okay good. I had to say it. I feel better.

And now we can look at the other side of the story. My advice: Get good materials!

While a lack of them is no acceptable excuse, it is also true that good materials can make a big difference in your work. And one thing is for sure: They make your life a lot easier. Also good materials are more permanent and durable, which is important if you intend your work to last.

Basic Techniques

He who masters the correct techniques has freedom of creativity.

In this chapter we will go over the basic techniques used to develop the drawings contained in this book, from fundamental tasks such as sharpening a pencil to more advanced methods such as how to successfully mix colors in a way that they stay radiant. Knowing and practicing these basic techniques will give you the foundation from which to build your masterpieces.

How to Hold and wield a pencil

There are probably as many ways of holding a pencil as there are artists. After studying and trying many of them I will tell you the ones that, in my opinion, are the most useful and helpful for different situations.

Holding the pencil in different ways delivers different results and you should choose the one that is best for you for that particular task. Some grips will give you better freedom of movement; others leave stronger marks and are more fluid, while yet others deliver better control and precision.

Some people say that they are used to holding the pencil in a certain way that works just fine for them and they draw very well with it. It may be true, and I by no means am saying that they are not drawing well. But if they learned to use the pencil in different ways, their drawings could be even better and richer.

> Various pencil holds allow a wide range of marks – thin, wide, fluid, deliberate, precise, etc. – which add up to a richer drawing and visual variety. If you always hold the pencil in the same way you limit the range of possibilities that this tool can deliver when drawing a line or a mark.

When you are used to employing one grip, sometimes it is hard to learn and get used to a new one. When you first try, it feels uncomfortable and unnatural and you cannot draw as well as you are used to; therefore, many people give up. That's a pity because they are throwing away a good opportunity to improve.

The five main pencil grips

I recommend that you learn the following five grips and practice them over and over, until they become second nature. After a while you won't even have to think about what grip to use for which scenario, like a backhanded grip for sketching on a vertical board or a brush grip for fine detail.

To make the jump from uncomfortable to this second-nature stage, I recommend you do exercises such as:
- Draw ovals and circles over and over;
- Mark two dots at a distance and then draw a straight line that unites them, repeating this many times at different angles (e.g. vertical, inclined, and horizontal lines);
- Mark three dots and then draw a curving line that connects all three;
- Place four dots hinting at a rectangular figure and freely draw an oval that touches all four points. Shade square and rectangular figures as evenly as you can.

After many practice exercises, the new grips will feel comfortable enough for a real drawing. Once you are used to them you won't look back and you will have a hard time believing that until recently you were drawing without this arsenal of tools.

Following are what I consider the five main grips for holding the pencil.

UNDERHAND GRIP

With the palm of your hand facing upwards, hold the pencil with the thumb against the index finger. (Or alternatively, hold by the thumb against all four fingers.) This underhand grip favors the loose movement of your arm, all the way from your elbow and shoulder. It produces a flowing, sweeping line and is great for sketching and shading using the side of the lead. It is the best for vertical or near-vertical plane drawing such as when you have your paper on an easel or vertical board, and for large format drawing. You don't need to lay your hand on the surface to sustain it.

You should stand at about an arm's length from the board. If you are doing life drawing it is important to place the board in a position that allows you to see both your drawing and the model easily, without having to turn around and without the board blocking your view.

OVERHAND GRIP

This is similar to the underhand position but with your hand facing down. Hold your pencil loosely between the index finger and the thumb while stabilizing the pencil with your other fingers. This position allows you to use the side of the exposed lead, instead of just the tip (same as in the underhand position).

For drawing large, this grip is one of the best. It works on vertical, tilted or horizontal planes. While using this method try to move the whole arm from the shoulder for best fluidity.

A variation of this grip is placing the hand "vertically," with the side down. That would be in the middle between the underhand and overhand positions. You can easily switch between these three grips.

TRIPOD GRIP

The tripod grip is the most "natural" for many people because this is the grip most people are taught to use for writing.

This type of grip works for drawing very fine detail. Your hand needs to be on the surface to support it. The tripod grip allows minute control from the fingers and only uses the tip of the lead. The closer your fingers are to the tip of the pencil the more control your fingers and wrist have. If you use this grip for general drawing you risk getting stiff and jagged lines. I recommend the tripod grip only to do minute detail and small, precise lines.

BRUSH GRIP

The brush grip is a variation of the tripod. One could say that it is a step in between the overhand and the tripod grip. For this grip hold the pencil as you would a paintbrush, with the index finger resting on the pencil. It allows for a more fluid motion than the tripod grip, and you can use it with or without elbow support. Generally speaking, the farther away you hold the pencil from the tip, the loser your lines can be. When using this position try to move your whole arm, using your elbow and shoulder, unless you are working on a small drawing.

FINGER ON TIP

Hold the pencil between the middle finger and the thumb while pressing on the tip with your index finger. This grip is used when you need to lay a lot of lead on the paper. The tip position is flat since the pencil is near parallel to the surface.

This grip is useful for shading powerfully and filling in large areas rapidly. It is also effective in drawing vertical lines by placing the tip of your pencil facing up (if you are drawing on a vertical board) and moving the whole arm straight down. This type of grip delivers a strong mark.

Each grip has its own purpose and you might use them all in a single drawing – overhand grip for your initial sketch for great fluidity of line, then switching to a brush grip to define the shapes in finer detail before changing to a finger on tip for rapid and powerful shading. Then back to the brush grip for detailed shading and refining lines and even to a tripod grip for minute detail.

Using this arsenal of grips will imbue your drawings with an X-factor of variety and richness of mark difficult to otherwise achieve.

Optimum Paper Position

The most recommended paper position for drawing is vertical. This is because the paper is perpendicular to your line of vision so you see it without distortion, and you can get to every part of it with your hand easily – allowing you to keep your hand and arm free and lose. It also allows you to step back and see your drawing from farther away, which is very helpful to see it as a whole. In fact, you should make it a practice to step back and look at your drawing from some feet away every few minutes.

When the paper lies on a horizontal table, your view of the drawing is distorted as it is at an angle from your line of vision. Also, your hand usually rests on the table, impeding free movement. If it is a large drawing, some sections of the paper will be far away from you, which makes it more difficult and awkward to get to them and you can't step back to look at your drawing from a distance unless you move the drawing vertically (or climb onto a ladder!).

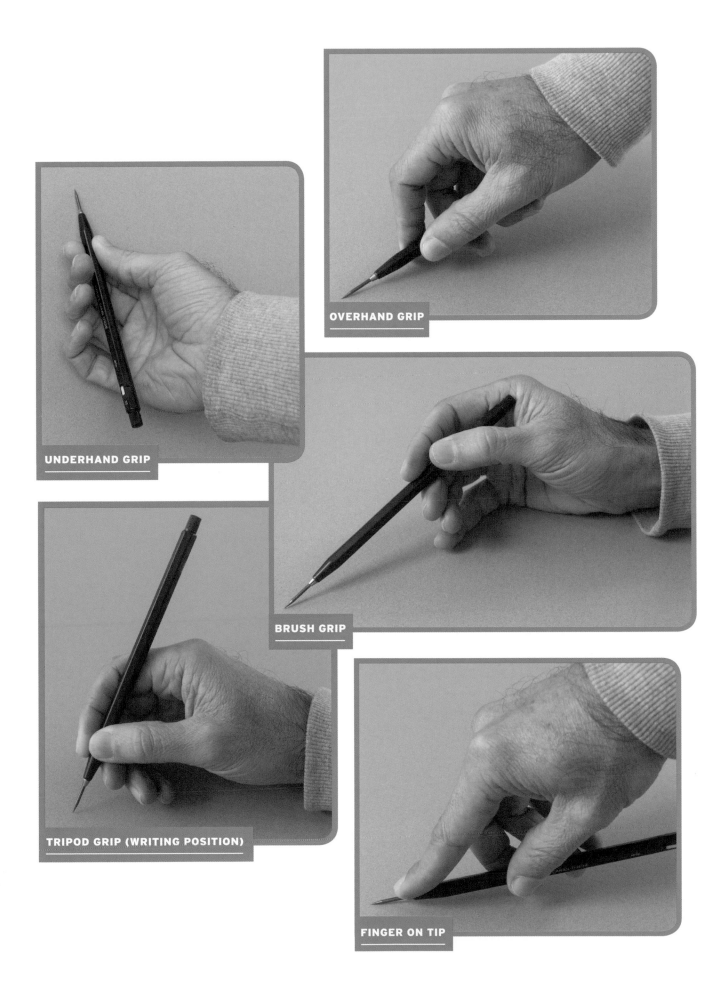

OVERHAND GRIP

UNDERHAND GRIP

BRUSH GRIP

TRIPOD GRIP (WRITING POSITION)

FINGER ON TIP

21

Color Pencil Techniques

Color pencils are a great medium for expressing yourself. To me, the color pencil technique is a fusion of drawing and painting. It is a drawing instrument with the precision, cleanliness, and feel of a pencil, however, because they are oil or wax based, you can saturate the paper with brilliant and permanent color that gives an impression as rich as that of a painting.

There are some advantages to drawing with colored pencils, too. They add the dimension of wonderful, radiant colors that black-and-white drawings don't. And, compared to paints, they are more easily portable, make no messes and are less expensive than most painting supplies.

Hatching, cross-hatching, and scumbling

Color pencils can be applied in different ways. The most common are hatching and cross-hatching, and scumbling.

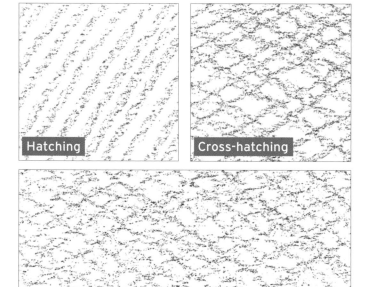

Hatching

Cross-hatching

Cross-hatching with 2 colors

HATCHING AND CROSS-HATCHING:
The color can be applied by making a series of parallel lines, or by crossing lines, hatching and cross-hatching respectively, as we mention in the shading section (see page 28). It can be done with a single color or by adding more than one color.

SCUMBLING:
The color may also be applied using circular or elliptical movements, and by scribbling. This, in color pencil jargon, is called scumbling. If you go over the ellipses in different directions or overlap the circles, you can get an even surface.

Of course you can apply the color in a number of other ways, including tapping the paper like in pointillism, or making lines of different shapes and directions.

Layering

Because they are a transparent medium, you can apply (layer) colors over one another and thereby mix them. When you overlay two or more colors you will produce a blend, which creates a new hue. When layering I recommend you start light, with little pressure. If you want to mix two colors, apply a light layer of each first. Then, as you mix them you can start applying more pressure in subsequent layers to get more intense tones. It is harder to mix them well if you saturate the surface with one color from the beginning.

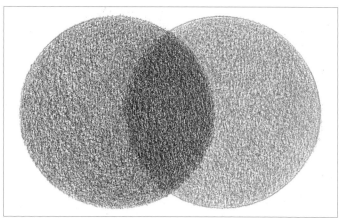

You can see how layering True Blue and Scarlet Lake (red) makes a dark purple.

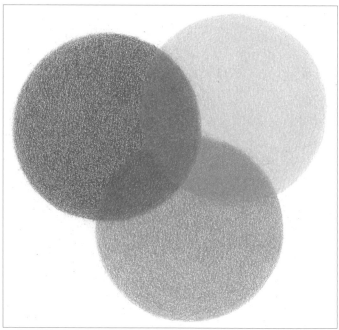

Layering a light blue (Non-Photo blue) and yellow (Jasmine) makes a complete new hue of green. But when layering the blue or the yellow on the green, it only modifies it slightly.

Burnishing

After a layer or layers of color have been laid in, apply a hard, rubbing stroke to mix the colors (or to intensify a single color) to produce a lustrous surface. This is generally done with a light color pencil or with a colorless blender (a pencil which has no color of its own and is used for blending). It can also be done with the same color you used for that subject.

Burnishing will get rid of the visible grain of the paper by getting the pigment to fill in all the blank spaces, making an even, more painterly surface.

Mineral spirits

To create a more even and painterly finish, you can dissolve the color pencil medium by applying mineral spirits to it. This works on both wax- and oil-based materials. Most solvents will dissolve, but I recommend using the lightest, odorless mineral spirits. After layering in a color (or colors) with the pencil, you can gently go over it with a brush or cotton swab, or on small areas with a cue tip.

Warning: Although odorless mineral spirits are among the least toxic solvents, they are still toxic and flammable. Make sure your working area is well ventilated and handle them with care. *Do not leave them within a child's reach.*

This is the blue before the mineral spirits were applied.

And this is the blue after the mineral spirits were applied.

In the illustrations above we can see the progression of Scarlet Red applied by scumbling (1), then layered with Pale Vermillion (orange) (2), and finally burnished with Sunburst Yellow (3). In this case, though the hue becomes lighter, the colors stay vibrant.

Here, we see a burnishing effect on a single color, the same scarlet red, applied on itself.

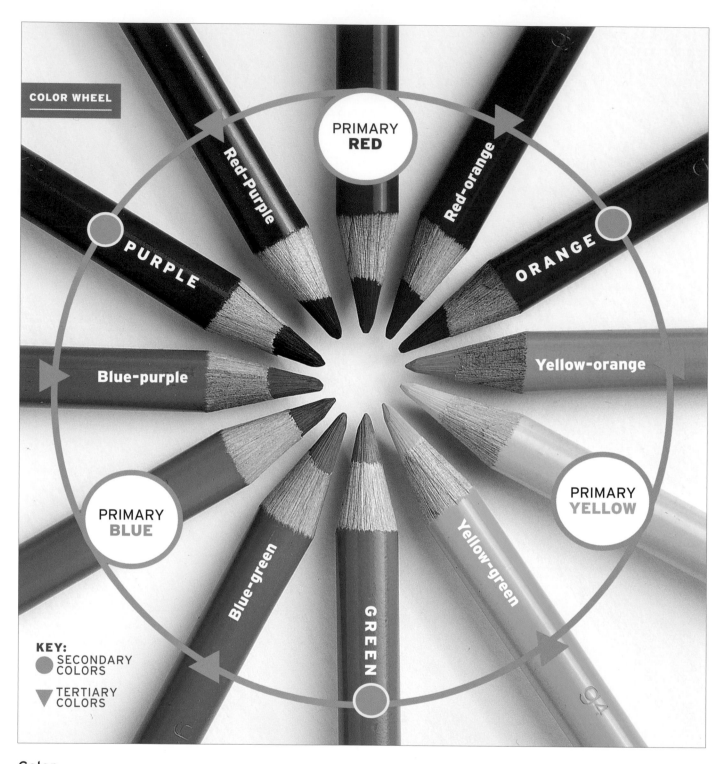

COLOR WHEEL

PRIMARY **RED**

Red-orange

ORANGE

Yellow-orange

PRIMARY **YELLOW**

Yellow-green

GREEN

Blue-green

PRIMARY **BLUE**

Blue-purple

PURPLE

Red-Purple

KEY:
● SECONDARY COLORS
▼ TERTIARY COLORS

Color

There are some basics about the use of color you should know when working with color pencils.

Primary colors: As you probably know, as far as fine art is concerned, there are three primary colors: blue, red, and yellow. They are called primary because they cannot be produced by mixing other pigments; they are basic and, in fact, you mix them to create other colors.

Secondary colors: There are three secondary colors and they are each made by mixing two primary colors.

Mixing blue and red will produce purple, blue and yellow make green, and red plus yellow equals orange.

Tertiary colors: These colors are made by combining either a primary and a secondary together, or mixing two secondary colors. They are sometimes called intermediate colors.

Complementary colors: Pairs of colors that when combined cancel each other out are known as complementary colors. I think a better term would be

24

This illustration shows how an original crimson red (center) was lightened by layering an orange (pale vermillion) on it (left) and was darkened by layering a Dahlia purple on it (right).

"opposite colors." In fact, they are located in opposite sides of the color wheel.

You create the complementary of a primary color by combining the other two primary colors. For example: To find the complementary of blue, we mix yellow and red, which is orange. Orange is the complimentary of blue and blue is the complimentary of orange. The complimentary of yellow is purple, which is produced by blending blue and red. The complimentary of red is green, a combination of blue and yellow.

When placed next to each other, complementary colors create the strongest contrast and therefore may produce some striking optical effects. To make a red apple really stand out, draw it on a green background. This will make it stand out more than using any other color for the background.

Additionally, the shadow of an object may contain a tint of its complementary color. For example, the shadow of a yellow banana may have a little purple in it. This effect separates the object from the shadow even more than it would by just making it darker.

You may use complementary colors in other ways: If you have a color that is too intense and you would like to tone it down, you can lightly layer on its complementary color, e.g., tone down a bright red with a light layer of green.

Analogous colors: Colors that are next to each other on the color wheel are analogous colors. The word analogous in this context means something similar or related. Using them together helps create a color harmony. Examples are red and orange, orange and yellow, blue and green, etc.

You can use analogous colors to create changes of tone. If you have an object, for example a red apple, and it looks too flat, you could add some orange in the areas of light and some violet or purple in the areas of shade. This would make the apple look much more realistic and three-dimensional. If you had an area in red and you wanted to lighten it, you could layer in some white, but this would dull the vibrancy of the color. A more effective approach would be to layer orange on some areas of red, as described above. This would lighten its tone while preserving its vibrancy. If you would like to darken a side of the apple and you layer in black, it could look muddy. A better solution would be to layer in violet or purple, which would darken it while keeping the colors clean.

Hue: Hue is the specific color. In fine arts we use the word hue to refer to any of the colors on the color wheel.

Colorfulness: How vivid and intense a color is, in other words, how far it is from a grey, is its colorfulness. Some people call this "Chroma." Mixing a color with its complimentary or with a neutral color (such as black, grey, and white) reduces its colorfulness.

Value: Value is expressed by the lightness or darkness of a color. Applying light pencil pressure produces a light value, while strong pressure produces a dark value. This is true for black and white drawing and when drawing with color pencils.

When all values are close to each other in a drawing, it will tend to flatten out. Nothing will stand out. This type of drawing would have a subtle look. On the other hand, if we use contrasting values with real lights and real darks, the shapes will tend to separate from each other, creating volume and a three-dimensional effect.

It is important to know the above concepts to use the effects that colors can produce in your favor. By applying the medium with the best techniques for each occasion and by combining the right colors, your drawings will look radiant and you will be able to create visual effects with the level of impact you are looking for. This photo shows the many different values of one color.

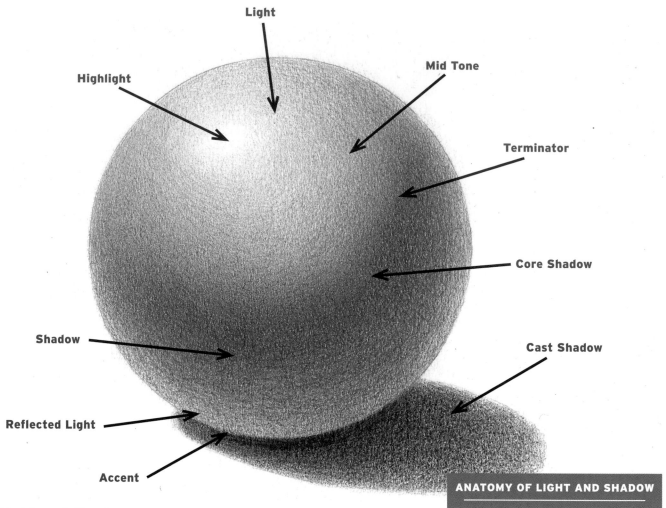

Light

Highlight

Mid Tone

Terminator

Core Shadow

Shadow

Cast Shadow

Reflected Light

Accent

Light and Shadows

The observation and handling of light and shadow are fundamental parts of drawing. They are what create the three-dimensional effect and are key in making an image look realistic.

Correct application of light and shadow has an almost magical effect – some simple pigment on a flat piece of paper all of a sudden conjures 3D volume and makes the drawing come to life.

In reality, this effect is achieved by the correct application of tone, which transitions from lighter to darker or vice versa in believable increments.

Value, in art, means the relative degree of lightness or darkness of a color – the tone. We use values to interpret the effect of light and shadow in an object and therefore achieve a lifelike drawing with form and depth.

When drawing, we can divide an object into two main areas: the ones in light and the ones in shadow.

Areas in light

There are several types of light you can render in your drawings. The types depend on factors like where the light comes from, whether it is direct or reflected, whether it is diffused by the atmosphere or sharp and bright, as well as how direct it is hitting the object. Also, is it perpendicular to the surface, or is it softened by the plane moving away from the source? Let's look at these factors in more detail.

Light Source

This is where the light that illuminates the object is coming from. There are different types of light sources and each produces different types of shadows on the object. A soft, diffused light, like on a cloudy day, makes soft and blurry shadows. Photographers achieve this effect artificially by placing diffusers in front of their lamps. If the source is intense and bold, it will produce sharper shadows and more dramatic contrast of lights and darks. Keep in mind that there may be more than one light source.

Highlight

A reflection of the light on the object, highlight creates the brightest spot on the object's surface. Highlights are especially evident on shiny (reflective) objects.

The spot of the highlight not only depends on the light source but also on the position of the viewer. You will notice (and should experiment with this) that if you are looking at an object that has a reflection (highlight) and you move, the reflection will seem to move as well.

Light

These are the areas that catch the most light because they are where the light hits the object more perpendicularly, illuminating it. As the surface curves away from the light, the light tones down.

Mid Tone (or Half Tone)
As the surface continues to curve (or face) away from the light source, the true tone of the object is perceived, unaffected by reflections or shadows.

Shadow Line (or terminator)
We call the shadow line (or terminator) the border where the shape transitions from light to shadow. It's located at the edge where the light source stops directly hitting the surface, that is, just before the plane begins to face away from the light.

Areas in Shadow
There are basically two types of shadows: form shadow and cast shadow. Each may have different degrees of darkness. The form shadow falls on the planes that are turned away from the light source and therefore get no direct light. The cast shadow is produced by one object blocking the light from hitting another surface. Let's define them more in detail.

Form Shadow (or shadow)
When the surface curves or turns away from the light source it catches no direct light and is therefore darker. This is a (form) shadow area. Within the form shadow we can have different degrees of darkness.

Core shadow
The core shadow is the darkest value on the object and is located a step beyond the terminator. It's where the surface is turned away from the light source and has the least amount of light. The core shadow is part of the form shadow. It may be thin or wide, very visible or not at all, depending on the reflected light. When we have a reflected light bouncing off the surface, then the core shadow is visible. The angle of the light source and of the reflected light hitting the object will determine the thickness of the core shadow.

 Note: We do not have to figure all this out mathematically. As an artist, just be aware that the area closest to the bottom edge of an object is usually less dark than the rest of the shadow area. Also, usually with a rounded object, the darkest zone is a stripe along the surface, within the shadow side.

Reflected light
When light is reflected onto an object from the surface it sits on (or from another surface), it lightens the shadow of the object. Shiny or white surfaces reflect the most light, while dark and opaque surfaces reflect the least amount of light.

 I would like to note two things in regard to the reflected light:
1. It does not always exist as not all surfaces reflect light back to the object;
2. Many artists get confused by the words "reflected light" and draw this area of the same value as the areas that are in light. This is a mistake. One needs to understand that we are looking at an area (zone) in shade and that it should be darker than any of the areas that are in light. A good way to draw it without getting fooled is to divide the object into what is light and what is shadow. Give all the area in shadow a darker tone. Then further darken the area of the core shadow. By doing this, the reflected light will "automatically" appear lighter, as compared to the darker area you just made. This should be, generally speaking, about the right tone for the reflected light.

Cast shadow
When an object gets in the way of the light rays, it blocks the light from reaching what is behind it. Areas in this zone of blocked light are not illuminated. We call these areas cast shadow.

 The characteristics of the cast shadow depend on the intensity of the light source. A hard light source will project a stronger cast shadow, which has a sharp edge, while a soft or diffused light will project a dimmer cast shadow with a more blurry edge.

 As the cast shadow gets farther away from the object, it receives more and more ambient light. Consequently, it often lightens and the edges soften, while closer to the object it is darker with sharper edges.

 The cast shadow should be darker than the shades on the object. You can find the shape of this shadow by projecting lines from the light source that touch the borders of the object on either side and land on the surface. (See illustration below.) If the light source is very far away, like the Sun, these projecting lines will look parallel. The closer the light source is to the object, the more at an angle the projecting lines will be.

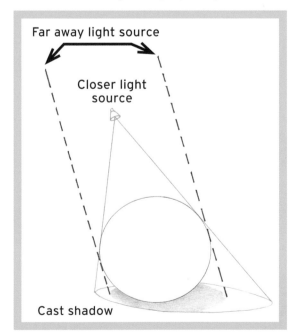

Far away light source

Closer light source

Cast shadow

Accent
On the spot where an object touches a surface (or another object), and therefore blocks the light, a dark area is created. This is the darkest spot of the cast.

Shading

There are many ways to do shading and they are all fun to do.

HATCHING AND CROSS-HATCHING

You can make a series of parallel lines to give a tone to the object. This is called hatching. To make the area darker you can make these lines thicker and closer. Or you may overlay lines in a different direction, which is called cross-hatching.

If you are hatching a rounded surface, try to follow the shape of the surface when making the lines. This will increase the illusion of volume.

Hatching and cross-hatching can be done with pencil or charcoal; it is an ideal technique for ink drawings.

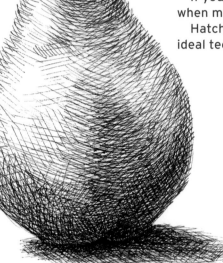

SHADING WITH CIRCLES

You can shade using other patterns such as tiny circular (or elliptical) motions, overlapping them one on another. I find this very effective. After doing a layer you may do another layer on top of it, changing the direction of your strokes. This helps achieve a more uniform (and darker) finish. With practice you will develop your own way of shading. Your shading will be distinguishable, like your handwriting.

Hatching and Cross-hatching

Layers of circles

Smudging with a chamois

Smudging with a brush

SMUDGING WITH A CHAMOIS OR BRUSH:

You can smudge your shading with a chamois or with a brush (or if it is a smaller area, with a stump or a tortillion).

Instead of just smudging what is on the drawing you can also directly tone with the chamois, brush, stump, etc. by saturating it with graphite or charcoal powder and "painting" with it. Please make a test on a scrap of paper before using it on the drawing, because it may not produce the desired effect.

SHADING WITH INK (WITH A MARKER)

There are many different ways of applying the ink in a drawing to create transitions in shading. The techniques you can use to make your transitions include hatching and cross-hatching (see above), and stippling and doodling (bottom).

One can sketch and draw directly with the ink on the paper, but as we know, the ink cannot be easily erased and therefore doesn't leave room for mistakes. So, you may choose to first do a sketch with graphite and once you are happy with it, you can go over it with the ink. Once the ink has completely dried you can erase the graphite, leaving a clean and high-contrast effect. These same stippling and doodling techniques can be applied to pencil drawings.

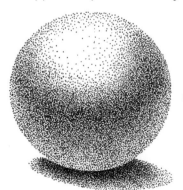

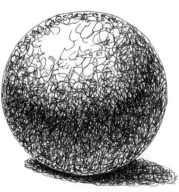

Shading with stippling

Shading with doodling

Sharpening Your Pencil

Please also refer to the sections Sharpening Tools (page 16) and How to Hold and Wield a Pencil (page 19).

We artists tend to sharpen our drawing pencils differently than most people sharpen writing pencils. This is because an artist uses the lead of the pencil in a number of positions to make a variety of marks. Having a longer, exposed lead gives you more freedom and flexibility to do that. A long, exposed lead also lasts longer between sharpening, giving you more drawing time, with fewer interruptions.

You can use the fine point of the tip to do small details as well as fine lines. By tilting the pencil you can use the side of the lead for wider lines or for rapid shading with broad strokes and everything in between.

The "common" ways for an artist to hold the pencil for sketching are "overhand" and "underhand" (see pages 20-21). With both, the pencil is held in a position that is fairly flat in relation to the paper – not parallel to the paper, but close to it. (With a short, exposed lead, you'd be scratching the surface with the pencil's wood.) Charcoal in particular is sharpened with a longer, exposed lead, as one tends to use the side of the lead more; some artists use graphite pencils this way.

To minimize interruptions due to sharpening, it is a good practice to have several pencils of the same type and sharpen them all before you start drawing, so that when a pencil needs sharpening you just put it aside and pick up one that already is. Having three or four pencils at the ready gives you a much longer uninterrupted drawing span. When the last one gets dull, take a short break and sharpen them all again so they are ready for the next charge.

Sharpening charcoal pencils

Charcoal breaks if you try to sharpen it with a hand sharpener; it's softer than graphite and breaks more easily so you need to be more careful with it. The correct way is to sharpen it with a blade or an X-acto knife. Of course be careful and make sure your fingers are never in the way of the blade in case it slips.

Sharpening graphite pencils

You can sharpen graphite pencils the same as you do charcoal; many artists like to have the longer exposed lead. But, graphite pencils can also be sharpened well with both a regular hand sharpener (page 16) or with an electric sharpener (page 16), which is much faster and effortless.

Sharpening lead holders

If you are using a lead holder you can use a hand sharpener even if you like long leads, because you can pull out as much lead as you want (after you've sharpened it) since it is not stuck inside the wood. As we mentioned on page 16, there are basically two kinds of lead holder sharpeners: lead pointers, which are a mini-hand sharpeners and the rotary barrel sharpeners (see photo on page 16). Pointers work well and are inexpensive, but barrels are faster, more comfortable and easier to use.

Sharpening mechanical pencils

The lead of the mechanical pencils is so thin that it doesn't require sharpening. When your lead is getting too short just click on the back of the pencil to get more of it. Sometimes, however, when you are drawing, the tip "flattens" more than you would like for doing minute detail or something like that. When this happens, all you have to do is rotate the whole holder slightly (and therefore the tip) to avoid using the flattened surface of the lead. If you keep rotating it every so often while drawing, the lead stays "sharp."

(If you are left-handed, reverse these instructions.) Using an overhand grip, firmly hold the X-acto knife with your right hand and hold the pencil facing away from you with your left hand. With your left thumb on the back (dull) edge, slowly push the blade down the pencil shaft. Take off thin layers of wood and continually rotate the pencil. Don't take off too much wood at once or you risk breaking the lead. Taper the wood like this until you expose a half inch or so of the charcoal. Sometimes taking the wood off leaves a film of glue on the charcoal; remove that by rubbing it with the blade. Use a sanding pad or a sanding block to smooth any sharp corners on the charcoal and to sharpen the tip. When you are done, wipe the powder residue off using a cloth or tissue paper so it doesn't smudge your drawing.

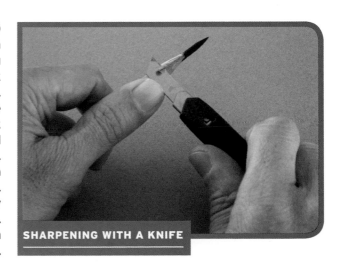

SHARPENING WITH A KNIFE

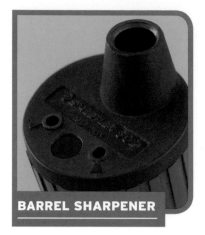

BARREL SHARPENER

This is a total breeze. On the top side of the barrel there are three holes: A big one for the actual sharpening and two small ones of different depth, for measuring, so you can gauge and pull out of the holder the proper lead length for the desired sharpening.

Let the lead sink to the end of one of those small holes, then insert it in the main (largest) hole and rotate it until you feel no more friction. When you pull the lead out it will be sharp, and may have some dust on it. The barrel comes with a soft felt material for cleaning dust off the lead. If you measured in the shorter hole you will end up with a fairly good point. If you measured in the deeper hole, after sharpening you will end up with a needle-sharp point. I love lead holders and rotary barrel sharpeners.

A NOTE ON "LEAD"

"Lead" is a misleading term since graphite does not contain lead.

Graphite is a form of carbon; in fact, it may be considered the highest grade of coal. The "lead" in pencils is commonly a mix of powdered graphite and clay. Graphite was originally called "black lead" due to its resemblance to the metallic element. We still use that name today.

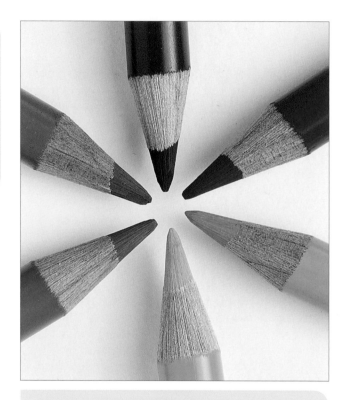

Sharpening color pencils

I always sharpen my color pencils with a regular hand sharpener. Make sure yours is of good quality and intended for color pencils. Prismacolor, Faber-Castell and Staedtler all make quality sharpeners. The blade needs to be sharp; when it starts getting dull it breaks leads, so either replace dulled blades or get a new sharpener.

However, there is a time when a blade comes in handy. That is when the color pencil has been damaged (e.g. the pencil fell off the table and the lead cracked inside). If you try to sharpen it using a hand sharpener, the lead will just keep breaking, no matter how careful you are. In this case, sharpen it with the X-Acto knife.

I personally don't like sharpening color pencils with electric sharpeners, mainly because I like to have control. Sometime, I just want to give it a half a turn to get that little bit more sharpness. With an electric tool you don't have that kind of control, and generally speaking, they eat off the pencils faster.

It is fair to say, though, that quality electric sharpeners can work for color pencils and many people like to use them because they are so fast and effortless. If you routinely use one, the only thing I would advise would be to sharpen a graphite pencil in it after sharpening three or four color pencils to clean the blades. Otherwise the waxy or oily color pigments start sticking on them. ■

Regular sharpeners usually come with two orifices. The wider hole is the one to use with color pencils because it produces a shorter, more tapered lead. You need to be more careful when sharpening color pencils than graphite because the color shaft is more delicate. Due to this delicacy, they are not sharpened to as fine a point as graphite pencils. Even if you could somehow achieve a long, exposed lead, it would break when used. After a little while you'll develop a "feel" for when to stop sharpening before they break.

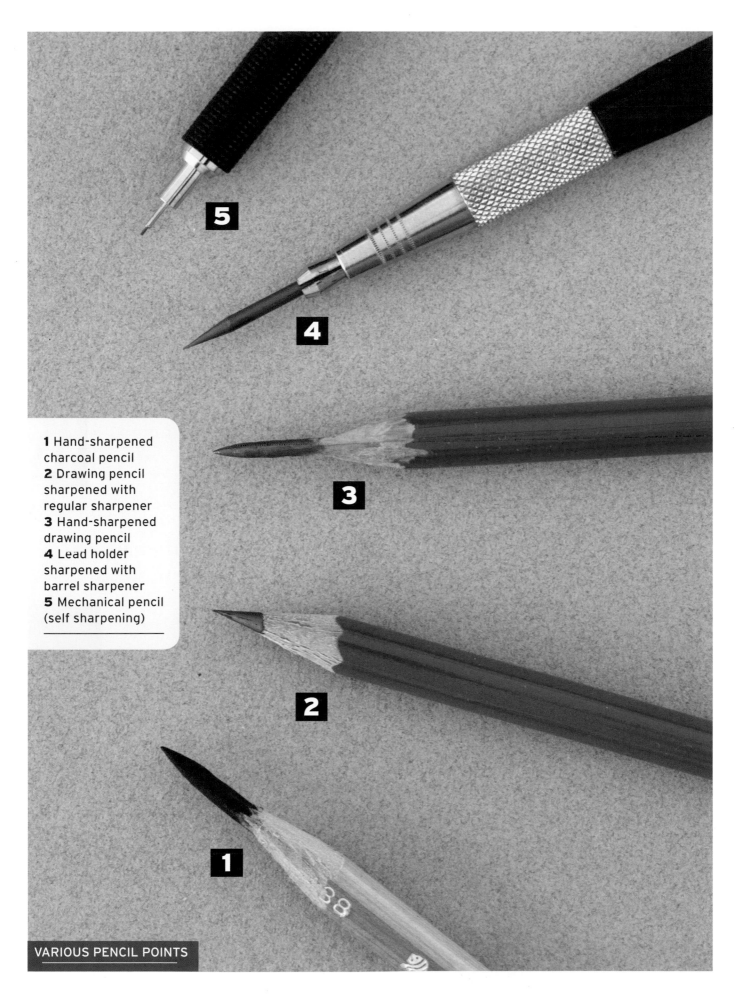

5

4

1 Hand-sharpened charcoal pencil
2 Drawing pencil sharpened with regular sharpener
3 Hand-sharpened drawing pencil
4 Lead holder sharpened with barrel sharpener
5 Mechanical pencil (self sharpening)

3

2

1

VARIOUS PENCIL POINTS

HOW TO DRAW
Gemstones

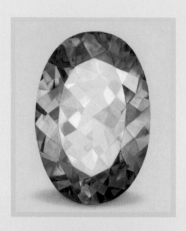

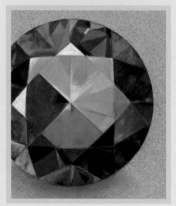

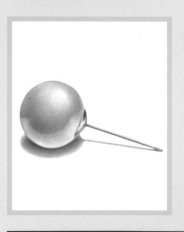

Gemstones are fascinating enough because of their physical characteristics and attributes, but their scarcity, uniqueness, beauty, and complex facets, all add to their mysterious allure.

Gemstones often have fairly basic shapes in a two-dimensional sketch, and making them look realistic, luminous, and reflective as a three-dimensional marvel takes some knowledge and practice. We have to understand the lines, the facet cuts, and the reflections. If rendered correctly, they immediately enhance the reality.

We will cover techniques on how to draw two gemstones with color pencils – an emerald and an aquamarine – techniques I hope will enable you to successfully draw other types of gems.

I included an organic gem, a pearl rendered with graphite pencil, to show you how its reflections and elegance can be captured in black and white.

AQUAMARINE • EMERALD • PEARL

How to Draw an Emerald

MATERIALS

5 or 6 reference photos

A compass (or glass, cup, or any round object)

Prismacolor Premier color pencils (set of 72):
True Green
Spring Green
Apple Green
White
Olive Green
Dark Green
Grass Green
Parrot Green

Pencil sharpener

Prismacolor kneaded eraser

Faber-Castell Magic-Rub eraser

Surface: Light grey cardboard

A fabulous effect of transparency and brightness can be achieved with color pencils, which is perfect for drawing precious stones. Here, we are going to draw an emerald.

Like all cut precious stones, emeralds have many facets (flat geometrically shaped surfaces) that both reflect and refract light. Because the gem is translucent, you can see both the outside surface and the inner angles of each facet. As light travels through the emerald, it bounces off of the angles, creating many different shades and hues of green. We will have a lot of fun drawing all of these details.

Please note that the following step-by-step illustrations are closer-up views that have been cropped slightly. The full-page image at the end of the sequence shows the complete drawing.

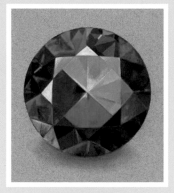

TO MAKE THIS DRAWING,
YOU MAY FIND IT HELPFUL TO REFER TO THESE BASIC TECHNIQUES:
• blending and layering colors (page 15)
• color pencil techniques (page 22)
• cast shadows (page 27)
• eraser techniques (page 14)
• graphite pencil techniques (pages 19-21)
• light sources and light reflection (page 26)
• pencil points and sharpening (pages 29-31)
• shade and shadow (pages 27-28)
• tone, hue, color, tint (pages 24-25)

1 Using a compass or any round object, draw a circle with the Olive Green pencil (which you'll use in steps 1 and 2). Then, sketch vertical and horizontal lines that bisect the circle and cross at the center point. Mark a dot on each line near to the circle, each at the same distance from the circle. These will be the vertex (angles) of the squares you'll draw in step 2.

2 Using the step 1 dots as reference points, draw a square. Don't form the lines of the sides totally straight; it looks better if you bulge them out a little, as shown. Then draw a second square, with a 45° rotation from the first one. All eight corners should be the same distance from the circle.

3 Start coloring some of the brightest areas with shades of light green, specifically Spring Green, for some triangle shape figures and True Green on the top and left corners of our original square. You will develop this drawing in layers and will add other tones on these.

4 Draw more of the small figures with Spring Green and Apple Green. Keep in mind the small facets that you want to represent. (These are actually on the opposite [back] side of the emerald but they will be visible because of the object's transparency.) Later, you will layer in other tones to create the facets that are on top.

Go over the corners of the original square with White, layering it on top of the True Green.

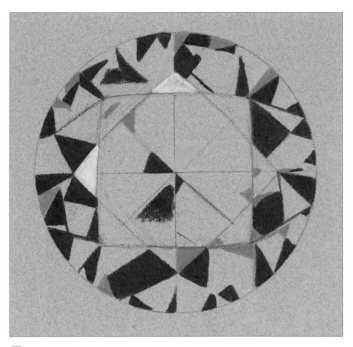

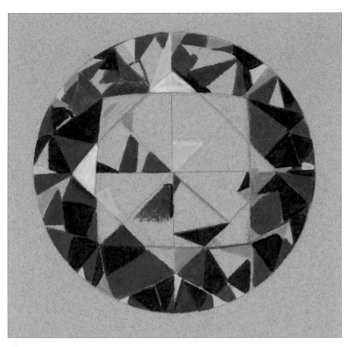

5 With Olive Green, fill in more geometrical figures. This will be the overall, medium tone of the emerald.

6 Keep filling in the emerald as in step 5. Add Dark Green to some figures to create contrast. Consider your light source. In this case it is from the top left, so that side will be slightly lighter and the bottom right darker.

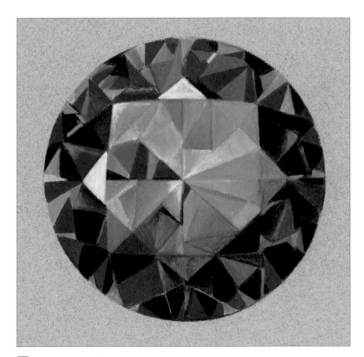

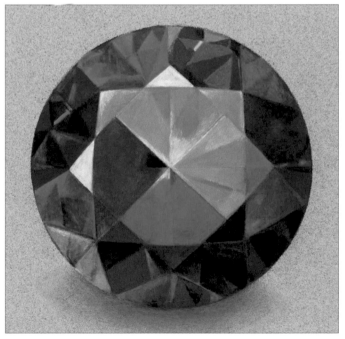

7 You may layer in different tones of green to gain a richer spectrum of tones. Grass Green on top of Apple Green looks particularly good. Not all the triangles need to be evenly flat. With a dark or light color you may degrade an area from light to shade or from shade to light.

8 It's time to create the facets that are on the top (front) surface of the emerald. With Dark Green or Olive Green, go over an area that covers several small triangles; this will be a cut facet of the stone. Do one layer this way. The original triangles will still be visible, creating a see-through appearance. Then visualize another area and select another tone such as Parrot Green and cover that area with one layer. For areas of reflection choose a lighter green such as Spring Green or you can even go over the existing green colors with some White.

35

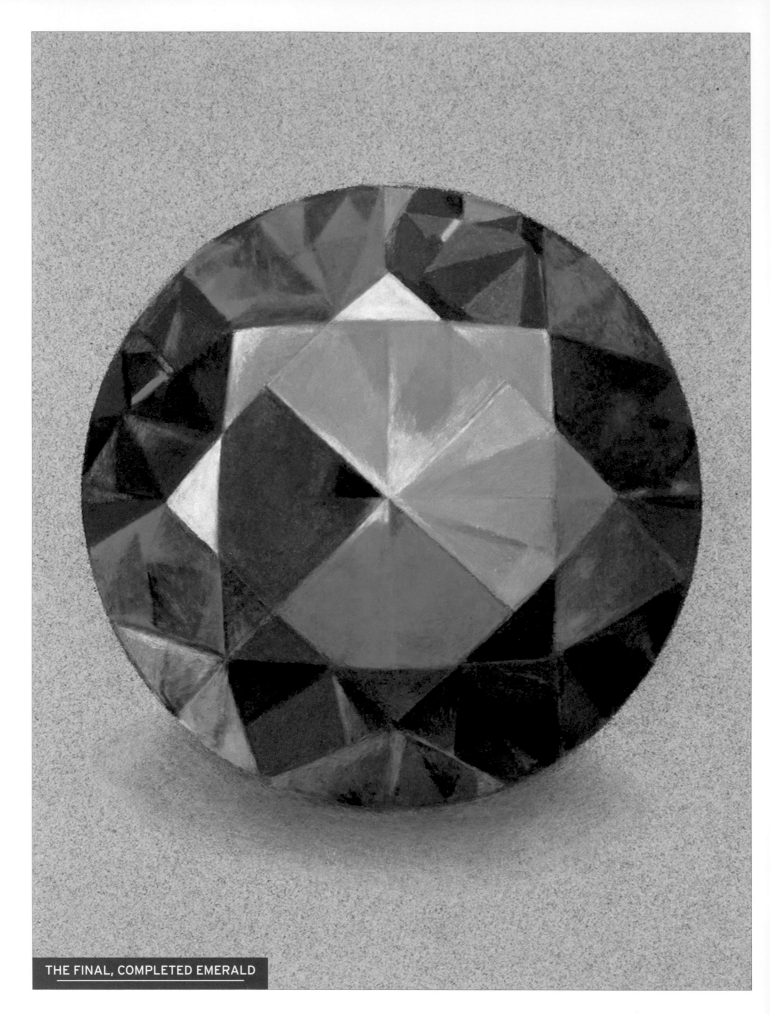

THE FINAL, COMPLETED EMERALD

How to Draw an Aquamarine

MATERIALS

5 or 6 reference photos

Mechanical pencil with a 0.7 HB lead

Prismacolor Premier color pencils (set of 72):
Ultramarine Blue
True Blue
Light Cerulean Blue
Light Aqua
Cloud Blue
Peacock Blue
Violet Blue
Copenhagen Blue
Indigo Blue
White
70% Cool Grey

Pencil sharpener

Prismacolor kneaded eraser

Faber-Castell Magic-Rub eraser

Surface: Light blue cardboard paper

Aquamarine stones are beautiful and inspiring because of their light reflection, transparency, and gamma of blues. We will splurge into drawing one of them with color pencils.

The word aquamarine comes from Latin: aqua marina, which means "water of the sea." Like the water of the sea, this gemstone manifests a wide range of blues, from intense, to very light, to bluish-green. All have a wide range of transparencies. The challenge is to be able to represent all this realistically. We will take an approach that is both simple and effective.

Please note that the following step-by-step illustrations are closer-up views that have been cropped slightly. The full-page image at the end of the sequence shows the complete drawing.

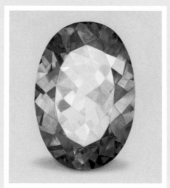

TO MAKE THIS DRAWING, YOU MAY FIND IT HELPFUL TO REFER TO THESE BASIC TECHNIQUES:

• blending colors (page 15)
• color pencil techniques (page 22)
• cast shadows (page 27)
• eraser techniques (page 14)
• graphite pencil techniques (page 12)
• light sources and light reflection (page 26)
• pencil points and sharpening (pages 29-31)
• shade and shadow (pages 27-28)
• tone, hue, color, tint (pages 24-25)

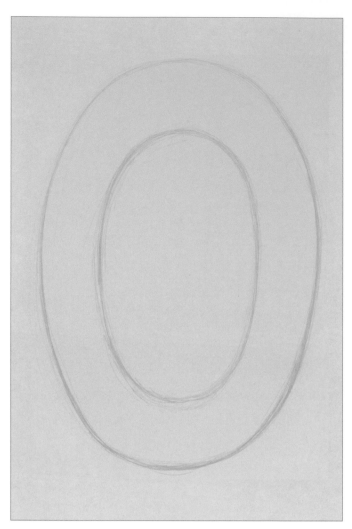

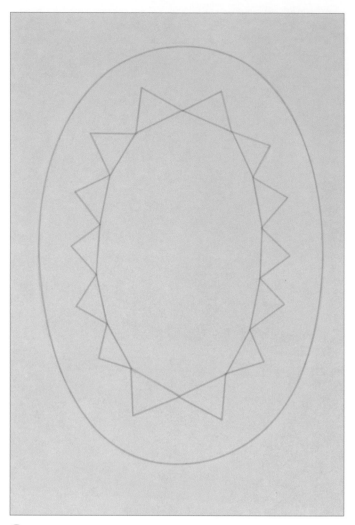

1 Using your mechanical graphite pencil, draw a large oval and a smaller oval inside the larger one. You'll use this pencil for steps 1-3.

2 First, work on the smaller oval, which is there as a guide. Make short straight lines of about the same size along all of its perimeter, so that instead of one curved line forming the oval, a series of short lines form it. At the top and at the bottom there should be a vertex (an angle). Then, using the short lines you just made as the bases, draw triangles of about the same size around the perimeter.

TIP
These shapes don't need to be perfect and are not necessarily final. When adding the color you will be able to change their shape or refine the size and form. But, they are a good guideline.

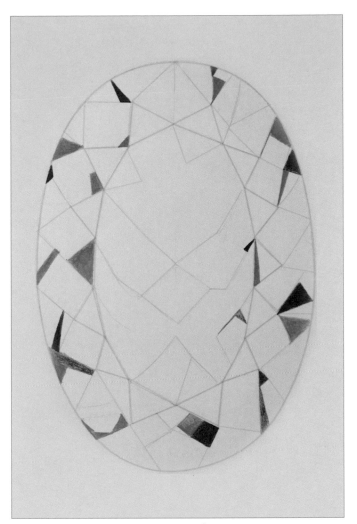

3 Fill in the whole figure with geometric shapes, mainly (but not exclusively) triangles, as shown. They can be of different sizes and do not need to be placed symmetrically.

4 Using your Ultramarine Blue pencil, start coloring some of these shapes you made in step 3. Choose some figures to fill in, mainly on the large oval, while none or very few on the smaller one, since this area is going to be a lighter tone.

Using your True Blue pencil, fill in more shapes. You can distribute this color in figures more or less evenly all around the bigger oval for now. You'll use more of this nice color later.

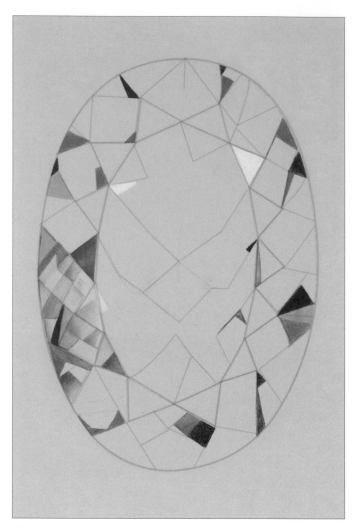

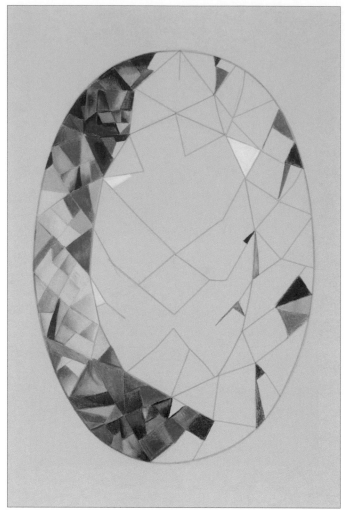

5 Choose where your brightest reflections will be and fill those triangles with your White pencil. Now, you are going to really go on a coloring roll. Select an area (in this case the lower left) and color in different tones of blue, such as Ultramarine, True Blue, Light Cerulean Blue, Light Aqua, and Cloud Blue. You may place them alone or mix them in layers, one on top of the other. You may color them flat or do gradations from light to dark within a geometrical figure.

6 Continue working around the outer oval as in step 5 concentrating on the left side. I decided that, in regard to the outer oval, the lightest area was the left side, the right side the next lightest, the upper part is darker, and the bottom area is the darkest. Therefore, while working the left side, generally use lighter blue tones like Cloud Blue, Light Cerulean Blue, and True Blue. As you advance, if you don't like your original sketching, you can modify the shapes of your figures or break them down into smaller ones. Keep creating (and having fun) as you go!

TIP
When layering colors, it's a good practice to start with a light pressure on the first layer of color and then press a bit harder on subsequent layers. This is true whether you are layering in with the same color or with a different one.

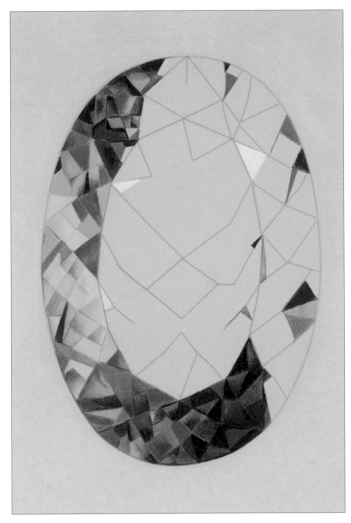

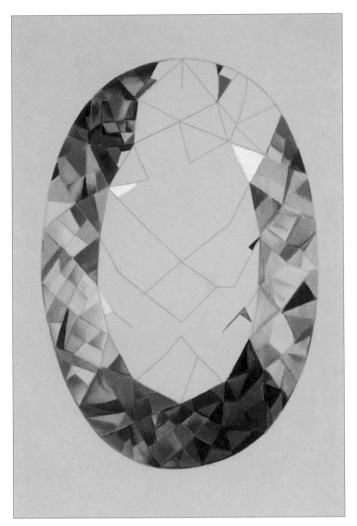

7 As you move on to the lower part of the outer oval, you can add in the darkest hues such as Ultramarine Blue, Indigo Blue, and Violet Blue. Again, you can layer one color on top of another or modify them by going over them with lighter blues.

8 Moving on to the right side, you can go back to slightly lighter tones, such as Cloud Blue, Light Cerulean Blue, and True Blue. It's okay to mix in a greenish hue (such as Light Aqua), here and there.

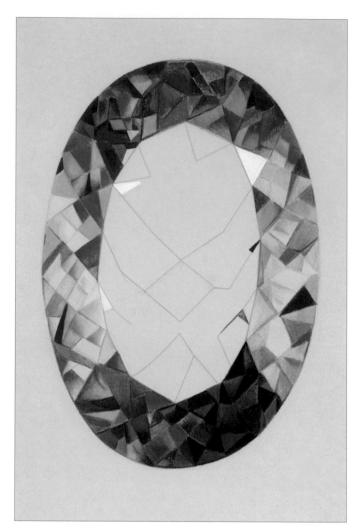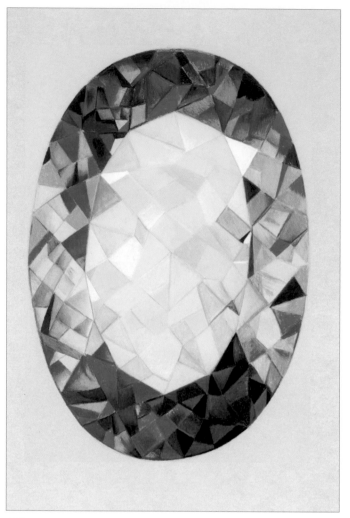

9 As you complete the top area (using darker pencils such as Peacock Blue, Copehagen Blue, Ultramarine Blue, and Indigo Blue), the whole outer oval is filled in. Note that the transitions between the upper, left, right, and bottom areas are made gradually/gradiently to indicate that they are all on the same plane, and not all of a sudden, which would indicate a distinctly different plane.

10 The smaller oval is, in fact, a distinctly different plane from the outer oval. It's flat on the top surface, but there are facets on the other (back) side of the stone. Because the stone is translucent you should be able to see them. Therefore, start filling in the shapes with lighter tones, such as White, Cloud Blue, jade green and aquamarine to indicate the facets on the other (bottom) side.

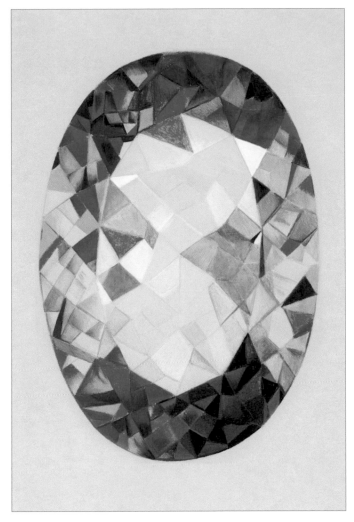

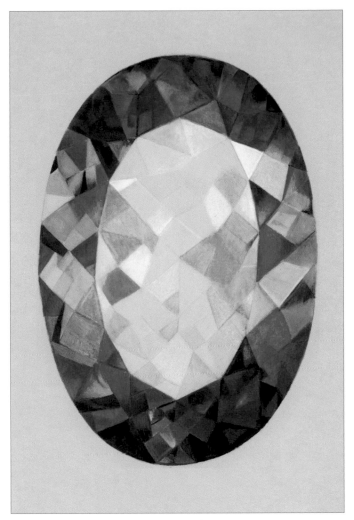

11 Continuing to work on the inner oval, you can also use slightly darker blues such as Cerulean Blue and Peacock Blue. Next, layer some White or light blue on the darker blues. Continue working this way throughout the small oval.

12 Now that you've rendered the shapes on the opposite (back) side of the stone, create a flat layer on top of the aquamarine to visually send all this work to its back by doing a flat layer of Cloud Blue (or another very light blue) over the whole smaller oval.

See what touches you can add. To me, it looks a bit flat. To add more life, draw more lights. Choose a couple of figures in the top and bottom areas and add light in a corner with the White. With a very dark blue (like Indigo Blue), darken some of the figures slightly on the outer perimeter to give more volume. Straighten any lines that are crooked or too blurry.

Draw the drop shadow (see finished aquamarine on page 44) by adding a light layer of 70% Cool Grey. Then layer Indigo Blue on top of the grey, except on the area immediately by the stone. Use True Blue (lighter than Indigo Blue) to create a glare, as shown.

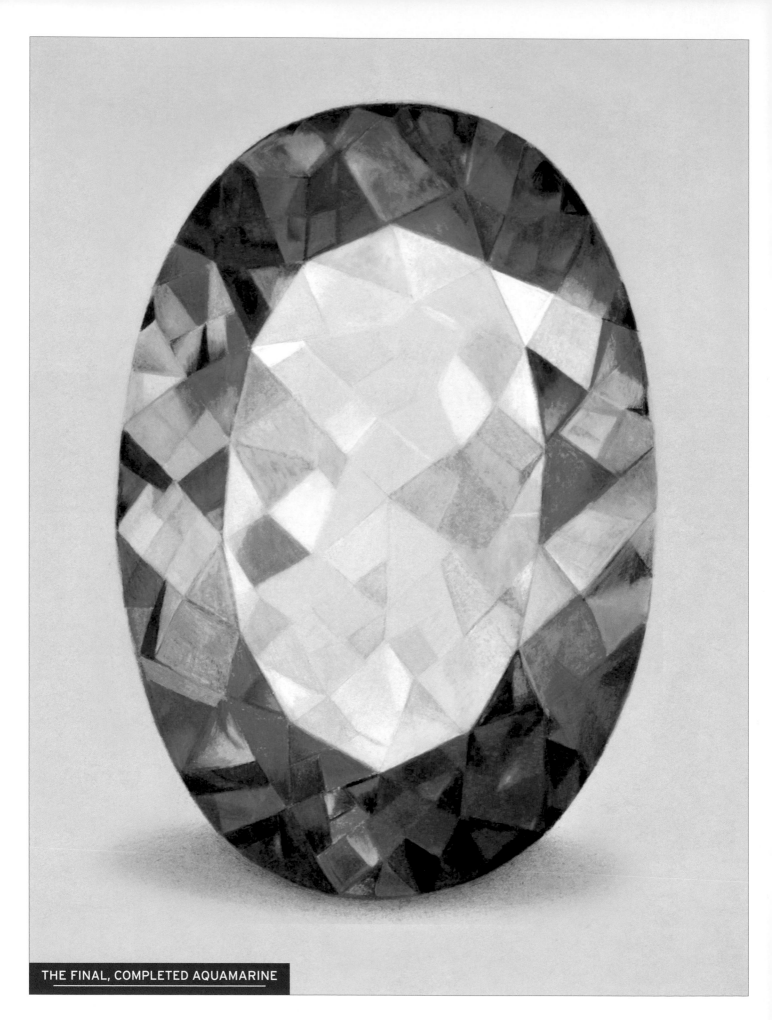

THE FINAL, COMPLETED AQUAMARINE

How to Draw a Pearl

MATERIALS

5 or 6 reference photos

Mechanical pencil with a 0.7 HB lead

2mm lead holders with H, 3H, and 6H leads

Lead sharpener

Prismacolor kneaded eraser

Tombow MONO Zero eraser, round tip

Faber-Castell Magic-Rub eraser

Chamois (or cotton cloth)

Surface: Fabriano sketching 56 lb. paper, fine grain, white

Clean paper (for under hand to prevent unwanted smudging)

Pearls are marvelous objects of nature. There are few objects more romantic than they are.
In this illustration, we will use a basic graphite technique to draw a single pearl nesting in the silver setting of an earring. The shiny properties of the silver will emphasize the pearl's opalescent quality and smooth, creamy texture.

Please note that the following step-by-step illustrations are closer-up views that have been cropped slightly. The full-page image at the end of the sequence shows the complete drawing.

TO MAKE THIS DRAWING,
YOU MAY FIND IT HELPFUL TO REFER TO THESE BASIC TECHNIQUES:
- cast shadow (page 27)
- eraser techniques (page 14)
- graphite pencil techniques (pages 19-21)
- light sources and light reflection (page 26)
- pencil points and sharpening (pages 29-31)
- reference photos (page 18)
- shade and shadow (pages 27-28)
- using a chamois (pages 15 and 28)

1 Normally, pearls are not perfectly round, so sketch a circle freehand using an HB lead. (You'll use this lead for steps 1-4.) Draw a series of loose circles with a continuous line, one on top of the other. As you draw each new circle try to correct what you see wrong on your prior one, for example, making it wider or taller, or "rounder" on a specific area.

2 Using the Tombow MONO Zero round tip eraser, clean up all the lines you don't want, leaving a good circle of one single line. You can make additional corrections at this stage if you are not happy with your circle. It doesn't have to be perfect but it should look good and round enough.

3 Draw the pearl on an earring setting with a base and a spindle. Sketch a straight line at an angle, from the circle; the farther end should be at more or less the same level as the bottom of the circle and the closer end at the center of the circle, as shown. (In this case, I placed the farther end just a little below the bottom of the circle to make it look as if the spindle is slightly toward us.)

4 Add details to the spindle; give it some width with a thinner section toward its end, as shown. Clean up the lines as needed with the Tombow or kneaded eraser.

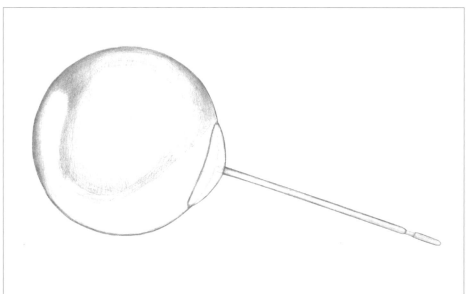

5 Using a hard lead, like the 3H, start shadowing the pearl. Use light, short, even strokes in different directions. The light source comes from the top-right area, so the shadows should darken toward the bottom left. In my visual study of many pearl photos, I have noticed that in nearly all of them I could see a reflection of the surface they rested on. Show this on the lower area of the pearl with a lighter-toned table shape, which will be distorted by the roundness of the sphere.

Mark an oval-shaped area near the top right where the lightest reflection is. Leave the inside of it blank.

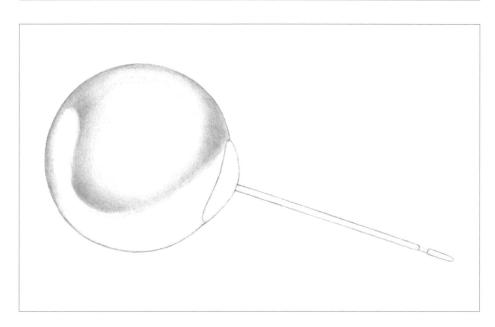

6 Keep darkening the area above the table reflection a bit more. Then wrap a chamois around your index finger and lightly smudge the graphite to even out the pencil marks and the finish. Instead of the chamois you can also use a cotton cloth or a piece of actual cotton, although I have had the best results with the chamois.

47

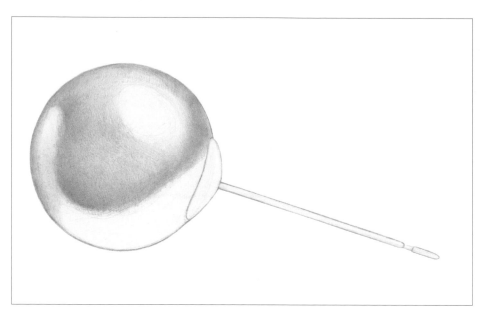

7 Little by little keep filling in the pearl without darkening it too much. The tone should be from light to medium. Try both the 3H and 6H leads and see which one works best.

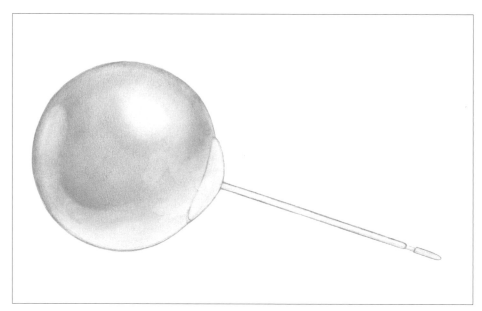

8 Smudge the graphite again with the chamois. Go over the lower part as well to integrate it with the rest of the pearl. You don't want a sharp line for the table reflection, since reflection on a pearl is blurry.

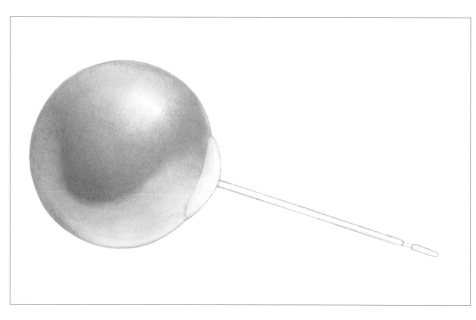

9 With the 3H or 6H lead keep filling in the pearl, evening the tones and darkening the areas close to the table. Smudge with the chamois as needed to blend transitions between intensities of tone.

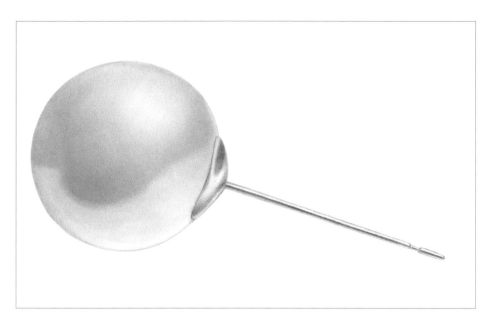

10 Step back and analyze your drawing. With mine, I felt the left side of the reflected table was getting lost, so I indicated it a little bit better.

Using an H lead, draw the silver setting. The reflections on this surface will be sharper than the ones on the pearl and the darks will be more intense. With the HB, create light and dark reflections on the setting holding the pearl and a dark reflection along the middle of the spindle. Leave a white reflection above the dark line on the spindle and blur the area below it with a chamois to give it a light tone.

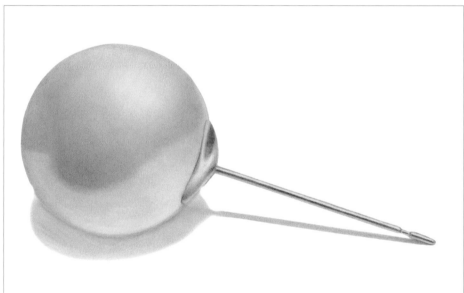

11 With the 3H lead, draw a slender shadow coming from the tip of the spindle to the sphere. Start rendering the cast shadow of the pearl with an oval shape around its lower part. Drawing the shadow totally lands the object and makes it much more realistic.

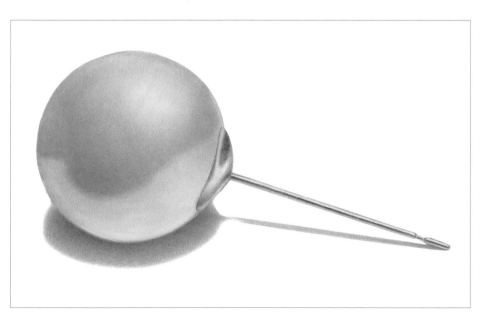

12 When you are happy with the shape of the pearl's cast shadow, darken it with the 3H or the H lead. The area closer to the pearl should be the darkest and the tone should lighten farther from it. Smudge it with the chamois so that it is even and has no sharp line where the shadow ends; it should end gradually and softly. Sometimes, you might smudge a bigger area than you wanted. If this happens, clean it up with a kneaded eraser, tapping on the paper so as to maintain a soft edge line.

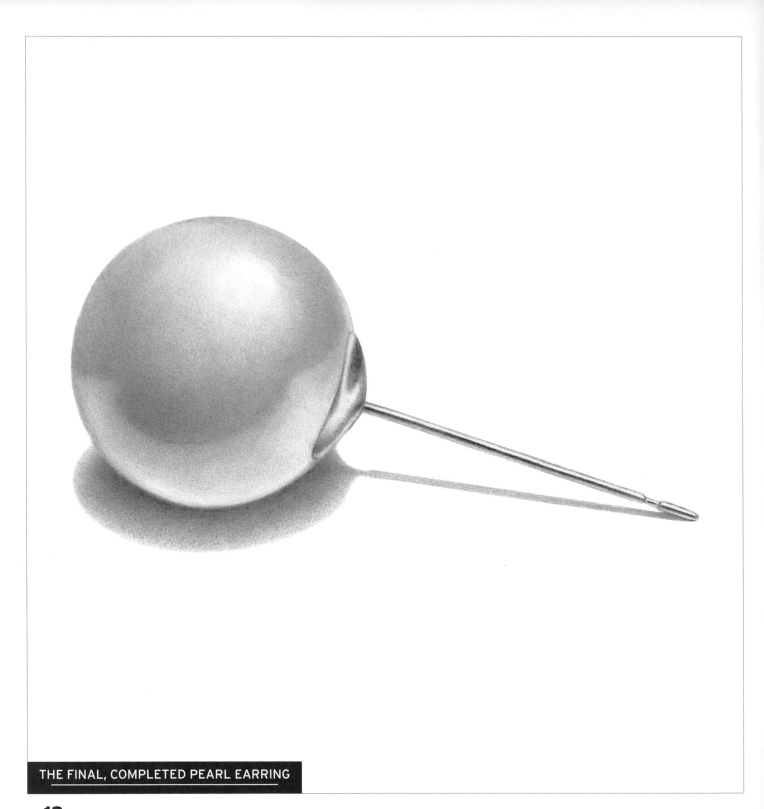

THE FINAL, COMPLETED PEARL EARRING

13 You are down to the final touches. Look over your drawing
to see if there is anything you wish to do to enhance it. On mine,
the reflected table is way too wide on the right side compared
to the left side; I want it wider but not that much, so I used an H
lead to add more tone on the right. I also want the whole pearl to
be of a slightly lighter tone and more even, so I smudged it again
with a clean chamois. When you smudge with a clean peace of the
chamois it lightens the tone as it takes on some of the graphite.
(If the chamois is already impregnated with graphite, it smudges
but doesn't lighten.)

Finally, with the kneaded eraser, I pulled a bright light in the
middle of the pearl's lighter area in the upper right, as shown in
the final drawing artwork on this page.

HOW TO DRAW
Metals

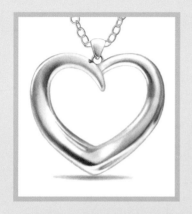

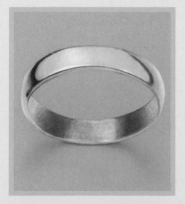

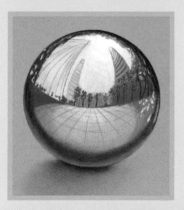

SILVER • GOLD • CHROME

Drawing metal is very rewarding. It may be hard to believe the results were achieved with regular color pencils or graphite and not with metallic paints.

When drawing metals (especially highly reflective ones), keep in mind three key factors:

1. The shape of the reflections (which is distorted by the form of the metal object itself);

2. The contrast of the reflection. In shiny metal the intensely bright highlights contrast with the dark tones; the more contrast, the brightest it will look;

3. How sharp and clearcut the reflections are (as compared to blurred or diffused).

Observe carefully. Reflections in metal show great contrast, so make sure you display a good range of values, from the brightest white to the darkest tones.

How to Draw a Gold Ring

MATERIALS
5 or 6 reference photos

Mechanical pencil with
0.5mm, H lead

Prismacolor pencils:
Tuscan Red
Yellow Ochre
Cream
Goldenrod
Canary Yellow
50% Cold Grey
70% Cool Grey

Pencil sharpener

Faber-Castell Magic-Rub
eraser

Surface: Grey
cardboard paper

We humans have treasured gold since prehistoric times. It is a soft, yellow metal with a beautiful lustrous sheen. It is the most malleable and ductile of all the elements. Gold is, of course, a precious metal largely used for jewelry and coinage. Gold represents success, achievement, and triumph. It is often associated with abundance and prosperity. When drawing it we have to consider that it is normally shiny and reflective, although it may also have a matte finish.

With the following sequence, we are going to strike gold!

Please note that the following step-by-step illustrations are closer-up views that have been cropped slightly. The full-page image at the end of the sequence shows the complete drawing.

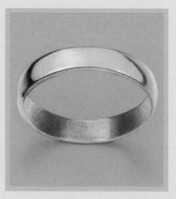

TO MAKE THIS DRAWING,
YOU MAY FIND IT HELPFUL TO REFER TO THESE BASIC TECHNIQUES:
• blending and layering colors (page 15)
• color pencil techniques (page 22)
• cast shadows (page 27)
• eraser techniques (page 14)
• light sources and light reflection (page 26)
• pencil points and sharpening (pages 29-31)
• shade and shadow (pages 27-28)

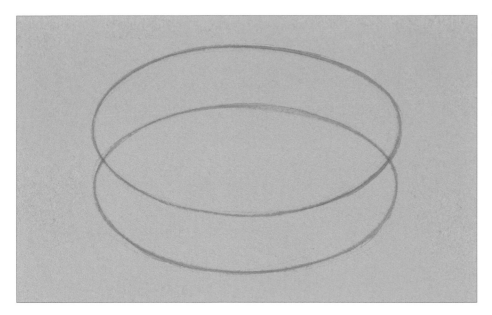

1 Use your H lead pencil for steps 1 and 2. Draw two horizontal ovals (which will be interlaced later). The distance between one oval and the other will determine the width of the ring.

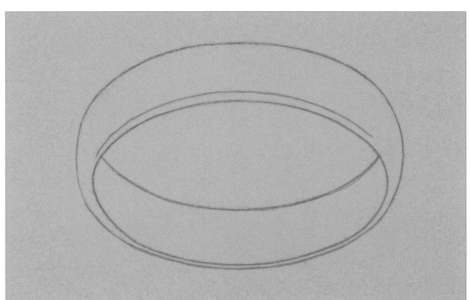

2 Unite the ovals with curved lines at the left and right sides. Then erase the segments of the ovals that are going to be covered by the interlacing and therefore not seen. You can also indicate the thickness of the ring with an additional line near the bottom of each oval, as shown.

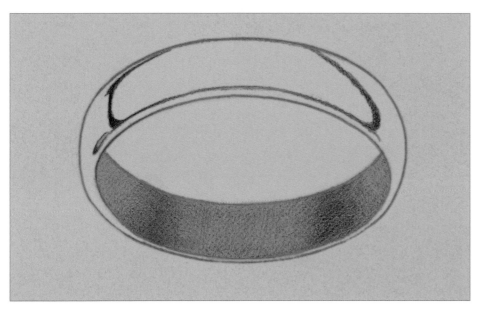

3 Now, you'll begin coloring, working first on the shade (the ring's interior) and the dark reflection on the top outside of the ring. Lightly apply a layer of Tuscan Red on the bottom, inside ring area and on some narrow areas of the top, as shown. Note that the bottom part has some gradations to define areas of darker shadow.

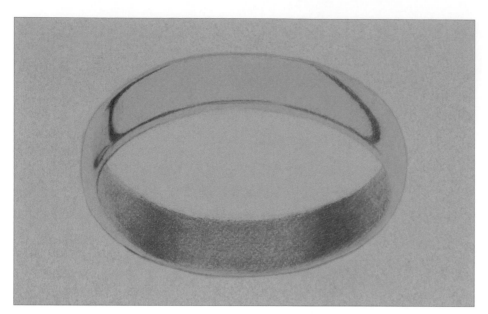

4 Apply a flat layer of Yellow Ochre on the whole ring, including over the Tuscan Red.

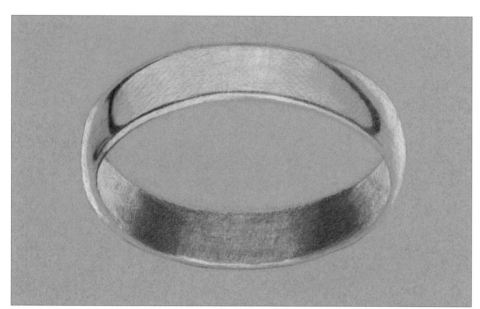

5 With a light color, like Cream, lighten some areas such as the left and right of the outside of the ring, the top center of the ring, and the center of the inside bottom area. Also indicate a reflection along the bottom border. By now it should start looking like a gold ring!

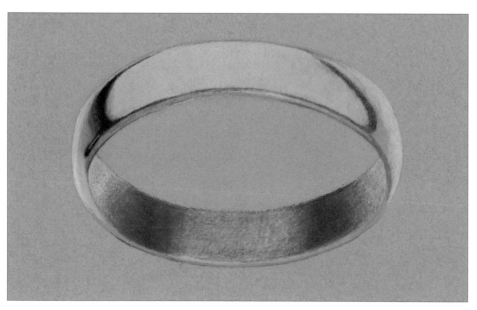

6 Apply a layer of Goldenrod (it's an intense yellow, you may also use a Canary Yellow or similar) to even out the lights added in steps 3-5. You don't want the texture of the paper to show through, because gold has a smooth surface. This additional color layer will help create that smooth surface and will give more richness to your drawing. At this stage you don't need to do a flat layer; instead look for where a flat layer is needed.

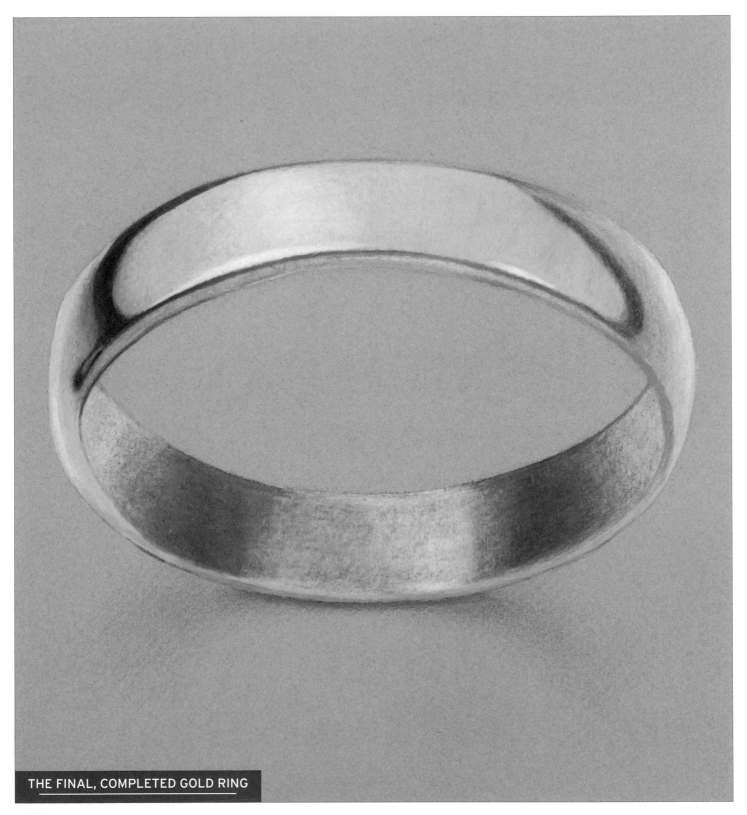

THE FINAL, COMPLETED GOLD RING

7 It's time for some final touches! Review your drawing and go over every part that needs smoothing or reinforcing. You may want to increase the intensity of some of the dark reflections. With the Tuscan Red, give some light reflections. With the Cream, flatten some areas or merge changes of tone with the yellows, etc.

Finally, draw the cast shadow. For the area nearest the ring you may want to use a dark grey such as the 70% Cool Grey, and for the farther area where it is lighter, a 50% Cold Grey. Of course, you can do this with a single color pencil, just applying it darker when you are immediately closer to the ring. Note that the cast shadow curves in the opposite direction from the ring.

How to Draw a Silver Heart

MATERIALS

5 or 6 reference photos

Mechanical pencil with 0.7mm, HB lead

Mechanical pencil with 0.35mm, H lead

Lead holder with 2mm, 4B lead

Chamois

Prismacolor kneaded eraser

Surface: Fabriano white drawing paper, fine grain

For this silver heart drawing, we are going to keep it simple, using graphite on white paper.

Silver is the most reflective of all metals and has a wide range of industrial uses (having the most electrical conductivity of any element). It is very ductile and malleable and has a brilliant white metallic luster that can take a high degree of polish. Of course it is largely used in jewelry as well.

Please note that the following step-by-step illustrations are closer-up views that have been cropped slightly. The full-page image at the end of the sequence shows the complete drawing.

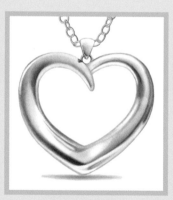

TO MAKE THIS DRAWING, YOU MAY FIND IT HELPFUL TO REFER TO THESE BASIC TECHNIQUES:

• cast shadows (page 27)

• eraser techniques (page 14)

• graphite pencil techniques (pages 19-21)

• light sources and light reflection (page 26)

• pencil points and sharpening (pages 29-31)

• reference photos (page 18)

• shade and shadow (pages 27-28)

• using a chamois (pages 15 and 28)

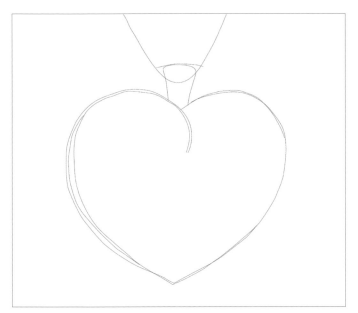

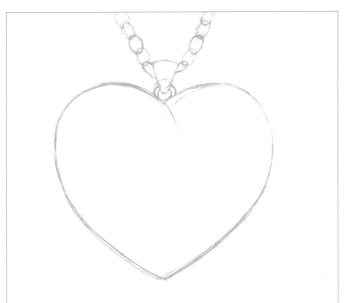

1 Using the 0.35mm H lead mechanical pencil, sketch the overall shape of the heart. Your first line doesn't need to be perfect; keep it loose and find the shape you want. (You can always erase it.) It helps to draw a light, vertical center line to aid in keeping a mirror-image even distances from the center to each side of the heart. Keep it symmetrical.

In my design, the line of the heart on the left side will come up and then pass in front of the rest. You may follow this or design your own.

At this stage you can suggest the placement of the chain, ring, and hanging heart.

2 Still using the H lead, define all the shapes a bit better, and draw the chain with more detail.

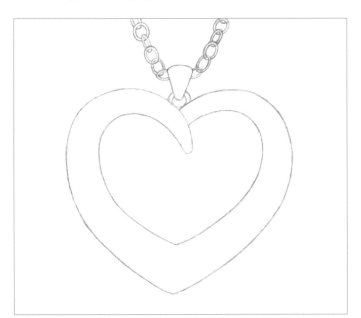

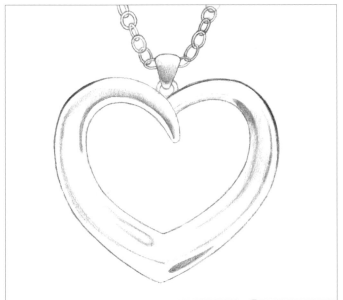

3 Clean up the lines with the eraser and redraw them cleanly, as needed with the H pencil. Then draw the thickness of the heart inside the original heart shape (here crossing the symmetrical halves at the top, left over right).

4 Start to add the shading with the H lead. This is a fairly hard lead and if you use it lightly it will produce soft shades. The shading can vary widely depending on the lighting and on the surrounding area being reflected by the silver. In this case, a soft light is coming from above, and a white surface is reflected on the heart from below. Make some darker spots to give contrast, giving the impression of a smooth, shiny surface and a sense of volume.

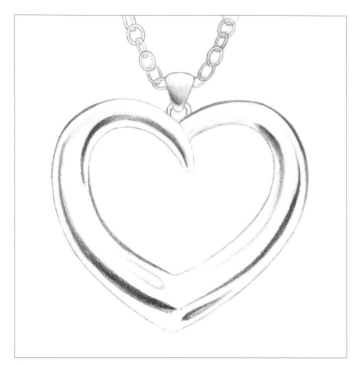

5 With the HB lead, do the dark reflections. The more high contrast you create between the lights and the dark shades, the more it will look like a polished, shiny surface.

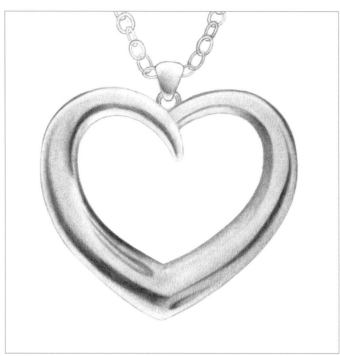

6 Wrap a chamois around your index finger and gently go over the graphite to smudge it. This gives a light, smooth overall tone to the surface. Don't worry if you run off the heart and into the surrounding areas; that can be easily erased.

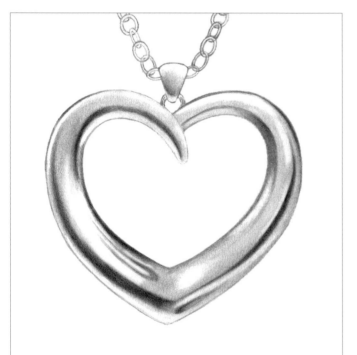

7 With a kneaded eraser, clean up any stray pencil marks in the areas outside the heart. Pull some lights on the heart as shown. Some can be sharp (like the ones on the upper left and right) and some may be blurred, like on the lower area of the heart).

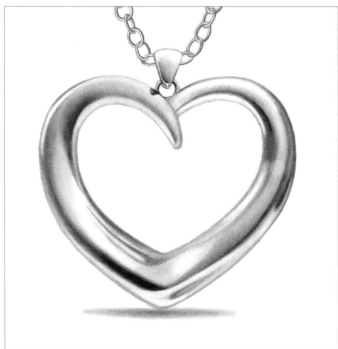

8 With a softer lead such as a 4B, reinforce the darker reflections to increase contrast and volume. Do this on the heart as well as on the chain, ring, and hanging parts. If you wish, draw a soft cast shadow with the HB lead. This will immediately create the illusion that the heart is hanging. It should be darker toward the center and lighter and becoming blurred toward the edges.

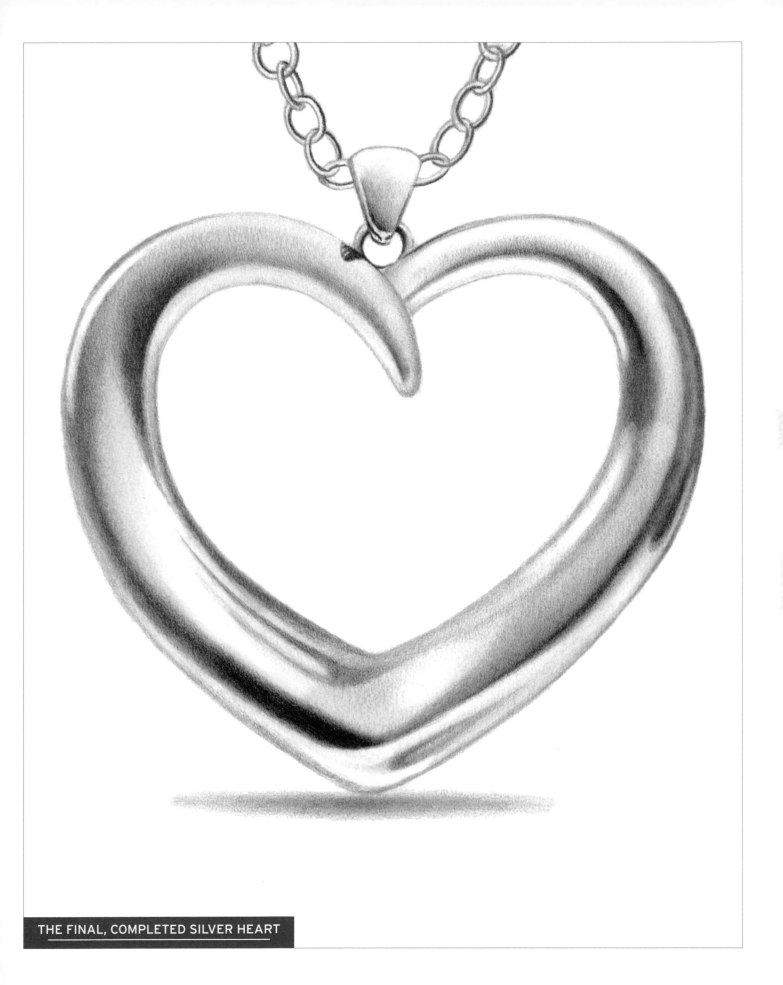

How to Draw a Chrome Sphere

MATERIALS

5 or 6 reference photos

A compass (or any round object)

Mechanical pencil with 0.7mm, HB lead

Mechanical pencil with 0.5mm, 2H lead

Prismacolor Premier color pencils (set of 72):
Dark Green
Putty Beige
Dark Brown
Light Umber
Dark Umber
White
Cloud Blue
Light Cerulean Blue
50% Warm Grey
50% French Grey
70% Warm Grey
Dark Grey
Black

Primo Bianco Charcoal (White)

Pencil sharpener

Chamois

Prismacolor kneaded eraser

Faber-Castell Magic-Rub eraser

Surface: Grey toned cardboard paper

I love drawing chrome because it can deliver truly amazing, jaw-dropping effects. It is a highly reflective surface and its look may vary notably depending on the surroundings and the environment it's in. This reflective quality is a great effect for drawing because you can give the whole ambience and feel of an overall setting without actually drawing it, except in the reflection.

Chrome should have a high contrast of tones, with intense highlights and darks.

Please note that the following step-by-step illustrations are closer-up views that have been cropped slightly. The full-page image at the end of the sequence shows the complete drawing.

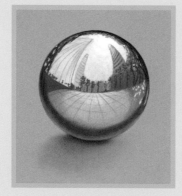

TO MAKE THIS DRAWING,
YOU MAY FIND IT HELPFUL TO REFER TO THESE BASIC TECHNIQUES:
• blending and layering (page 15)
• cast shadows (page 27)
• color pencil techniques (page 22)
• graphite pencil techniques (pages 19-21)
• light sources and light reflection (page 26)
• shade and shadow (pages 27-28)
• tone, hue, color, tint (pages 24-25)
• using a chamois (pages 15 and 28)

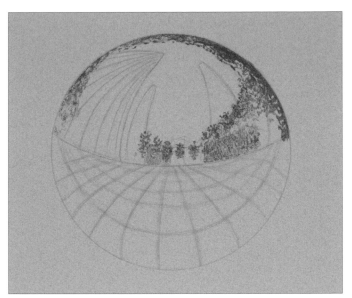

1 Using a compass (or round object) and a mechanical pencil with 0.5 2H lead, draw a circle. Then draw a curved horizon line slightly above or below the center of the sphere. If your horizon line is above the center of the sphere, it should curve up, as shown; if it's below the center of the sphere, it should curve down. Now sketch in the basic shapes of the surroundings that will be reflected in your sphere. In this example, I sketched some buildings and trees above the center/horizon line and a plaza with squares on the lower half. Note that the lines you draw on the left and right from center should curve left and right, respectively. The farther from the center (either up or down, or left or right from the center point of the sphere), the more all lines should curve.

2 Draw the reflection of the trees with your Dark Green pencil along the upper border, across to the other side. You may want to do a row of trees along the horizon line going toward the center. For composition purposes, I like the green moving toward the center of the sphere.

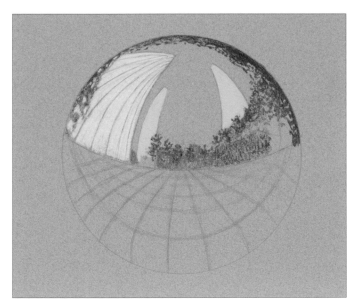

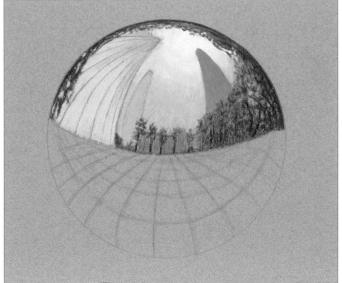

3 Using your Cloud Blue (a light blue) and Putty Beige pencils draw the tall buildings. Use the Light Umber for the short ones behind the trees. These buildings can be of different colors representing different materials, like glass (Cloud Blue) or concrete (Putty Beige).

4 With the Primo Bianco Charcoal draw an intense White in an area of the sky as shown above. I recommend the Primo Bianco rather than the Prismacolor White for this effect because it is brighter and more intense. With the Light Cerulean Blue pencil, draw the sky around the white area you have just drawn. The Primo Bianco Charcoal will not hold on the waxy Prismacolor, so apply it first.

Use the Dark Brown and Dark Umber to draw the trunks of the trees.

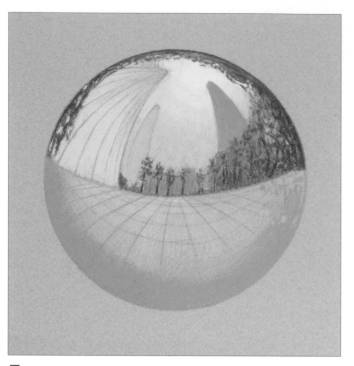

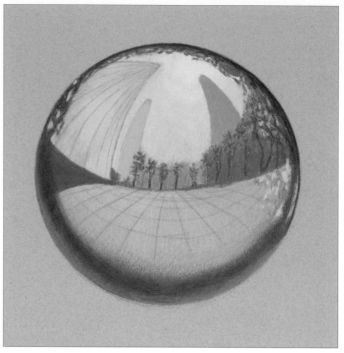

5 Add a shaded area around the bottom of the sphere with your 50% French Grey pencil (a medium grey). This will be the base for both the shade and the light reflection in this area.

6 With your Black pencil draw the darkest shade of the sphere on its lower part, but not on the very bottom since that area will reflect light bouncing off the floor.

Of course you may modify your drawing as you go and create on it as it takes shape.

I didn't like the look of my original horizon line on the left and felt there was a missing element. So, I drew a short wall there, with a 70% Warm Grey. And on the opposite (right) side, I added some light reflections with the Cloud Blue and the White.

With a 50% Warm Grey, go over the lowest part of the bottom of the sphere to render the reflected light bouncing off the floor.

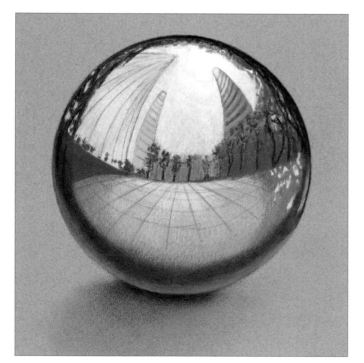

7 Add more detail as desired such as the windows of the buildings.

In order to make the center part of the sphere come forward and stand out, you may want to tone down the left and right sides by applying some grey over the Black. This helps deliver the volume and 3D effect.

Because the color pencils don't smudge well because they are greasy, and because I wanted the cast shadow of the sphere to look blurred and soft, I used graphite pencils to draw it (the cast shadow).

Use a mechanical pencil with an HB lead for the cast shadow areas close to the sphere (darker) and one with a 2H lead for the areas farther from it (lighter). Then, wrap a chamois around your index finger and smudge the graphite areas so they became very even and soft. Last, reinforce the area of the cast shadow by the sphere, with the Prismacolor Black pencil to really make the sphere standout.

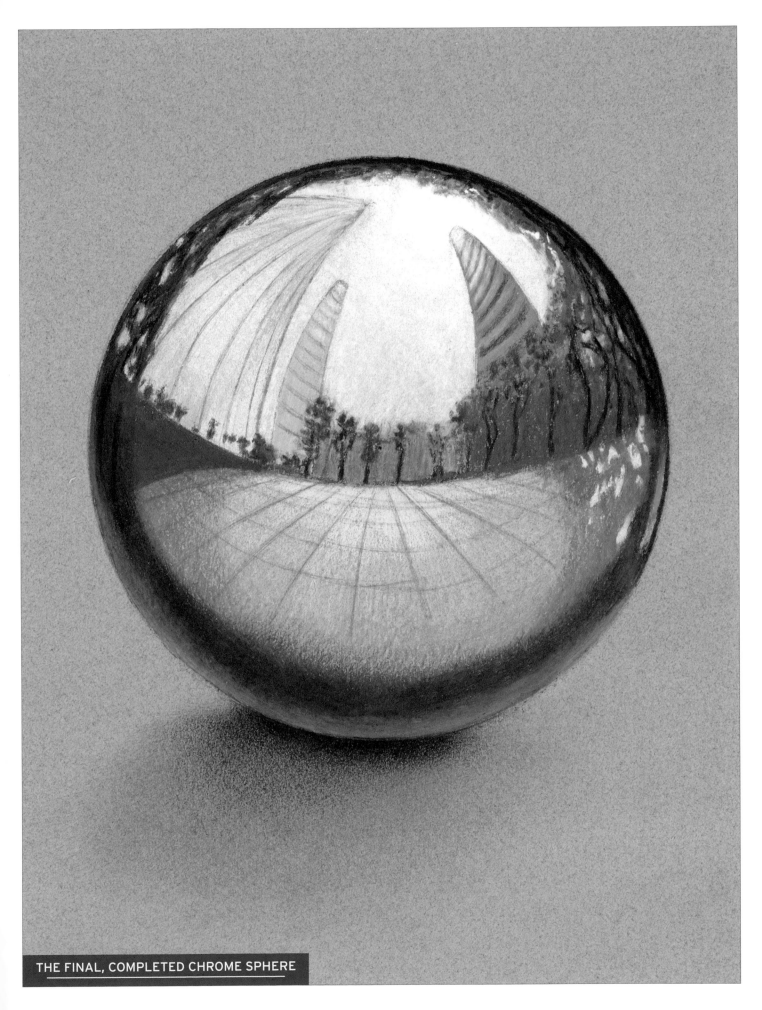

THE FINAL, COMPLETED CHROME SPHERE

Hard Surfaces

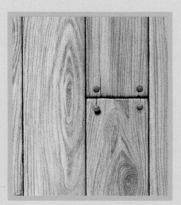

MARBLE • WOOD • ROCK

In the first chapters we drew very shiny objects. Now we will switch gears and create some hard, opaque surfaces like wood, marble, and rough stone. Unlike with crystals, here we will have little or no reflections, no shiny highlights (except for polished marble), and no sharp contrasts. The changes of tone will be softer, and not as varied, so we'll use a simpler value scale.

What I love about drawing hard surfaces is that they have a lot of personality! The grain, texture, and cracks of the wood or the rock can tell a story of their own.

How to Draw Wood

MATERIALS

5 or 6 reference photos

Primo Euro Blend Charcoal HB

Chamois

Felt pad

Prismacolor kneaded eraser

Faber-Castell Magic-Rub eraser

Surface: Recycled Fabriano white drawing paper, fine grain, 24 lb.

Drawing wood is extremely entertaining because of its strong character. There are many types, qualities, and tones of wood – each with its own textures (smooth, shiny, rough, weathered, etc.), hues (light, dark, red, yellow, gray, etc.), and even personality. It almost always has a warm feel.

When drawing wood it is important to choose the right paper – one with a fine grain and some "tooth." It can help you render the wood texture fairly easily from the start (whether using pencil or charcoal). Make sure you test the paper's grain and lay the paper so its grain runs in the same direction as the wood you're drawing.

I love rendering wood and I hope by the end of this project you will, too.

Please note that some of the following step-by-step illustrations are closer-up views that have been cropped slightly. The full-page image at the end of the sequence shows the complete drawing.

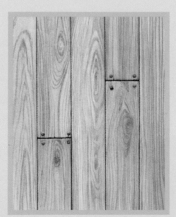

TO MAKE THIS DRAWING,
YOU MAY FIND IT HELPFUL TO REFER
TO THESE BASIC TECHNIQUES:
- pattern and texture (pages 22-23)
- charcoal techniques (page 12)
- using a chamois (pages 15 and 28)
- using a felt pad (pages 15-16)
- eraser techniques (page 14)
- shade and shadow (pages 27-28)
- light sources and reflection (page 26)

1 Lay the paper so its grain is running in the same direction as the grain of the wood. Using the HB charcoal pencil, start giving a tone to the whole area, i.e., the whole sheet of paper. Make your strokes in the direction of the grain. If you are right-handed, start from the top left and work your way to finish at the bottom right (if you are left-handed, reverse the direction starting from the top right and working toward the bottom left). This way you will not rub your drawing hand over the charcoal you just laid in. I also advise you to always place a piece of clean paper under your hand so it doesn't leave skin oils on the paper. This can adversely affect the drawing.

2 Following the step 1 technique, complete your entire wood area. Don't worry if it doesn't look beautiful at this stage. It's pretty hard to get the charcoal uniform and it is not necessary because you'll smudge it to even it out.

3 With a chamois wrapped around your index finger lightly smudge the charcoal. Use long, even strokes always in the direction of the grain, moving from top to bottom and bottom to top, to even out the tone, which will be the overall tone of your wood (you'll draw darker grain patterns later). Every pass of a clean chamois will make the tone lighter. To darken the overall tone, go over it again with the charcoal pencil (or charcoal powder), or with a "dirty" (charcoal-saturated) area of the chamois.

4 To draw a surface of wooden boards, (like floors, doors, etc.), draw evenly spaced straight lines with a sharp HB carbon pencil and a ruler (in the direction of the grain, of course). In this case we created five 'boards'. Because of the grain of the paper and the pattern you left by swiping the chamois, it already looks like a kind of wood. This is really good for our base.

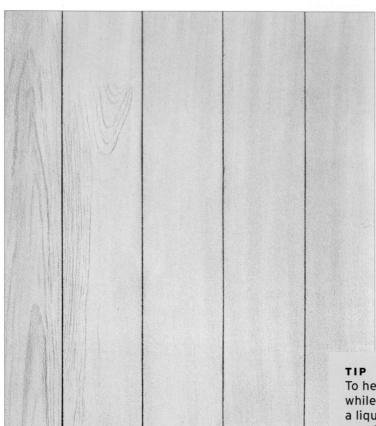

5 Make sure you have a clean piece of paper to rest your hand on because touching the charcoal with it would smear what you have done (in addition to leaving oils as already noted). With the HB charcoal pencil, draw the pattern of the grain. To do this, observe actual wood and study how it flows. The dark lines usually lead you somewhere and often they flow toward the same place or with a similar, repeating pattern.

TIP
To help you visualize the grain lines of wood while drawing them, imagine the waves of a liquid. They flow in a similar direction and envelope any object – in this case, the knots.

DETAIL

If you look at wood closely (as in this detail), the dark grain lines are not usually solid, but are composed of a series of thin lines that travel in the direction of the grain. In our case you can draw the dark grain by making a series of small and close vertical lines, forming the shapes of the overall grain patterns. One side may be more defined than the other, so feather the lines as you draw by starting your stroke with more pressure, then easing the weight on the stroke. (Grain pattern lines are not always like this, however, because sometimes they have a more even tone.)

When you work on the second board do not repeat the same pattern you did on the first one, because every piece of wood should have its own grain pattern.

6 When drawing knots, do not just place them randomly. The lines lead us to them and either become part of or flow around them. Knots often are the darker spots and sometimes they have cracks because their wood is much harder.

7 When you draw the dark, grain pattern lines with the carbon pencil they look a bit hard. In order to soften and to integrate them, gently pass the chamois or a felt pad over them using long motions following the direction of the grain.

The chamois lifts a lot more charcoal than the felt pads. In this case, I used the chamois and I erased the lines a little bit too much. I left this "error" in the book because it is something that commonly happens and it's not at all a problem. Charcoal is very friendly and allows you to keep working and reworking it until you set it with fixative (the only proviso for this being that you are working on quality paper). We will come back to this area later, but for now we are going to carry on.

8 Let's move to the next board and draw a new pattern on it with some round shapes on the right side and lines that flow along the left side. Pressing a little bit more while drawing will help to keep the carbon on the paper when you smudge it.

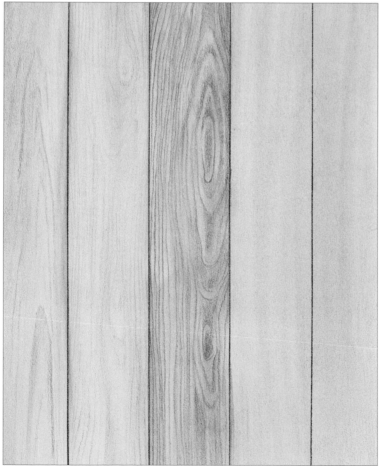

9 This time I smudged the pattern from step 8 with the felt pad and you can see how the paper retains a lot more of the charcoal than with the chamois. It gives us the desired effect, softening and integrating the lines. You can play with the felt pads and with the chamois, depending on the effect you want to achieve. If there are some areas that still look too dark or too grainy after they have been smudged with the pad, you can gently go over that section with the chamois.

10 For the next board we will start with an interesting knot. Draw a small oval or drop-like shape, then similar shapes (lines) around it that develop and grow with slightly different forms. Note how the "current" of the knot's whirl affects the lines alongside it.

DETAIL

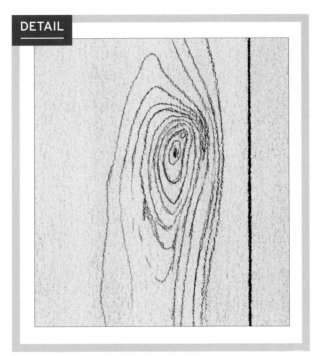

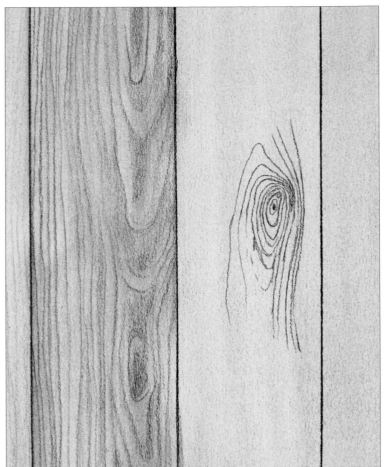

11 Darken and widen some of the lines around the knot and keep creating other grain lines (patterns). Make sure they are different from the ones on the other boards.

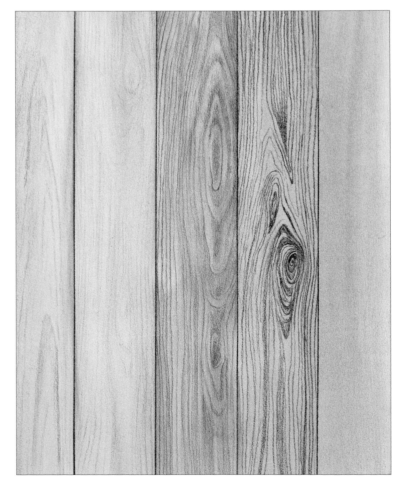

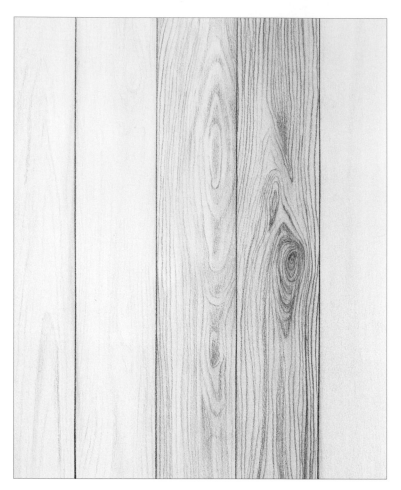

12 Go over the knotted board with the felt pad smudging some areas more than others, blurring and losing the lines in them, while leaving other lines sharper. Using a "dirty" spot of the pad you can add tone and darken, while with a clean part of it or with a clean chamois you can lighten areas to achieve the tones you envision.

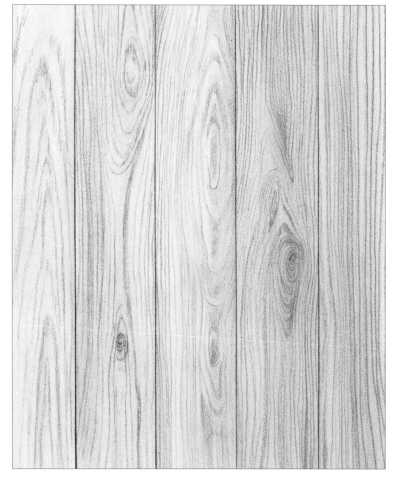

13 Continue with the same procedure of drawing unique grain patterns for each board using the HB charcoal and smudging and adjusting the tone with the felt pad or the chamois.

14 I decided to break up some of the boards for a more interesting result. As you have noticed, this is a drawing that I have been creating as I go.

Had I known I would horizontally divide a couple of boards I would have drawn different pattern lines on them, so that a specific line wouldn't continue from one to the other as this would not look realistic. The beauty of charcoal is that it allows you to keep making changes and modifying your drawing. I chose which part of the board I liked the most and using the chamois I lightened (almost erased) the other part. Then I modified its pattern, sketching new lines or redirecting them so they wouldn't match the ones on the board under or above it. I could actually leave the drawing like this and it would look pretty good. It would be proper for smooth flooring or the like. But my drawing still has a story to tell and I will carry on to achieve it.

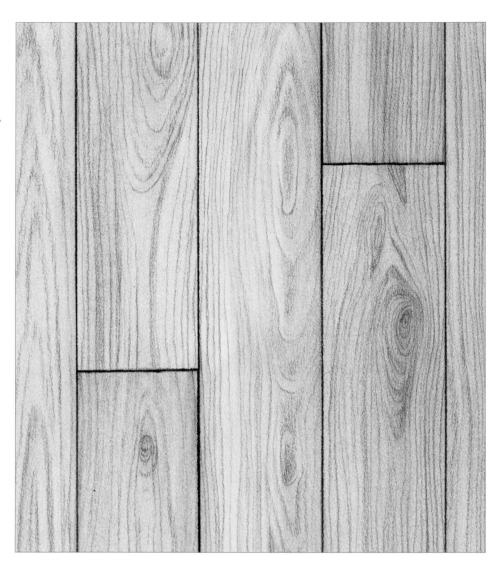

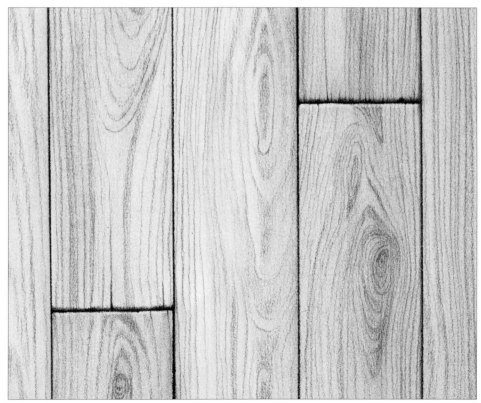

15 To give a more "aged" look to the wood, you may round the edges at the end of the boards that we divided in step 14. Using a stump, draw a shadow by darkening the bottom edges and draw light by tapping with the kneaded eraser on the upper part of these cut boards. Also, using the HB charcoal pencil and then smoothing it with the stump make some dark lines by the edge, as if the wood was breaking or chipping unevenly.

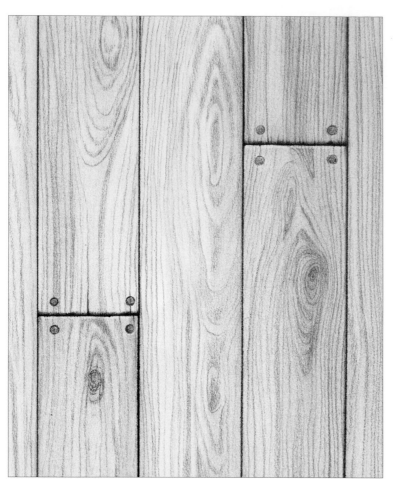

16 To make it even more interesting, let's nail the boards down. With the charcoal pencil draw two round nail heads on each end of the boards. Try to make the circumference of each the same size. Fill them in lightly with the charcoal pencil. Note: For this drawing the light source is at the top and slightly to the left.

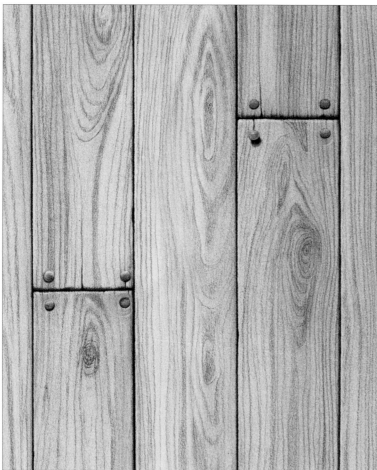

17 Smooth the tone of the nails with the stump. For each nail, draw a darker line along the bottom right for a shadow and pull some light with the kneaded eraser along the upper part, especially on the top-left edge. To make a nail that has been hammered in all the way, let the shadow of the wood fall on it by darkening its top left and lighten the wood around its bottom right. This nail is darker as it's catching less light. You can depict the effect of some hammering on the wood by doing dark sections of a circle above the nail and lighter ones below it.

Let's leave a nail halfway hammered in by drawing an oval-shaped shadow below it. Make the shadow darker by the nail and a little less dark and more blurred the farther away it is.

Using the stump, darken the right edge of all the boards and with the kneaded eraser slightly lighten the left edge of them because they will catch more light. You can define some knots and some pattern lines better or do some uneven indentations on the edge of some boards. This looks very realistic. With the kneaded eraser you may also pull some small lights on the boards and on the knots to indicate an uneven surface. If they are not totally smooth there will be some ridges, which catch more light. If you do that, also draw a slight shadow on the other side of each.

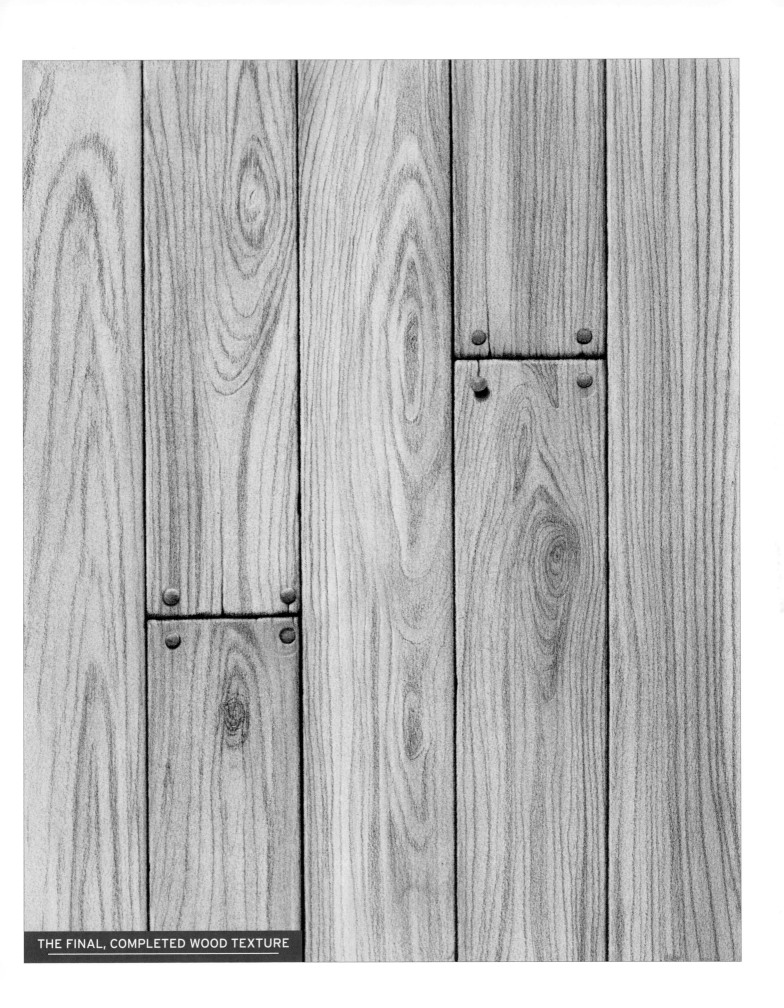

THE FINAL, COMPLETED WOOD TEXTURE

How to Draw Marble

MATERIALS

5 or 6 reference photos

Mechanical pencil with
a 0.7 HB lead

Mechanical pencil with
a 0.35 mm H lead

Lead holder with 2mm,
6H lead

Lead sharpener

Graphite powder

Prismacolor kneaded
eraser

Faber-Castell Magic-Rub
eraser

Ruler (or other straight
edge)

Chamois

Surface: Fabriano
sketch paper

Clean paper (for resting
hand to prevent unwanted
smudging)

**The word "marble" comes from the Greek
mármaros, meaning "crystalline rock,
shining stone." It is produced by millennia of
metamorphoses with other stones, resulting in**
an intertwined mosaic of carbonate crystals and minerals
that form veins and patterns in the marble. It's critical to
remember these geologic qualities when drawing it.

Marble can be finished in different textures, from highly
polished to varying degrees of roughness that are not
very reflective. It can vary in tone from green to pink, to
white or grey and the veins may be tightly hatched or far
apart, dark or soft, sharp or blurred. You will be drawing
white marble with soft veins in this illustration.

Please note that the following step-by-step illustrations are
closer-up views that have been cropped slightly. The full-page
image at the end of the sequence shows the complete drawing.

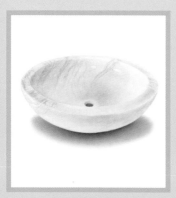

TO MAKE THIS DRAWING,
YOU MAY FIND IT HELPFUL TO REFER
TO THESE BASIC TECHNIQUES:
- cast shadows (page 27)
- eraser techniques (page 14)
- graphite pencil techniques (pages 19-21)
- graphite powder techniques (page 15)
- light sources and light reflection (page 26)
- pencil points and sharpening (pages 29-31)
- reference photos (page 18)
- shade and shadow (pages 27-28)
- using a chamois (pages 15 and 28)

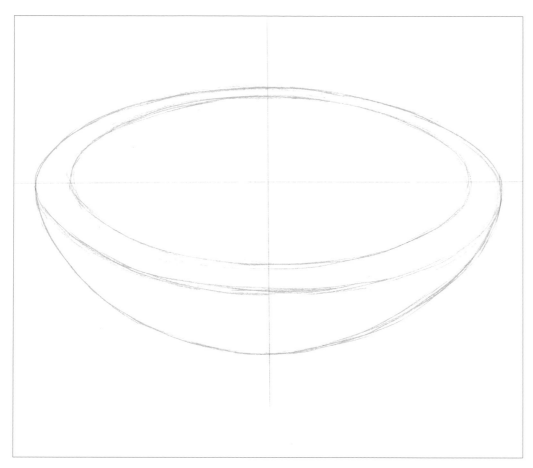

1 Using the 0.7 HB mechanical pencil and a ruler, draw a cross to form vertical and horizontal guidelines. Next, loosely draw two horizontal ovals and a bottom curved line for the lower part of the vessel, as shown.

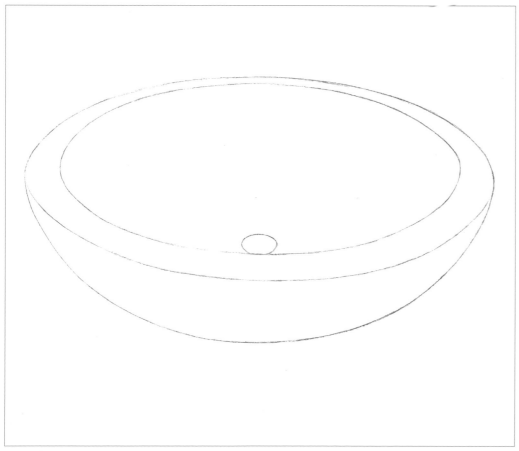

2 Clean up the lines with the kneaded eraser or the regular eraser. Then, refine them with the HB lead as needed, leaving a defined edge. Draw a small oval for the hole in the bottom of the vessel.

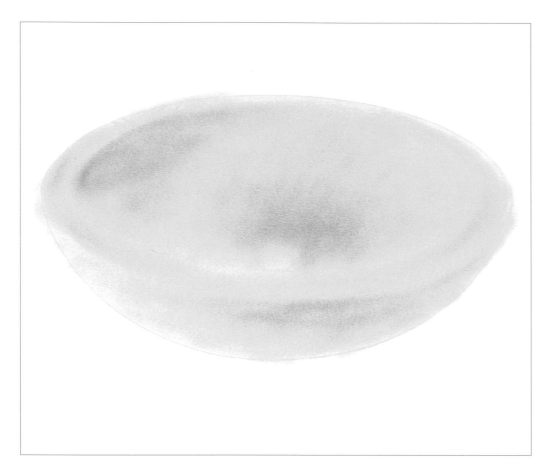

3 Wrap the chamois around your index finger and dab it in graphite powder; clean off the excess on scrap paper. Then, gently go over the drawing with the chamois, increasing the pressure on the areas where you want a darker shade along the upper left border, at the deepest basin area and near the lower right, outside the vessel. This builds volume. This technique is fast and efficient, but don't touch the paper with your hand or fingers because the skin oils will show through the graphite powder when it's applied this way.

4 Clean up the drawing with the kneaded eraser or the regular pencil eraser by taking off all the graphite outside the vessel and the bottom orifice. You can give some highlights on the forward edge to make it clear and give it contrast.

5 With a hard lead (like the 6H), define the edges and the shadows. Also draw the shadow of the hole in the bottom. You may want to carefully even out and flatten some areas with the lead holder by gently going over spots that are too light and by lightly tapping dark spots with the kneaded eraser to lighten them up.

6 Start drawing the veins of the marble using the H lead (or the 6H for the lighter ones). You can choose how dark you want them to be, because in nature they vary greatly. Most lines run fairly parallel to each other, but you can also have some running in different directions or crossing each other.

7 You don't need to fill the whole marble piece with lines. Some areas can remain blank, while others can have tightly knit patterns. Or they may be evenly distributed throughout. Decide what you like best from your reference photos.

Pull some bright reflections near the upper area with the kneaded eraser to make it look shiny and reflective.

Define the edge of the rim by slightly darkening the shaded areas up to the border with the lead holder. As needed you may also further lighten and sharpen the light edges with the kneaded eraser.

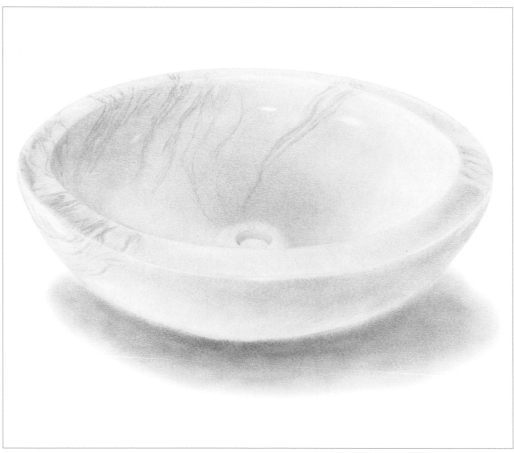

8 With the chamois and graphite powder, make the cast shadow of the vessel. You can saturate the chamois with the graphite a bit more than earlier, because you want to paint darker.

Even out the shadow: With the 6H lead fill in the spots that are too light; with the kneaded eraser, lighten the darker areas by gently dabbing them.

Check the overall drawing to handle any other details you see. In the final full-page drawing (page 81), I lightened some areas of the vessel with the kneaded eraser – the right of the inside and the outside bottom left – because I wanted my marble to look "whiter." I also made a few veins a little bit harder, not the whole line but only in selected short spots, to increase realism.

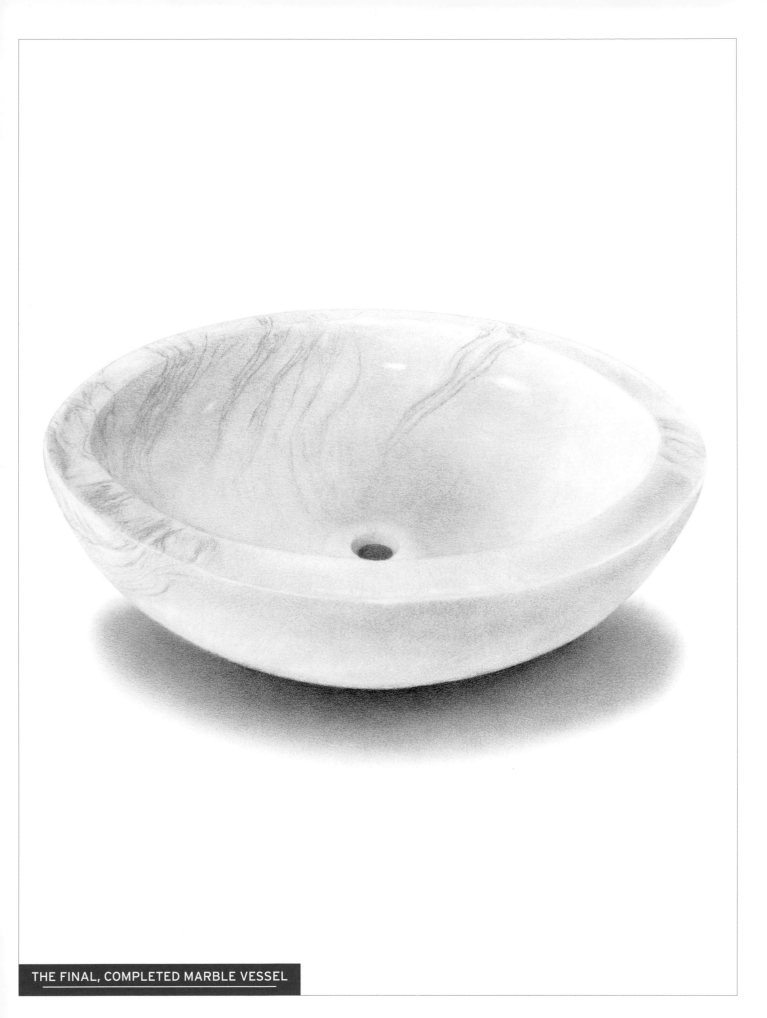

How to Draw a Rock

MATERIALS

Rocks (or 5 or 6 photos
of rocks) for reference

Mechanical pencil with a
0.7 HB lead

Prismacolor Premier Fine
Line Markers: 005 and 03

Faber-Castell Magic-Rub
eraser

Surface: Fabriano sketch
paper, 56 lb., white

**In this section, I want to expand our arsenal of
tools by using a different technique than the ones
we have used so far in this book.**

I chose the rock for this technique because by using
the pens with pointillism, they can deliver a rough texture
effect, which is perfect for this subject. It does take a lot of
patience and time for this approach because the progress
is slow. But the result is beautiful and unique.

While I used the pointillism for the rock itself, on the
cast shadow I handled the same pens in a different manner
(e.g., using hatching and cross-hatching), since I wanted to
achieve a different texture.

Are you ready to rock? Let's do it!

Please note that the following step-by-step illustrations are
closer-up views that have been cropped slightly. The full-page
image at the end of the sequence shows the complete drawing.

TO MAKE THIS DRAWING,
YOU MAY FIND IT HELPFUL TO REFER
TO THESE BASIC TECHNIQUES:
• graphite pencil techniques (pages 19-21)
• light sources and light reflection (page 26)
• marker techniques (page 28)
• shadows and cast shadows (page 27)

1 Sketch the overall shape of the rock with the pencil. Of course, the shape and surface textures of different types of rocks can vary widely; this project features a somehow porous rounded rock with a rough texture. After sketching the shape, decide where your light source will be and sketch its shadow. In this case, the light source is from the top, behind the rock and a little to the left of center.

2 With the 03 Fine Liner, start making close dots along the core shadow area, as shown. This will be the darkest area of the rock; the tone below it will lighten up slightly because of the reflected light bouncing off the surface it sits on.

What you do right now doesn't need to be your final tone. You can always darken it as desired, but since you can't lighten it, it's better to stay on the light side.

3 Continue filling the core shadow area with even closer dots to darken it and continue toward the bottom of the rock, spacing the dots more as you get closer to the edge, where the surface-reflected light bounces.

4 With the very thin 005 Fine Liner, make dots across the upper part and outside edges of the rock. Produce a lighter tone with this marker (you'll use this marker for sleps 4-6). You can begin moving toward the center of the rock, but stay even lighter in this area, making small dots farther apart.

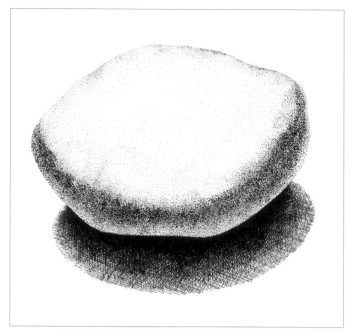

5 Continue filling the rock with dots so it has at least a light tone all over it.

I decided to do the cast shadow at this point rather than at the end because it has the darkest tone of all in the drawing. Seeing this tone helped me gradate the rest of the tones better.

You can create the shadow tone by drawing a series of parallel lines. To make it darker you can crosshatch, that is, do a series of crossing lines.

6 Continue working the cast shadow, drawing crossing lines in different directions, especially in the area closer to the rock, which we want to be the darkest.

Having achieved the darkest tone in the drawing, you can see how you need to increase the tone of most of the rock as well.

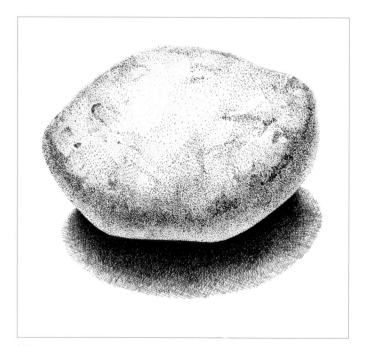

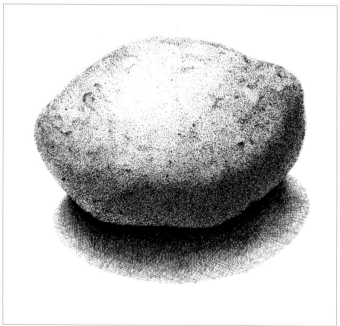

7 Switching between the very fine 005 and fine 003 markers, darken the body of the rock. While doing this, you can start adding texture to the surface by darkening with unevenly placed dots and creating some shapes with them.

You can do some very dark small spots representing holes and some darker areas showing uneven surface patterns. You can really play with this.

8 To finish the rock, darken the general tone even further, darken the reflected light, and in general make sure all the parts in the drawing are integrated.

This technique produces a very high quality and unique result.

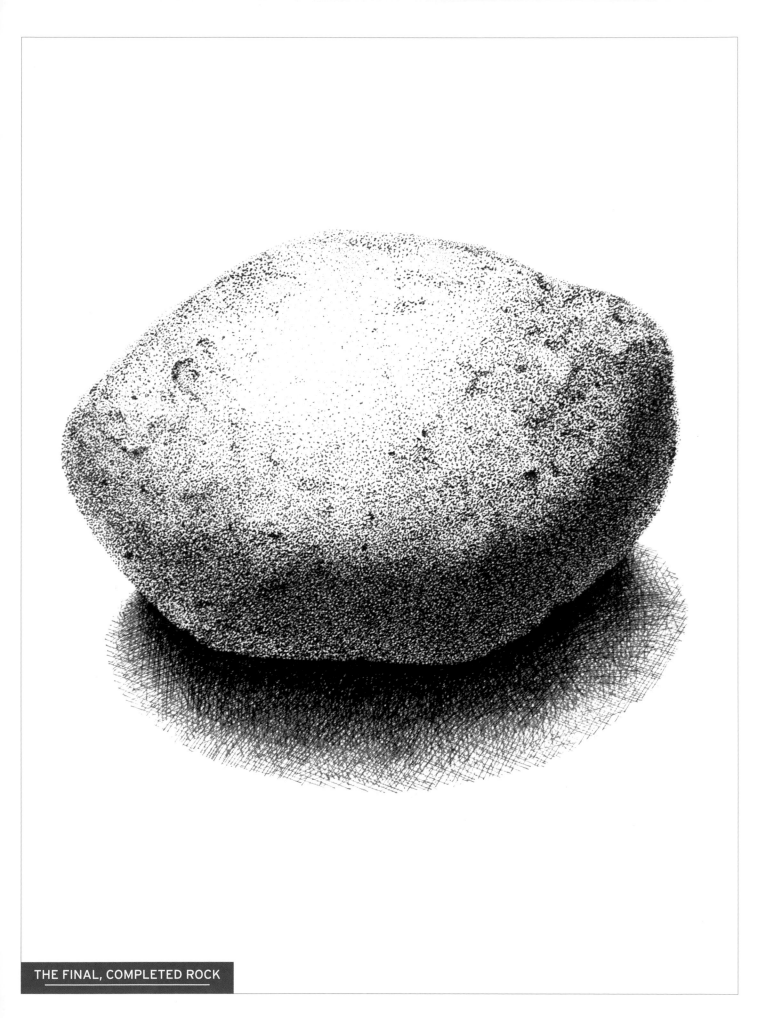

Crystal and Glass

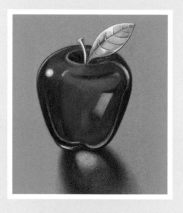

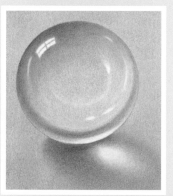

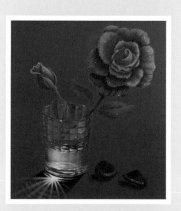

RED CRYSTAL • CRYSTAL • GLASS

What if the subject we want to draw is clear, with no color of its own?

Looking very carefully at crystal and glass, we'll see a lot of reflections (and maybe even what is behind it). In fact, when we draw crystal, we will primarily draw the reflections on the crystal rather than the crystal itself.

We'll look for straight lines, curves, and patterns on the crystal, and for any distortions caused by the shape of its surface.

Crystals are not necessarily void of color; there may be many hues reflected by the glass. If the glass itself is colored, then it will have its own hue while remaining highly reflective.

How to Draw a Crystal Sphere

MATERIALS

5 or 6 reference photos

A compass (or a cup, glass or any round object)

Mechanical pencil with 0.7mm, HB lead

Mechanical pencil with 0.35mm, 2H lead

Lead sharpener

Graphite powder

Chamois (or cotton cloth)

Prismacolor kneaded eraser

Tombow MONO Zero eraser

Surface: white Fabriano drawing paper (including scrap pieces for tests)

Clean paper (for under the hand to prevent unwanted smudging)

X-Acto knife (optional)

Crystal is transparent, almost invisible. When we draw crystal we are not actually drawing the material itself, but rather what is behind it or what gets reflected on it and the shape of the crystal itself can distort both. If the crystal is colored, the hue needs to be entered into the equation. Depending on the amount of tint, hues can range from almost transparent to a deep, non-translucent color.

When drawing crystal the consideration of the light source(s) is critically important because the light travels inside the object, illuminating its opposite side and possibly even the surface it is standing on.

It is very enjoyable indeed to draw transparent, reflective surfaces, and there is no other like crystal.

Please note that some of the following step-by-step illustrations are closer-up views that have been cropped slightly. The full-page image at the end of the sequence shows the complete drawing.

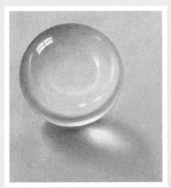

TO MAKE THIS DRAWING, YOU MAY FIND IT HELPFUL TO REFER TO THESE BASIC TECHNIQUES:
• cast shadows (page 27)
• eraser techniques (page 14)
• graphite pencil techniques (pages 19-21)
• light sources and light reflection (page 26)
• reference photos (page 18)
• shade and shadow (pages 27-28)
• using a chamois (pages 15 and 28)

1 First, give an overall tone to the paper. To do this, wrap a chamois (or cotton cloth) around your index finger and dab it in graphite powder. Then, test it and clean it up a bit on a scrap piece of the paper by lightly rubbing the chamois on the paper in clockwise and counter-clockwise circular motions until the graphite is painting evenly. When you are satisfied, go over to the real paper and lightly begin drawing/rubbing circles to start giving it a tone.

2 Fill in your desired tone on the whole sheet of paper (as in step 1). You will notice that the tone is uneven, so do another pass moving the chamois in a different pattern, like long, horizontal movements. Then, make another pass vertically. For these additional passes you don't necessarily keep dipping the chamois in the graphite powder. You may do this if you want to further darken your background or an area. (Remember to test on scrap paper each time you dip into the graphite.) If you don't want to darken all or any areas and just want to even the tone out, then use a clean piece of the chamois to caress the paper in the different patterns mentioned above.

TIP
When using the technique of toning with the chamois, do not touch the paper with your fingers or with any part of your hand, both before you start drawing or during the drawing. The hand, and specially the fingers, will transfer body oils to the drawing surface and this will show when you pass the chamois with graphite, ruining the drawing. Make sure to use a clean piece of paper under your hand to protect the surface.

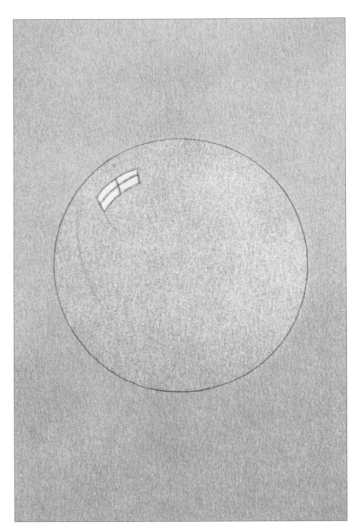

3 Using a compass (or round object), draw a circle with the 0.35mm 2H lead mechanical pencil. Draw it dark enough to see it, but not too dark since you will not be able to easily erase it without erasing the background, which you don't want to do. If you use a compass, just make sure to protect the paper so you don't drill a hole in it. (I drew this circle using an upside down glass.)

4 Draw a square to represent the window reflected on the upper part of the sphere. It will be distorted according to the crystal's shape. Note that the upper and lower lines are nearly parallel to the outside circle. Once you've drawn the square, erase the area inside of it with a small eraser such as the Tombow MONO Zero (or cut a sharp corner of a regular eraser with an X-Acto knife). To make it look more like a window, use hard lead such as 2H to draw a cross in it, representing the frame/mullions.

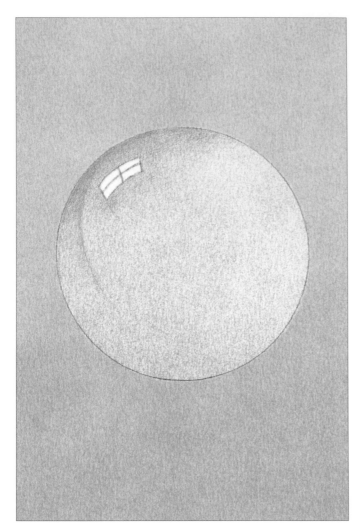

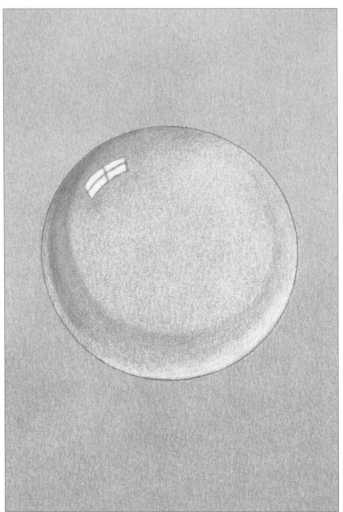

5 In this drawing the light is coming from the top left, therefore the darkest area will be this top-left side, because the light beams falling on a transparent object generally run through it and illuminate the opposite side. Use the 0.35mm 2H lead mechanical pencil to add shaded areas to the top-left side. With even, circular motions (or even straight, short strokes) give a tone to this area. Start very light and go over it again as needed.

6 To achieve the lighter area opposite the light source, (e.g., the bottom right of the sphere), tap the paper with the kneaded eraser. Crystal spheres are extremely reflective and what is reflected on them often overrides the general rule of the light I just cited on the prior point. I wanted a dark reflection near the lower side that represents a different plane such as the furniture below the walls in the room. Using the 2H mechanical pencil, darken this area as in the picture above.

TIP
All the shapes being reflected are distorted by the roundness of the sphere.

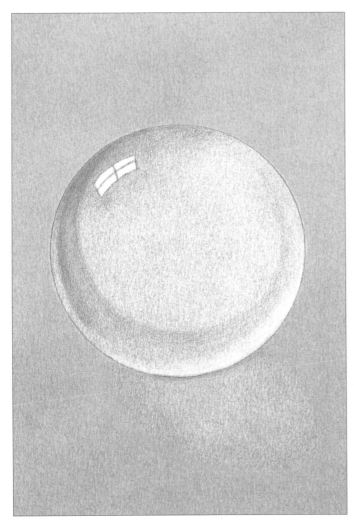

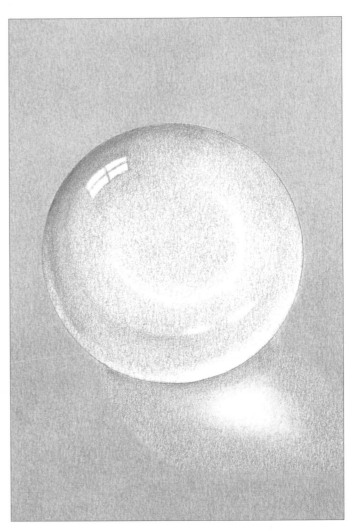

7 Start sketching the cast shadow with the 0.35mm, 2H lead mechanical pencil. Don't outline it, because you will not be able to erase the line if it is not correct without erasing the tone of the background. Visualize where the shadow will fall and start darkening the area little by little. Don't start at the outer edge; expand it gradually from the inside out as you visualize it. There will be a light reflection near the center of the cast shadow, so you don't need to darken this part.

8 Keep shaping the cast shadow with the pencil used in step 7 and the kneaded eraser. It should embrace the sphere. What I mean is that the shadow should pass around the entire bottom of the sphere. Lighten the center area of the cast shadow with the kneaded eraser, then finish cleaning it up with the regular pencil eraser. (It's best to start with the kneaded eraser because it does not smudge, but it's not as effective as the pencil eraser in getting the area totally white. So consequently, reinforce the kneaded erasing with the regular pencil eraser.)

Make some nice reflections on the sphere, then work them in a round shape using the kneaded eraser.

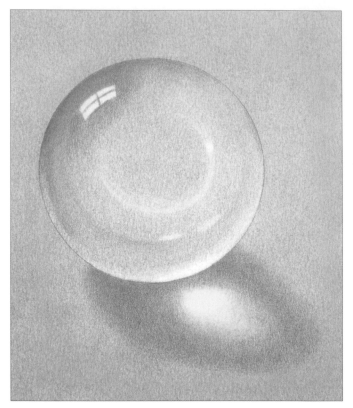

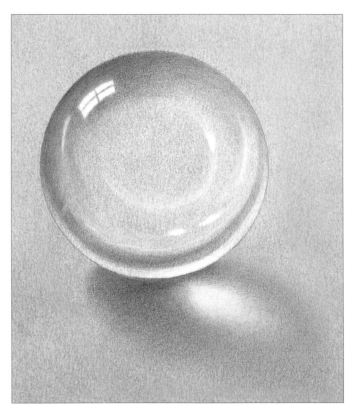

9 Darkening the cast shadow will create contrast in the drawing and will help the sphere stand out with almost a 3D effect. Do this with either an HB lead or with a 2H.

You don't want the borders of the shadow to be sharp, so make them blurry to give them a more ethereal effect and for contrast with the sharpness of the sphere. The area closer to the sphere will be darker (and sharper) and it will fade as it gets further away. Keep the (white) light reflection area, of course.

10 You may want to depict the reflection of the furniture, objects, and windows in the room on the lower part of the sphere. It's okay if you do it neatly with the shapes clearly delineated as depicted in this example. Or you may prefer to leave the reflection as a more general dark area, which is the look I am going for in the next step.

11 Using a mechanical pencil with 0.7mm HB lead, complete the dark "stripe" along the lower part of the sphere itself. This look should be smooth and even. Don't make a totally sharp line delineating the dark shadow; it should be slightly blurred and should blend with the dark areas of the sphere as it curves to the upper part on each side. To achieve this "melting" and integration, you may gently pass the chamois along the dark "stripe" to smudge it with the rest. Then, re-establish the lights with the kneaded eraser as needed.

It's time to look over your drawing and see what else you can do to improve it.

I decided to extend the dark area at the top left. This covers more background and fades more gradually, which increases the illusion of roundness and volume. I wanted the bright light at the bottom right to be more evident, so I made it smaller. I slightly darkened the area along the right and left of it, leaving a smaller bright spot.

In the illustration in step 10, you can see a very slight reflection in a crossing direction at what would be the position of 8:00. I didn't fully like this, so I took it off. And finally, with the kneaded eraser, I made the whole lower half of the sphere a little lighter. I also added an additional small reflection toward the top right of it.

I hope you had a ball drawing this. I did!

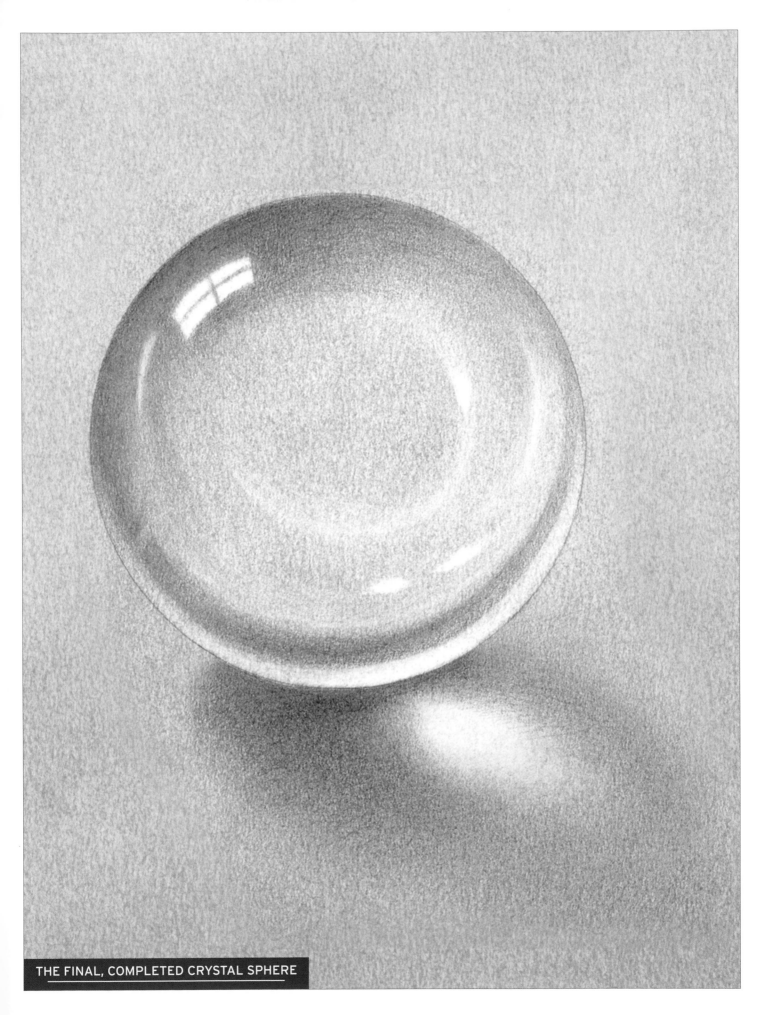

THE FINAL, COMPLETED CRYSTAL SPHERE

How to Draw a Red Crystal Apple

MATERIALS

5 to 6 reference photos

Mechanical pencil,
0.5 HB lead

Faber-Castell
Polychromos, set of 24:
Phthalo Blue
White
Cadmium Yellow
Dark Cadmium Orange
Pale Geranium Lake (red)
Deep Scarlet Red
Dark Red
Magenta
Warm Grey II (light grey)
Warm Grey V (dark grey)
Black

Pencil sharpener

Primo Bianco White
charcoal

Synthetic brush No. 4 (or
cotton pad)

Prismacolor kneaded
eraser

Surface: Light grey
cardboard

Odorless mineral spirits

Apples seem to have been involved in several turning points in the history of mankind. From early Greek mythology and the apple of discord that resulted in the Trojan War, to Eve's apple of temptation, to Newton's apple, which triggered his second law of motion . . . okay, enough of that.
Let's draw our own version, which will be a red crystal apple. We get to play with a smooth, glossy surface that is highly reflective and also transparent.

Please note that some of the following step-by-step illustrations are closer-up views that have been cropped slightly. The full-page image at the end of the sequence shows the complete drawing.

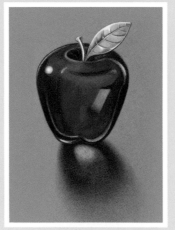

TO MAKE THIS DRAWING,
YOU MAY FIND IT HELPFUL TO REFER TO THESE BASIC TECHNIQUES:
• blending and layering colors (page 15)
• cast shadows (page 27)
• color pencil techniques (page 22)
• eraser techniques (page 14)
• light sources and light reflection (page 26)
• pencil points and sharpening (pages 29-31)
• reference photos (page 18)
• shade and shadow (pages 27-28)
• tone, hue, color, tint (pages 24-25)
• using mineral spirits (page 23)

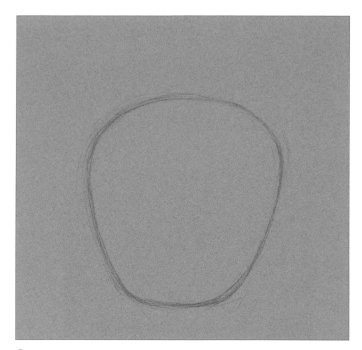

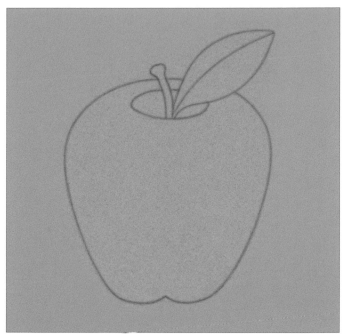

1 Start by sketching the outline of the apple using the 0.5 HB lead mechanical pencil. Its shape is close to a circle but the lower part is smaller and the sides are a bit flat. Apple shapes vary and you don't have to copy my shape identically.

2 Clean up the outline with the kneaded eraser. Draw a horizontal oval at the apple top, which represents the cavity for the stem and leaf. The bottom part of the apple may curl up once or twice, as shown.

Next, outline the leaf and stem, which come out of the oval.

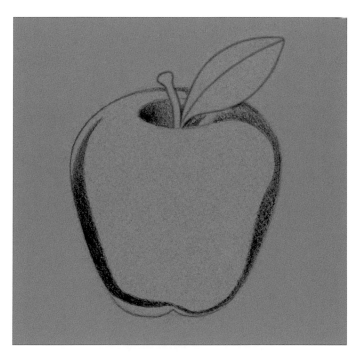

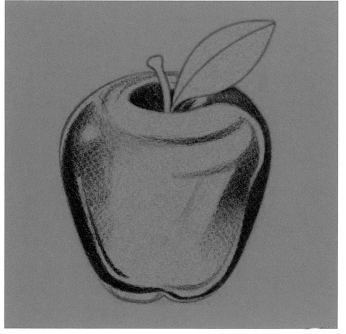

3 We will be coloring the apple in layers, starting with the areas in shade. Since the light source is above and slightly to the left and behind the apple, the shaded areas will be on the apple's sides, inside the oval, inside the stem cavity, and under the leaf. Use a Phthalo Blue pencil. Applying medium pressure, fill in the darkest areas of the apple.

4 Go over the blue with the Dark Red, then fill in the next darkest areas (the next tone up) with the same red – places like the sides next to the darker areas we did in step 3, and where the glass turns, making a horizontal oval-like reflection. You will end up with two distinctly different tones.

Make sure to leave the spaces for the light reflections blank, including a circular form toward the upper left for a very bright highlight.

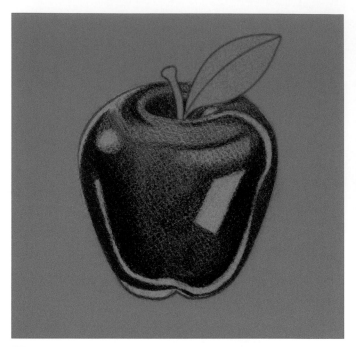

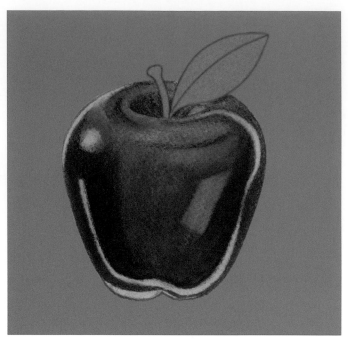

5 Fill in most of the apple with the Pale Geranium Lake to render the middle tone. Don't color this flat; give it some lighter and darker tones. You can go over parts of the darker red areas in order to integrate the dark and light. For more tonalities, you could color over with some Deep Scarlet Red and Magenta for the dark areas and Dark Cadmium Orange and even Cadmium Yellow for the lighter tones. Leave the reflections (as shown: upper left, inside perimeter, bottom left, etc.) blank.

6 You can fuse the colors into a more even layer with odorless mineral spirits and a soft brush (or cotton pad). I strongly recommend you test and practice this technique on scrap paper first. Using it sparingly, dip the brush in the liquid and take the excess off the brush with tissue paper. Then, lightly go over the color. The more you brush or rub the color, the more it will melt; some colors will darken. It will take about 10 or 15 minutes to dry completely. (Note: Don't go over the spaces you left blank for the reflections because the White charcoal may not adhere to the paper if it has oil on it).

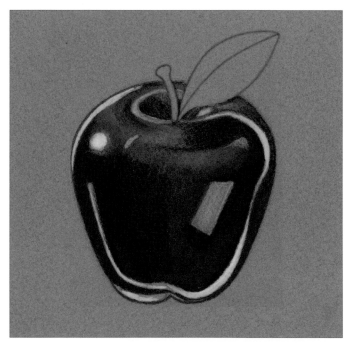

7 Apply the Primo Bianco charcoal (White) to the brightest reflections and the Polychromos White to the not-so-intense ones, as shown. I used the latter for the light square inside the apple and colored over it with the light red (Pale Geranium Lake) to gradate it.

8 Integrate the rest of the reflections gradually by coloring over them with red or orange. Leave the round, brightest reflection pure White, but you may want to go over its boundaries with the light red to create a gradient integration.

9 Draw the cast shadow with nearly the same procedure as the apple: a light sketch of the outline; with Phthalo Blue tone the darkest areas (in this case they will be closest to the apple and near the sides of the shadow but not on the edge because we will gradate them down). Fill in most of the shadow with Pale Geranium Lake, fading it as it gets farthest from the apple, while it becomes more intense as it approaches the reflection. Make the highlight with charcoal White and integrate it as in step 8.

10 Lightly apply Dark Red to the sides of the shadow and to the area farthest from the apple. Use the same color to merge the layers drawn in step 9 by going over them, especially over the areas where the different tones meet. You can also use the lighter reds (Pale Geranium Lake and Scarlet Red) to merge the lighter areas.

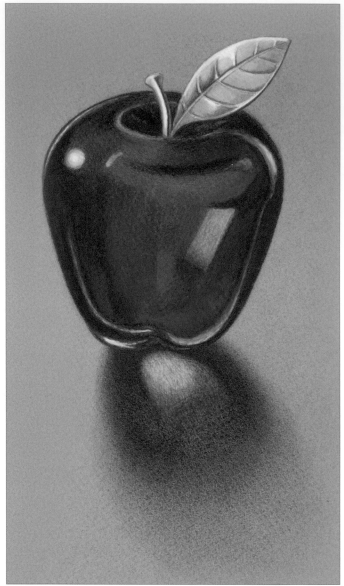

11 To give the illusion of silver on the leaf and stem you need high contrast of lights and darks. With the Primo Bianco White charcoal draw the places of high reflection (according to the light source), as shown. Here the light comes from the top left, so the brightest parts of the stem and leaf are the ones facing there.

12 With the Black pencil, draw some dark reflections on the stem and leaf. On the stem, I placed one of these right along the white reflection. On the leaf there would be a dark shadow on the opposite side, to indicate the thickness (and change of direction) of the surface. The body of the leaf can be rendered with a combination of light (Warm Grey II) and dark (Warm Grey V) greys. Look your drawing over and see if you would like to do anything else to it. I decided to extend the cast shadow a little bit and darken some areas of it with blue.

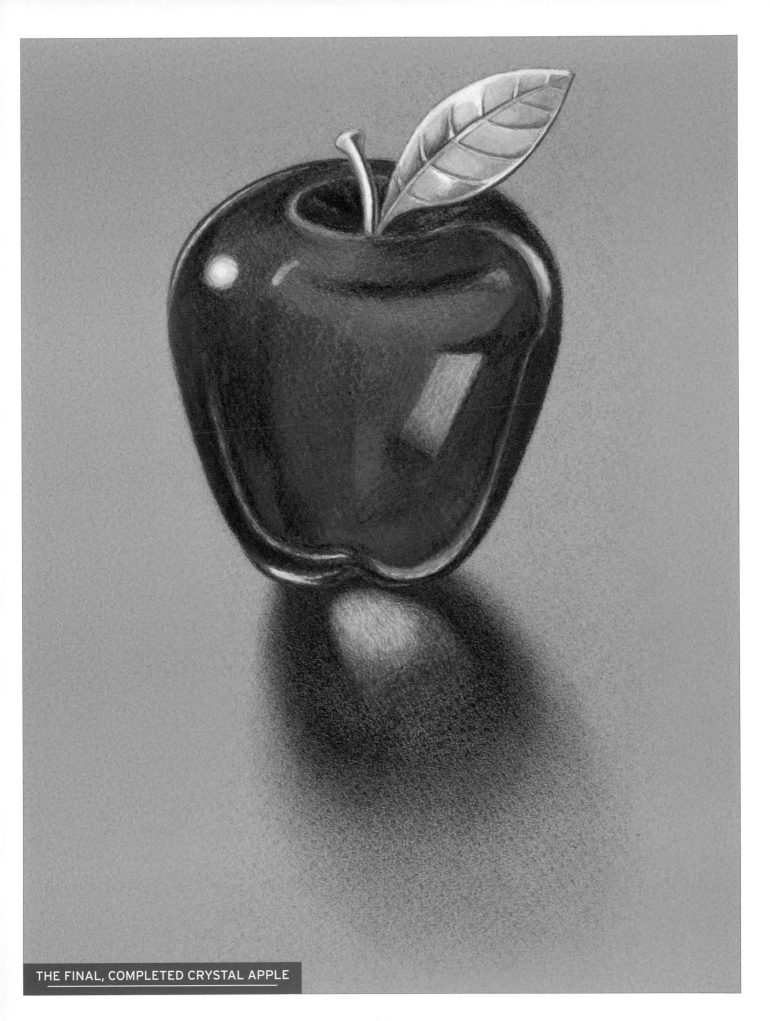

THE FINAL, COMPLETED CRYSTAL APPLE

How to Draw a Glass of Water with a Rose

MATERIALS

5 or 6 reference photos

Prismacolor Premier
color pencils:
10% French Grey
30% French Grey
70% Warm Grey
Caribbean Sea
Cloud Blue
Crimson Lake
Dark Green
Deco Peach
Denim Blue
Indanthrone Blue
Indigo Blue
Kelly Green
Mediterranean Blue
Pink
Poppy Red
White

Prismacolor Colorless
Blender

Faber-Castell Oil Pastel,
White

Primo Bianco Charcoal

Faber-Castell Magic-Rub
eraser

Prismacolor kneaded
eraser

Surface: Blue Cardboard

In this project we will draw a still-life composition of a simple glass of water holding a rose. This drawing offers a nice contrast of surfaces: one object is hard, cold, transparent and reflective; the other is soft, warm, lush, and full of color.

We'll use color pencils because they are versatile enough to deliver a quite realistic effect for both objects, as different as they are from one another. To achieve the desired intensity for the color of the rose, we'll lay in different colors in layers. I hope you enjoy the process and especially the result.

Please note that some of the following step-by-step illustrations are closer-up views that have been cropped slightly. The full-page image at the end of the sequence shows the complete drawing.

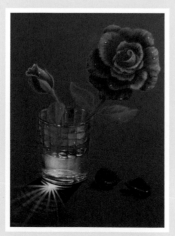

TO MAKE THIS DRAWING,
YOU MAY FIND IT HELPFUL TO REFER
TO THESE BASIC TECHNIQUES:
• blending colors (page 15)
• color pencil techniques (page 22)
• cast shadows (page 27)
• eraser techniques (page 14)
• light sources and light reflection (page 26)
• oil pastels (page 12)
• pencil points and sharpening (pages 29-31)
• shade and shadow (pages 27-28)
• tone, hue, color, tint (pages 24-25)

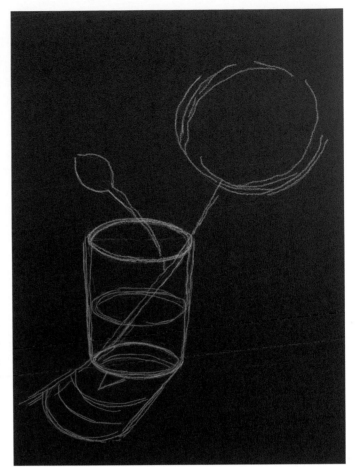

1 Using the Primo Bianco Charcoal, sketch the glass by first making two almost vertical, parallel lines, which in this case tapper slightly as they move down. Next, draw three horizontal ellipses to indicate the top and bottom of the glass and the water level (the one in the middle). I recommend you sketch with the Primo Bianco or with some other dry pastel pencil so you are able to erase and make corrections as needed.

2 Draw the overall shape of the rose and the bud to its left, as well as the shadow of the glass. Our light source will be coming from the upper right, so the cast shadow will fall toward the bottom left.

3 With Poppy Red, start giving shape to the rose. Use the pencil lightly as this is just a sketch at this point. If you prefer the line to be more evident use a more contrasting color such as pink (see step 4). Sketch a tilted oval to indicate the central part of the rose from where the petals open up. Just below the oval, start drawing the outline of some petals.

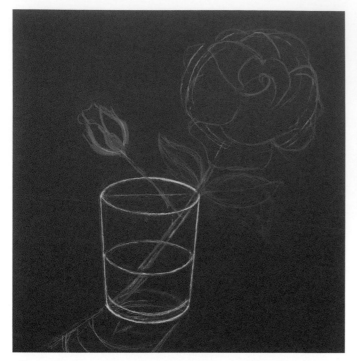

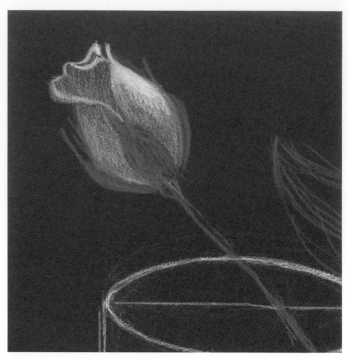

4 With Pink, sketch the bud toward the center of the rose and a row of petals just above and to the sides and below the bud; then add some layers of petals around them. Using the same Pink or Deco Peach (a lighter pink), sketch the bud on the left: First the general shape, then with more petal detail.

Sketch the stem and leaves, as shown in the picture, with Kelly Green. Note that when the stem enters the water it "breaks" and optically moves to one side.

5 If we lay in the actual coral color of the rose directly on this medium-to-dark blue surface, it will look dull and dark. To achieve the desired tonal quality, you must first apply a layer of White to the rose. Press a bit harder on the areas that catch more light (e.g. the ones facing the top right), and keep the pressure low on the areas that will have less light.

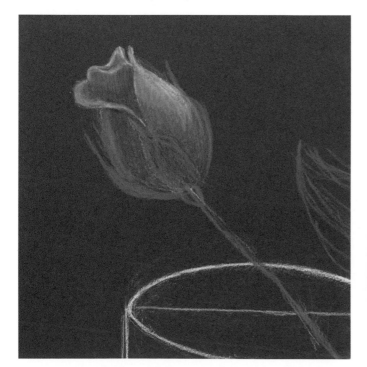

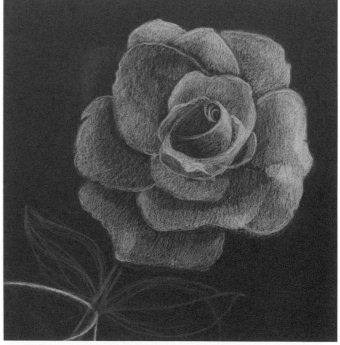

6 Layer Poppy Red on top of the White. Press harder on the areas that you want darker such as the ones on the lower side. Press lighter on the areas catching more light.

7 Keeping the same principle in mind, lightly tone the rose with White, pressing more on the petals catching more light and pressing lightly on the areas that will be in shadow such as the shadows on the petals cast by the petals above them.

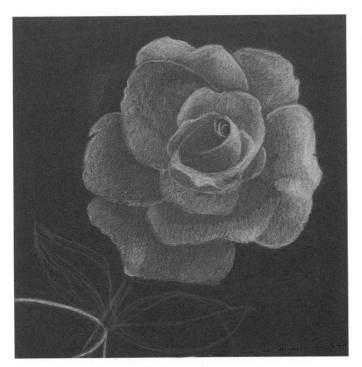

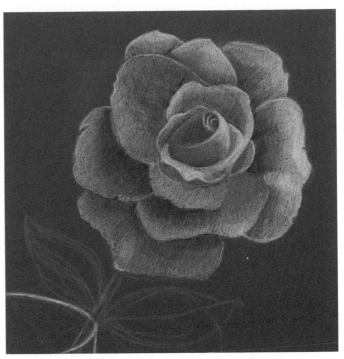

8 Apply a light layer of Pink. Again, apply very little pressure to the areas that catch the most light, such as the tips of the petals facing the top-right.

9 Layer Crimson Lake on the areas of shadow, like the parts of the petals that go into the center of the rose, hiding from the light.

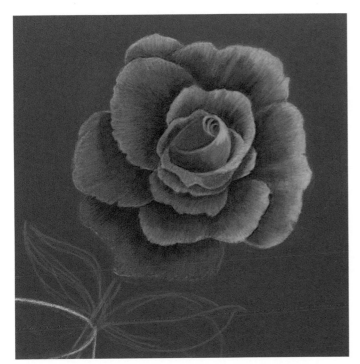

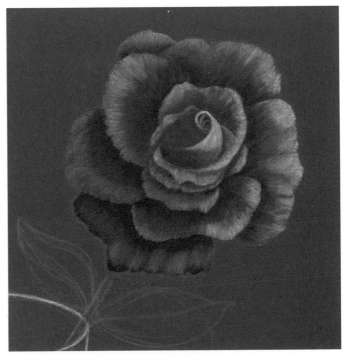

10 It's time to layer in the color of the rose—in this case the Poppy Red. Apply a medium amount of pressure (I do not recommend you press hard at this early stage because you want the colors to hold well and to mix with each other. This is more difficult to do on a hard-pressure layer).

11 Apply another layer of the Poppy Red, this time pressing harder. Continue adding Crimson Lake to the shadows and Deco Peach, or even White to the lights. Now you are achieving some intensity and volume!

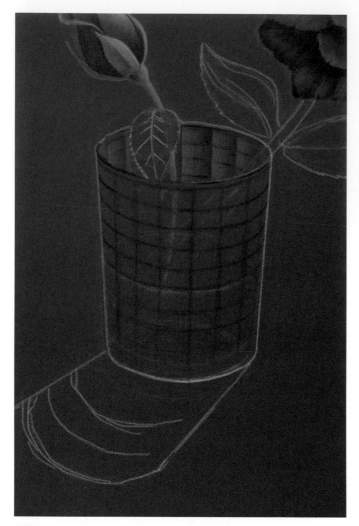

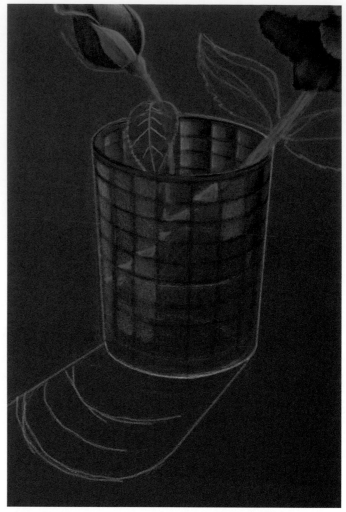

12 With Kelly Green and Dark Green, tone the stem and sepals (the green leaf-like parts that wrap around the bud petals).

Using Indigo Blue, lay out the pattern of the glass, making parallel, vertical lines that get closer to each other toward the sides of the glass (because of the perspective), and parallel (horizontal) ovals, which together create small rectangles.

On the left side of the rectangles at the back of the glass, lay some Cloud Blue lightly (and optionally a Caribbean Sea), while on the right side use a medium blue tone such as Mediterranean Blue.

13 With the Cloud Blue, Mediterranean Blue, and Caribbean Sea, keep filling the rectangles around the glass. Keep the right side darker to help show the volume of the glass.

Using Kelly Green and Dark Green, draw the stem of the rose inside the glass. This won't be a continuous line; it will have a ladder-like effect, as each square reflects the stem at a slightly different angle.

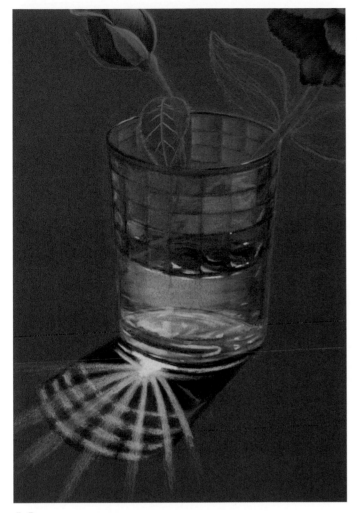

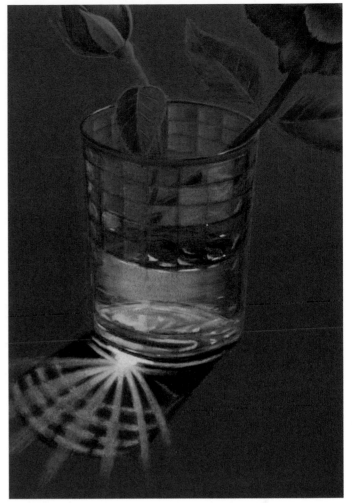

14 In the portion of the glass that contains water the rectangles will almost get lost. Use Mediterranean Blue and White to create the illusion of water. Blend them with the Colorless Blender to achieve a more even tone. With White, make some reflections on the surface of the water and on the bottom of the glass. With 70% Warm Grey add some dark reflections.

Following the direction of the light, render an intense white reflection on the surface by the base of the glass. If the sunlight is hitting the glass directly, it would project some lights as shown. Do the most intense part with pure White and then add Cloud Blue as the light moves away from the glass. Use Denim Blue and 70% Warm Grey for the shadow of the glass.

15 With the Kelly Green and Dark Green shade the stem and leaves of the rose. Remember, the areas that face the light source coming from the upper-right will be lightest and the ones turning away from the light are darker. The leaves of the common rose have ragged edges and some visible veins, as shown.

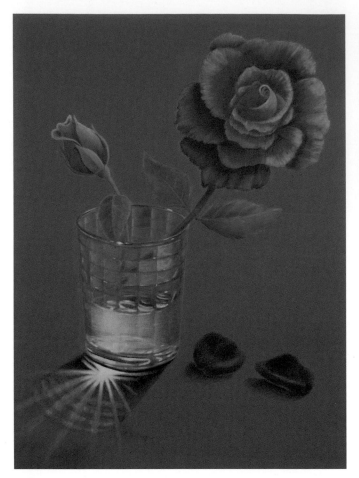

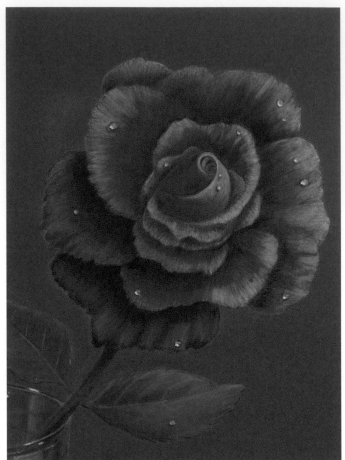

16 We are up to the final touches. Refine and darken the shadow of the glass. If needed, tone down the bright white lines on the surface (I used the Magic-Rub eraser for this, especially on the area farthest from the glass, so the reflections look more natural). Define details better if you wish. The color of the water was too blue for me, so I went over some areas of it with 10% French Grey (a light grey) and 30% French Grey (a mid grey).

As you see, I also drew two fallen petals using the same colors and procedure as I did on the rose itself. Draw their shadows with Indanthrone Blue. I also used this color to make a very light shadow of the rose itself, which falls beyond the shadow of the glass.

17 As a final touch of freshness, you can draw water drops on some petals and on the glass. You may do just one or two drops for the whole drawing or many drops on each petal, depending on the effect you want to achieve.

To make the drops on the petals, draw the outline of a small circle (or oval) with White. Lay some of the color of the petal (such as Poppy Red) on the upper-right half of the drop so it looks transparent and not opaque white. Then, with a dark color such as Crimson Lake or Indanthrone Blue draw a small cast shadow at the bottom left of each drop.

Repeat the procedure for the drops on the glass but instead of red use Mediterranean Blue or Denim blue inside the drops.

Lastly, I applied some small highlights of White Oil Pastel inside the drops, toward their lower left, as well as some small highlights to the glass (such as on the brim) to make them sparkle.

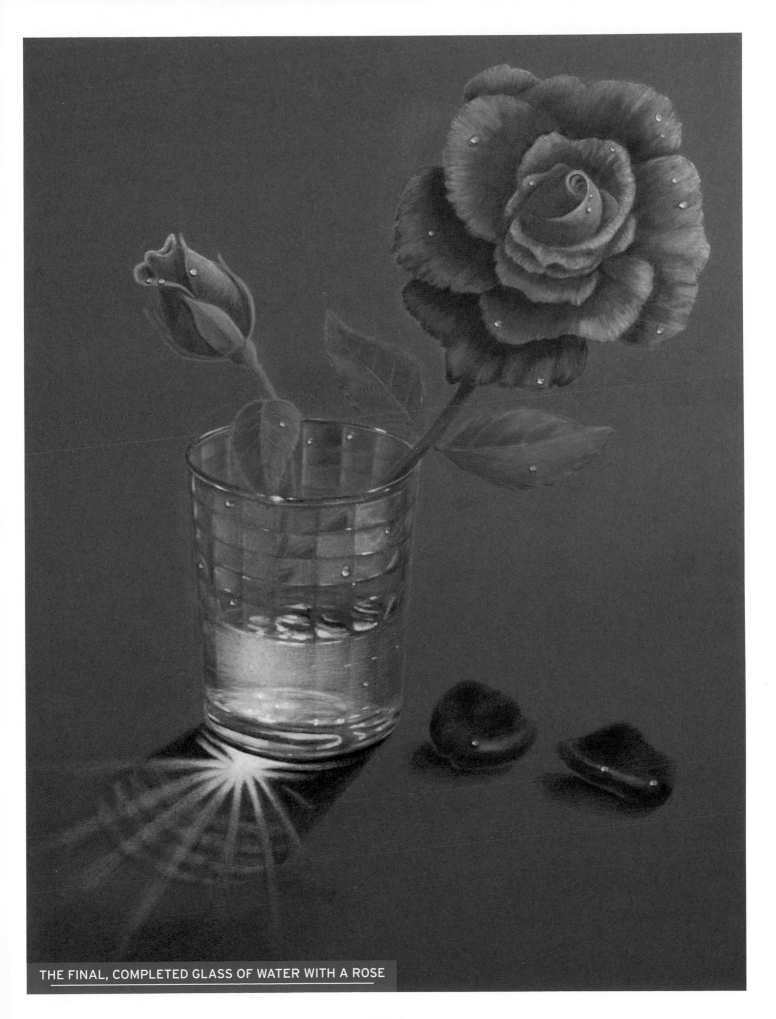

THE FINAL, COMPLETED GLASS OF WATER WITH A ROSE

HOW TO DRAW
Water

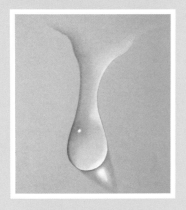

Water is a majestic element of nature that takes us away with the rhythmic motion of ocean waves, the soothing ripples of a lake, or the bubbling current of a stream.

It's not surprising that artists want to draw water, but it's difficult to know how to approach it.

Drawing water is not different from drawing crystal – it requires a level of observation and we'll draw not so much the water itself, but the interesting and rich reflections on its surface. We'll look for patterns in the reflections (caused by the ripples), which will distort the objects being reflected. When done well, this effect creates a wonderful sense of motion.

DOLPHIN UNDERWATER • WATER DROP • LAKE

How to Draw a Water Drop

MATERIALS

5 or 6 photo references

Faber-Castell Polycromos Helio Blue-reddish (dark blue)

Primo Bianco white charcoal

Blending stump No. 2

Prismacolor kneaded eraser

Surface: Light blue cardboard

Drawing a water drop is easy and can deliver a surprisingly great effect because it's both reflective and translucent — light travels right through it and illuminates the opposite side. We'll use just two colors to achieve these qualities, a blue color pencil for the water and shadows and a charcoal white for the highlights. A kneaded eraser helps pull more highlights and a blending stump enhances the effects. Drawing on a light blue cardboard is great for drawing a water drop; the color of the paper makes the lights really stand out.

Please note that some of the following step-by-step illustrations are closer-up views that have been cropped slightly. The large image at the end of the sequence shows the complete drawing.

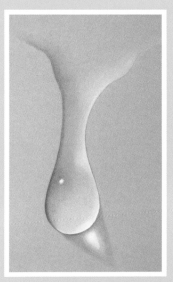

TO MAKE THIS DRAWING, YOU MAY FIND IT HELPFUL TO REFER TO THESE BASIC TECHNIQUES:

- blending and layering (page 15)
- charcoal techniques (page 12)
- color pencil techniques (page 22)
- cast shadows (page 27)
- eraser techniques (page 14)
- light sources and light reflection (page 26)
- pencil points and sharpening (pages 29-31)
- shade and shadow (pages 27-28)
- tone, hue, color and tint (pages 24-25)
- volume and shape (page 25)

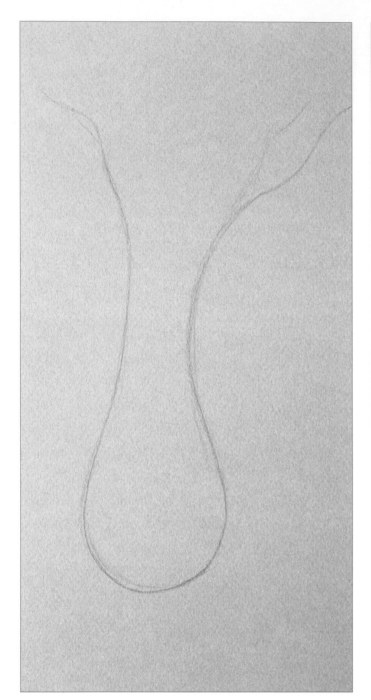

1 Start by sketching the outline of the drop with the Polycromos Helio Blue-reddish (dark blue) pencil. There are infinite shapes you can make. In this example, the drop is sliding down a surface.

Use loose motions with your arm and hand. There is no danger of making a mistake.

2 Once you are happy with the overall shape you may find that there are lines that you don't need. At this point you may erase them and clean up your outline.

TIP
I'm using toned paper because the white highlights will really stand out on it. If I were using white paper, it would not give this effect unless I toned the whole surface.

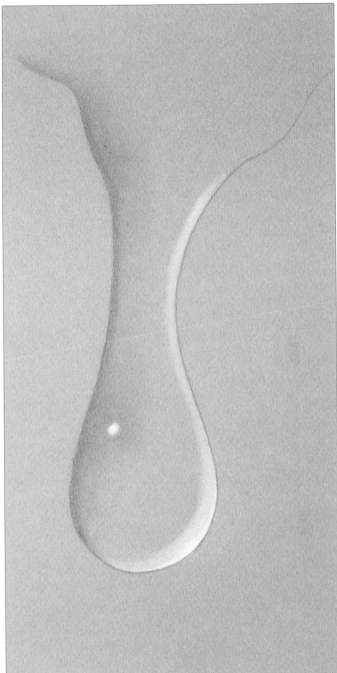

3 When light hits a transparent object like a water drop, it behaves in a particular way. The light source here is at the top left. The light beam hits the drop on the upper left then goes through it and illuminates the lower right of the water drop. Therefore, the darkest part of the drop is the top left except for a possibly very bright spot. Generally, the brighter area will be the lower right.

Keeping that in mind, use the dark blue pencil to shade the drop. Leave a small blank area on the left for a highlight.

4 Pull in some lights with the white charcoal. Draw it along the opposite side of the light source; draw a very white, small reflection toward the upper left of the drop, as shown.

Smudge the drawing with a blending stump for a smoother finish. Do not blend the dark blue and white together because it will look murky and unrealistic. Blend each color separately – the dark blue and, with a clean end of the stump, the white.

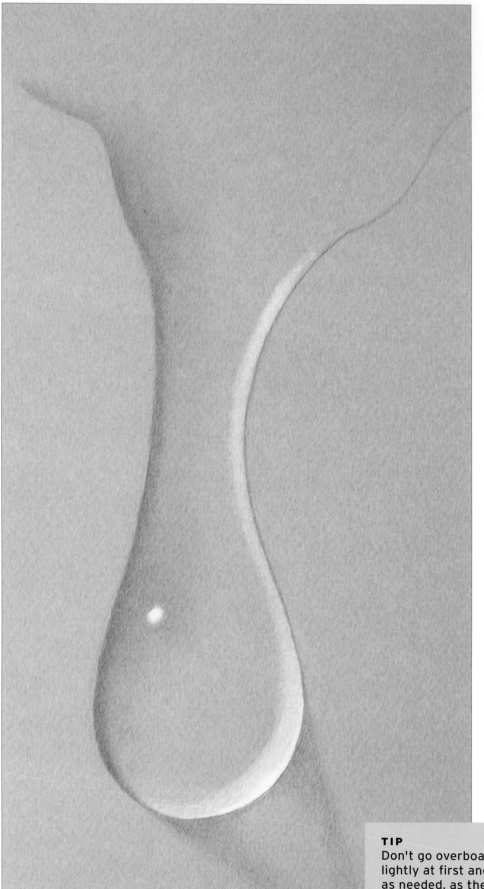

5 Now, draw the cast shadow with the dark blue. Since the drop is transparent, the shadow shouldn't be totally dark. Its shape will vary depending on the angle and intensity of the light source. In this case depict it with a triangular shape, leaving the center part empty for some light.

TIP
Don't go overboard with the white. Lay it lightly at first and increase its intensity only as needed, as the drawing develops. Too much white would make it look unrealistic.

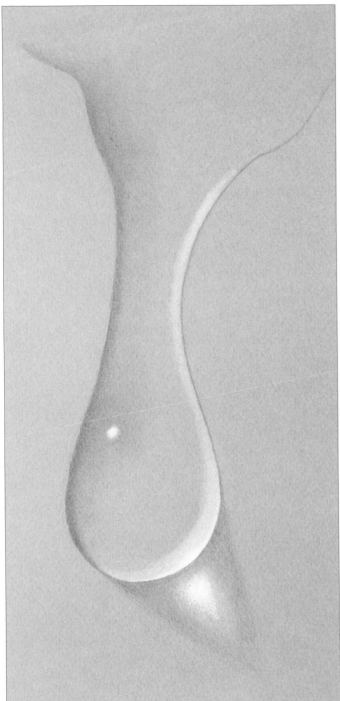

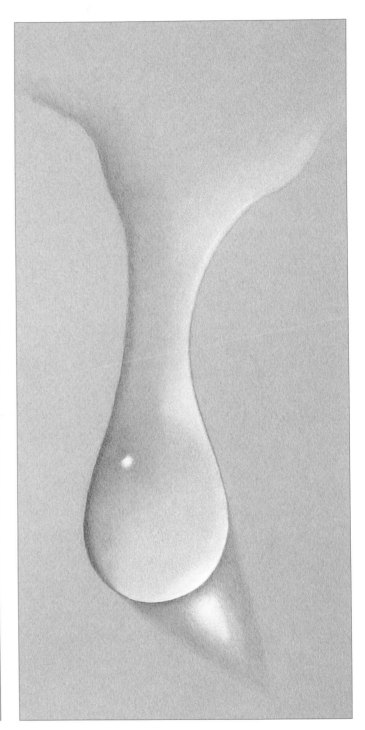

6 Because of the magnifying glass effect of water, there is condensed light in the middle of the cast shadow. The brightest part should be closer to the drop and fade as it gets farther away. This effect looks really good, by the way!

7 It's time to look your water drop over and see what else you would like to do with it. In mine, I slightly refined the contour and added some white to the body of the drop to give it more volume.

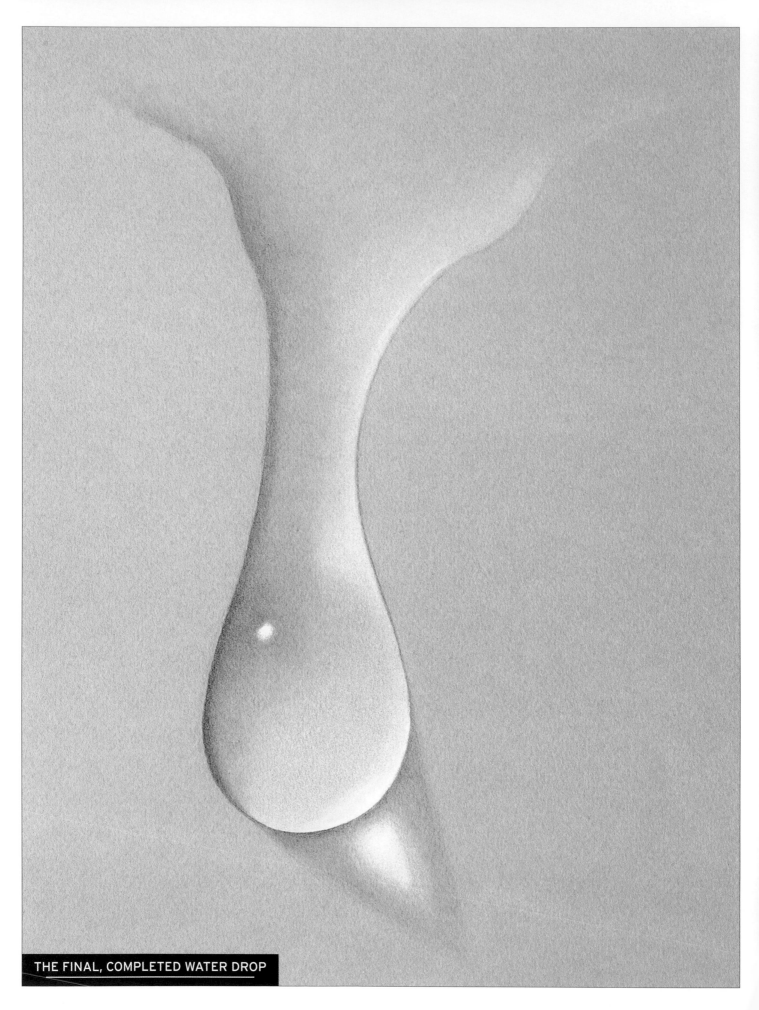

THE FINAL, COMPLETED WATER DROP

How to Draw a Dolphin Underwater

MATERIALS

5 or 6 reference photos

Mechanical pencil with a 0.7 mm, HB lead

Mechanical pencil with a 0.35 mm, 2H lead

Graphite powder

Flat synthetic brush, 1" wide

Chamois

Prismacolor kneaded eraser

Surface: Fabriano white drawing paper, fine grain

Clean paper (for under the hand to prevent unwanted smudging)

Now let's immerse ourselves in a drawing of a dolphin swimming underwater. A dolphin's skin has a lustrous and silky texture that will allow us to show how light shines through water and reflects off of it, as well as the movement of the water. There won't be any lines that are too sharp; we will try to keep the drawing soft and slightly blurry.

Note before you start: It is crucial for the success of this approach that you never touch the paper with your fingers, or even with your hand – they may leave body oils. And then, when you spread the graphite powder with the brush, it will reveal your fingerprints. This may be great news for a detective, but not for an artist!

Please note that some of the following step-by-step illustrations are closer-up views that have been cropped slightly. The full-page image at the end of the sequence shows the complete drawing.

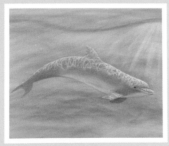

TO MAKE THIS DRAWING, YOU MAY FIND IT HELPFUL TO REFER TO THESE BASIC TECHNIQUES:
- brush techniques (pages 15 and 28)
- eraser techniques (page 14)
- graphite pencil techniques (pages 19-21)
- graphite powder techniques (page 28)
- light sources and light reflection (page 26)
- reference photos (page 18)
- shade and shadow (pages 27-28)
- using a chamois (pages 15 and 28)
- value, tone, and hue (pages 24-25)

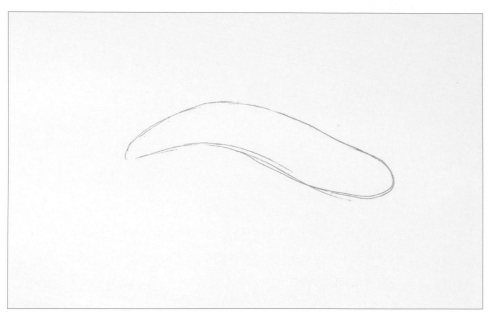

1 Using your mechanical pencil with a 0.7 mm, HB lead, sketch a simple outline of the dolphin based on your preferred reference. Draw the creature in a curved pose to give it life and movement.

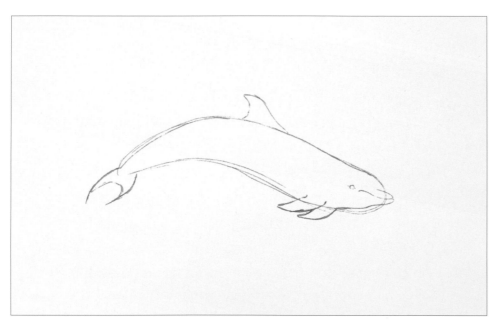

2 With the same pencil, add the tail, fins, snout, and eye. Refine the form of the head. Each one of these features is simple if taken on its own, one by one.

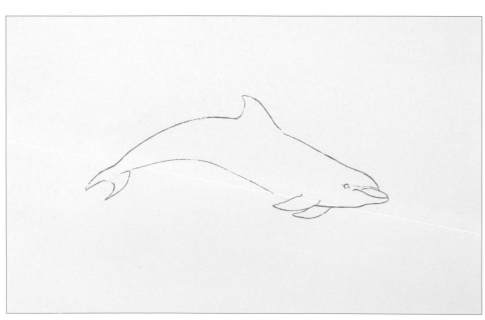

3 Using the eraser and redrawing with the pencil as needed, clean up the outline of the dolphin.

4 Gently sprinkle some of the graphite powder on the drawing. It is not going to be distributed completely evenly, which is totally fine because the "lumps" of the powder will create differences in tone, which will help give the illusion of waves.

It is better to start light. Begin with a little powder, sprinkle it around, then sprinkle more as needed (it is much easier to darken than to lighten). The amount of powder shown in step 4 is about right.

5 With sweeping strokes, spread the sprinkled graphite using a soft 1-inch brush. Make the movements horizontally and then vary the angle, imagining how you want the waves to look. Go over the dolphin as well to give it a tone. You should have a result more or less like the drawing stage in step 6.

6 As needed, sprinkle a little more graphite in the areas that you would like to darken further, and spread it with the brush, as in step 5. (I like to darken the back of the dolphin a little bit more to create contrast when pulling lights in this area.)
This is the intensity of tone that will give you a fine contrast when adding highlights. Notice that toward the top of the drawing in step 7, I made a wave with the brush to indicate the surface of the water.

7 This is an easy way to pull highlights. Make a sharp point on the kneaded eraser (or use a sharp corner of a regular eraser) to pull highlights on the dolphin's body. Light reflecting on an underwater body can make different shapes — grids, lines, or dots — depending on its intensity, angle, the roughness of the surface waves, etc. Here, I made a crossing-lines pattern. Use photo references to help you visualize.

The light hits the surfaces that are facing up, like the dolphin's back and the up side of the fins. Follow the shape of each feature as you highlight it, emphasizing the roundness of the back and the relatively flatter flipper.

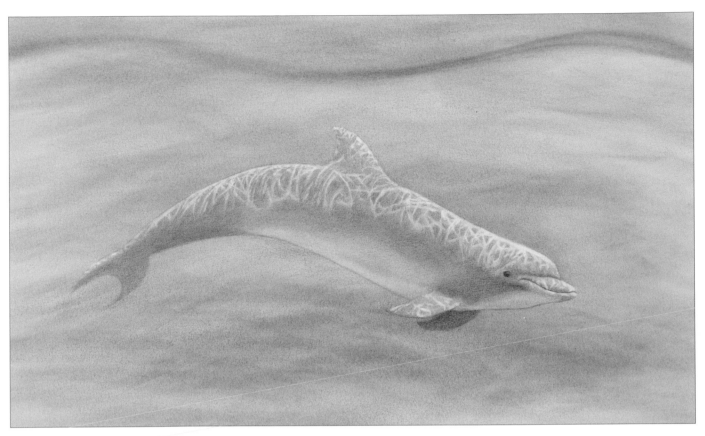

8 With the 0.35 mm, 2H lead mechanical pencil (or using the brush with powder) darken the areas that are in shade such as the bottom side of the fins and tail. Delineate some details like his mouth and eye.

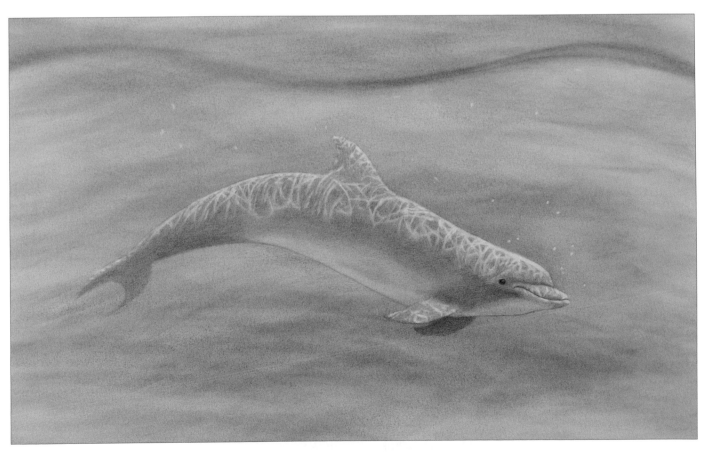

9 With a sharp point of the kneaded eraser make some dots representing air bubbles.

10 To show beams of light penetrating the water, take some of the graphite off the paper using a chamois wrapped around your index finger. Rest your hand on a clean piece of paper to avoid smudging and to serve as a guide edge for the beams. Press slightly harder toward the top of each beam and ease the pressure as you move down, so that the light fades as it goes into the deep. The beams can be short or long. Move the paper slightly to change the direction of each beam as if all beams emanate from the same source and spread out in different directions. The paper will leave one edge of the beam too sharp. After you lift the paper, go over it again freehand to even it out.

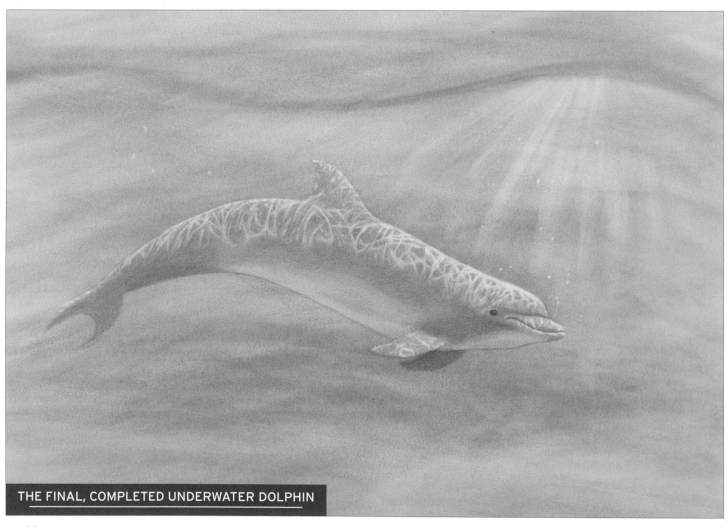

THE FINAL, COMPLETED UNDERWATER DOLPHIN

11 With the pencil or the brush, go over the top of the area where you started the light beams to make it even and smooth. Add any final touches to the dolphin and . . . you are done!

How to Draw the Water Surface of a Lake

MATERIALS

5 or 6 reference photos

Faber-Castell color pencils:
Helioblue-Reddish
White

Prismacolor kneaded eraser

Tombow MONO Zero eraser

Surface: Sky blue cardboard paper

Drawing still water is challenging, but at the same time so enjoyable that I could do it all day. There are an infinite number of ways still water can look. Even the same lake viewed from the same angle can change appearance, sometimes radically, depending on the lighting, on what is being reflected in or by it, and on how still or wavy the lake is. There are also diverse ways water surfaces in completely different scenarios can look. Often you don't see the surface itself, but its reflections.

Out of all the possibilities and artistic approaches to represent a still-water surface, I chose a fairly simple technique using only one blue and one white pencil on blue-toned cardboard.

Please note that some of the following step-by-step illustrations are closer-up views that have been cropped slightly. The full-page image at the end of the sequence shows the complete drawing.

TO MAKE THIS DRAWING, YOU MAY FIND IT HELPFUL TO REFER TO THESE BASIC TECHNIQUES:

- eraser techniques (page 14)
- color pencil techniques (page 22)
- light sources and light reflection (page 26)
- reference photos (page 18)
- pencil points and sharpening (pages 29-31)

1 With the Helioblue-Reddish pencil (which you will use throughout the drawing), begin by making a curvy, broken line from the top down. This is the reflection of a tree on the water's surface, so also draw some branches, upside down.
Go back to the top and go over the line, giving it thickness.

2 Continue giving thickness to the line. The reflections of branches are not always solid, so leave some blank spaces (broken lines) and also give the line different shapes as I did here. In some areas you may have a double line. It doesn't need to look beautiful at this stage.

TIP
Keep in mind that in this example we are drawing upside-down branches, so they should be thicker on the upper part and thin down toward the bottom. They should also branch out as they come down.

3 Branch out the main trunk of the tree in the reflection; give it a thickness and shape like the tree itself.

4 Move on and draw the reflection of other trees (we are drawing trees with bare branches), making zigzag patterns. The first tree reflection you make is the most prominent; vary the thickness of the rest of the reflections, but make them thinner than the first one.

5 Continue on to the next (smaller) trees. It's okay if a branch changes direction here and there; some can even go across the rest. And it is important that you vary the thickness of the branch. All of a sudden go much thinner, then wider to one side, then to the other, etc.

TIP
The calmer you want the surface of the water to appear, the straighter and more continuous the lines should be. A completely calm water surface is flat and would look like a mirror. The more wavy the water, the more distorted and broken the lines of the reflected branches appear.

6 Keep making tree reflections until you get to the bottom of the page. Make sure they don't look even. Draw some a little darker, some a little thinner. Create a variety of shapes, sizes, and directions. This will make it look more natural.

7 After you've drawn the main trunks and branches, draw smaller branches. Some may be as thin as a line created by a sharp pencil. Some will be thicker. Some branch parts may be separate from the original line. To indicate the form of a wave(s) you can use shapes that resemble a "V" or "U" or "M" rotated to one side.

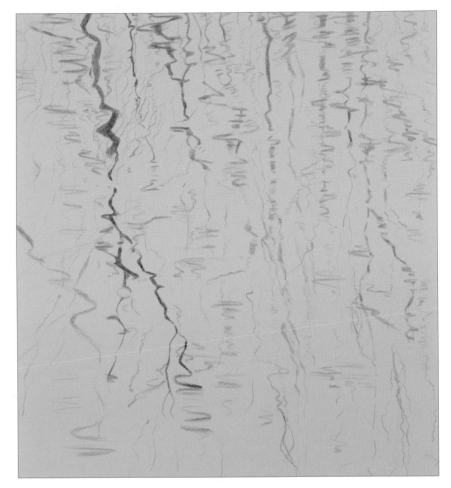

8 Depending on how thick with trees you want your drawing to look, you can keep adding more and more of them. In this drawing, I wanted the trees to be fairly thick so I drew some more of them at this point. You can close your eyes for a moment and imagine how a reflection would look with the movement of the ripples and create your own, which is a lot of fun, by the way.

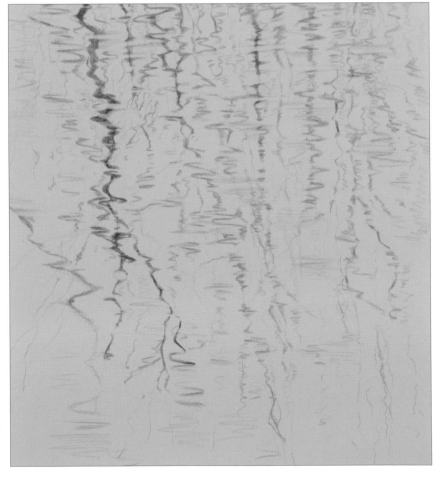

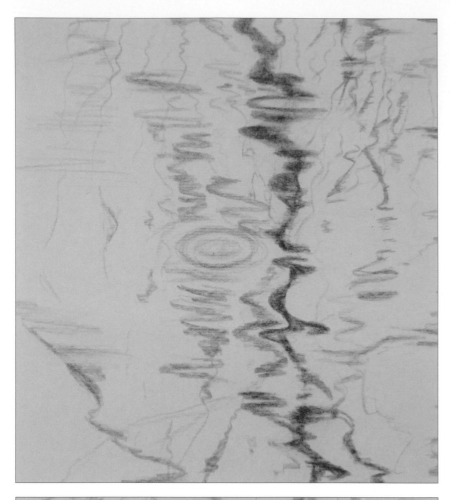

9 I added a couple of elliptical ripples, as if something had hit the water. (Note that viewed from an angle the circular ripples would look elliptical). I drew the first ripple (detailed view shown here) toward the left of the drawing, slightly higher than the middle; place yours where you see it fits best.

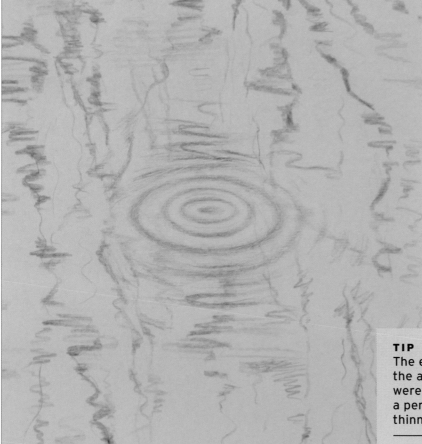

10 The second elliptical ripple (detailed view shown here) is toward the right and lower than the middle of the page, to visually balance the first ripple. Draw this second one, which is closer to you, larger than the first, and with more detail and clarity. (The other one can be left a bit more blurry.)

TIP
The elliptical shape of the ripples depends on the angle we are looking at them from. If we were directly above them they would look like a perfect circle. The lower our viewpoint, the thinner the ellipse becomes.

11 Make sure there are no branches crossing the ellipses of the ripples, because these ripples cancel out other reflections. If there are any branches crossing your ripples, erase them.

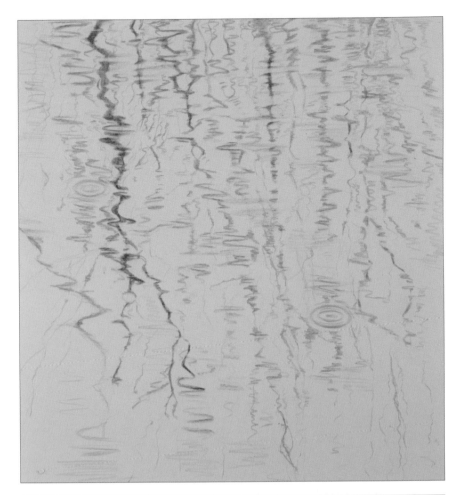

12 Using very light pencil pressure and holding it almost parallel to the paper to draw with the side of the lead, give a tone to some areas of the surface of the lake. I toned the upper right of the drawing in particular, not solidly, but leaving blank spaces to create the illusion of small waves or ripples. I continued toning here and there (not all areas) on the rest of the drawing. If needed, using the Tombow or kneaded eraser, you can sharpen the elliptical ripples and some other waves by erasing the areas that are already lighter but that may be blurry. Erase up to where the dark line is to leave the line against a blank space. You may want to finish the drawing at this point and it is totally okay.

But if you wish to add more striking highlights, you can go over some spots sparingly with a very light blue pencil or, as I did (see final drawing on the next page), with a white pencil. The highlights can be on the edges or corners of ripples or on the ripples of the ellipse. Apply some with very light pressure and press harder on others to make them shine. I recommend making these shiny reflections small, just a dot or a very small line. You can make a wider light-pressure area with a tiny highlight in it.

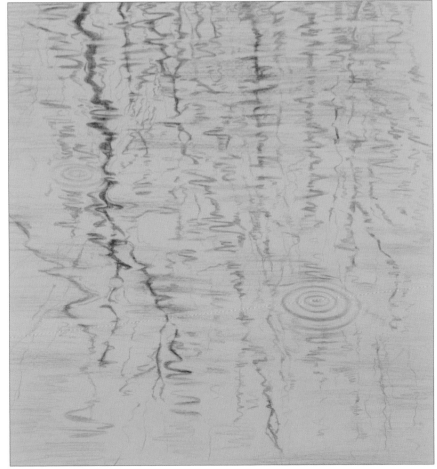

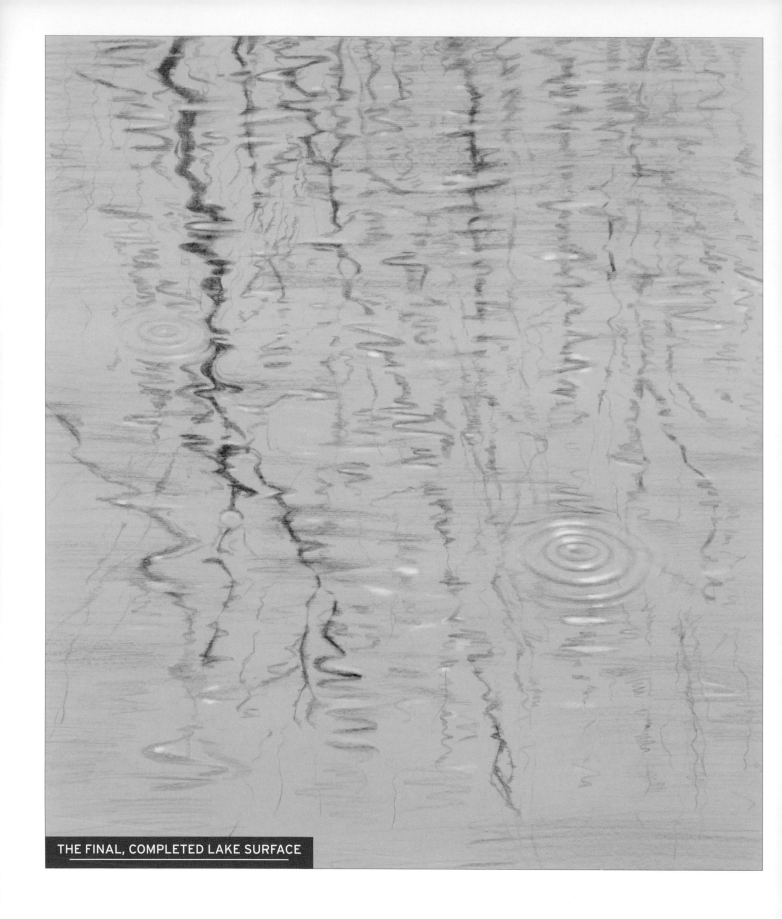

THE FINAL, COMPLETED LAKE SURFACE

HOW TO DRAW
Flowers

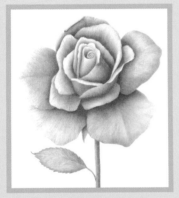

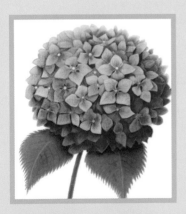

HIBISCUS • ROSE • HYDRANGEA

Flowers are so beautiful and have so much meaning attached to them that they are among the most popular themes in art.

When we first look into a flower in order to draw it, it may seem too complicated with all the layering of petals. The solution is to simplify the forms and the volumes to a minimum by finding a basic outline and start from there.

The good news is that a flower is a very forgiving subject. You can draw a petal slightly bigger than reality, or change it's shape, and it will still look good. So have lots of fun!

How to Draw a Rose

MATERIALS

5 or 6 references photos

Mechanical pencil with 0.7mm, HB lead

Mechanical pencil with 0.35mm, H lead

Lead Holder with 2mm, H lead

Lead Holder with 2mm, 3B lead

Faber-Castell Magic-Rub eraser

Prismacolor kneaded eraser

Surface: Fabriano white sketching paper, fine grain, 56 lb.

Since time immemorial roses have been a symbol of beauty. That is not surprising since a rose is breathtakingly beautiful. Throughout history the rose has been given many meanings, often dependent on its color. For example, the red rose most commonly stands for love, passion, devotion, and sensuality, the pink rose for first love and innocence, the yellow rose for joy and protection against envious lovers, and the white rose for purity.

When drawing a rose, it is important to capture its delicacy and the velvet-like feel of the petals.

Please note that the following step-by-step illustrations are closer-up views that have been cropped slightly. The full-page image at the end of the sequence shows the complete drawing.

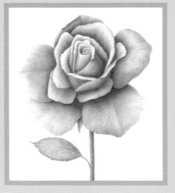

TO MAKE THIS DRAWING,
YOU MAY FIND IT HELPFUL TO REFER TO THESE BASIC TECHNIQUES:
• eraser techniques (page 14)
• graphite pencil techniques (pages 19-21)
• light sources and light reflection (page 26)
• pencil points and sharpening (pages 29-31)
• reference photos (page 18)
• shade and shadow (pages 27-28)

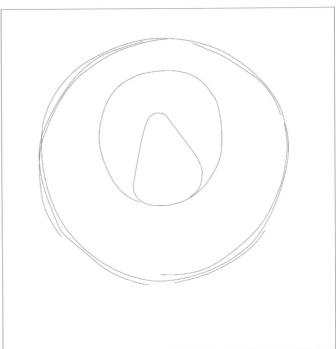

1 First, with the HB mechanical pencil, sketch the nearly triangular shape that will be the central bud part of the rose. Use this pencil in steps 1-8.

2 Then, draw an oval that has the same base as the figure from step 1 and that is about one and a half times its height (you don't need to be exact). Draw the outline of a larger circle, as shown, which will be a guide for the overall size of the petals. Make sure your original triangular shape stays in the central part of this circle.

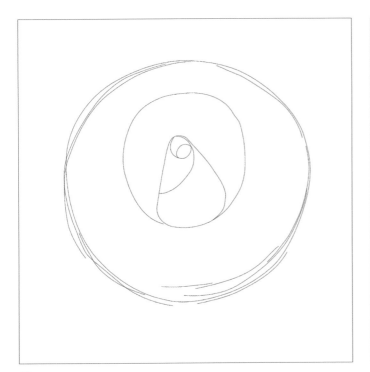

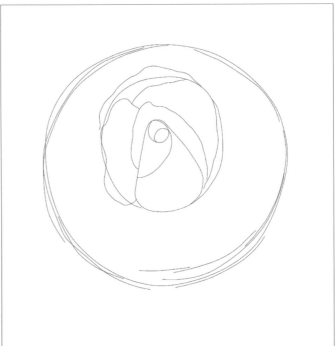

3 From the upper part of the triangular shape, draw a small oval and a spiral line that wraps around the middle of the bud.

4 Following the general shape and size of the original (innermost) oval, draw the outlines of a series of petals: One slightly above the bud; one slightly larger, higher, and to the left; another one still larger and to the right; and, finally, one above them all.

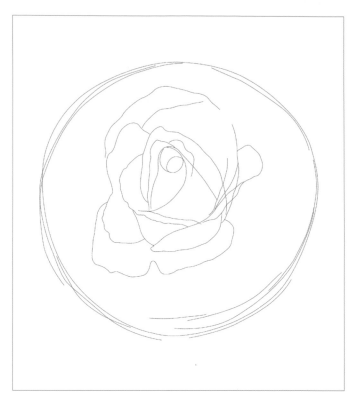

5 Give the rose some shape by curving in a line of the bud (here on the left of the bud). Draw additional petals to the left and right of the bud and directly below it. Of course, the precise shapes and positions of the petals can vary; you don't have to make them identical to this sample drawing. I drew the petals to the right of and below the bud with the top edges bent/rolled over, revealing the petal's other side.

6 Now for the larger petals: Draw one on each side and two toward the bottom. They should be slightly narrower toward the center and wider toward the outer edge. Use the larger circle as a guide, although you don't need to follow it precisely.

7 Erase the circular guidelines and give more detail to the shape of some petals.

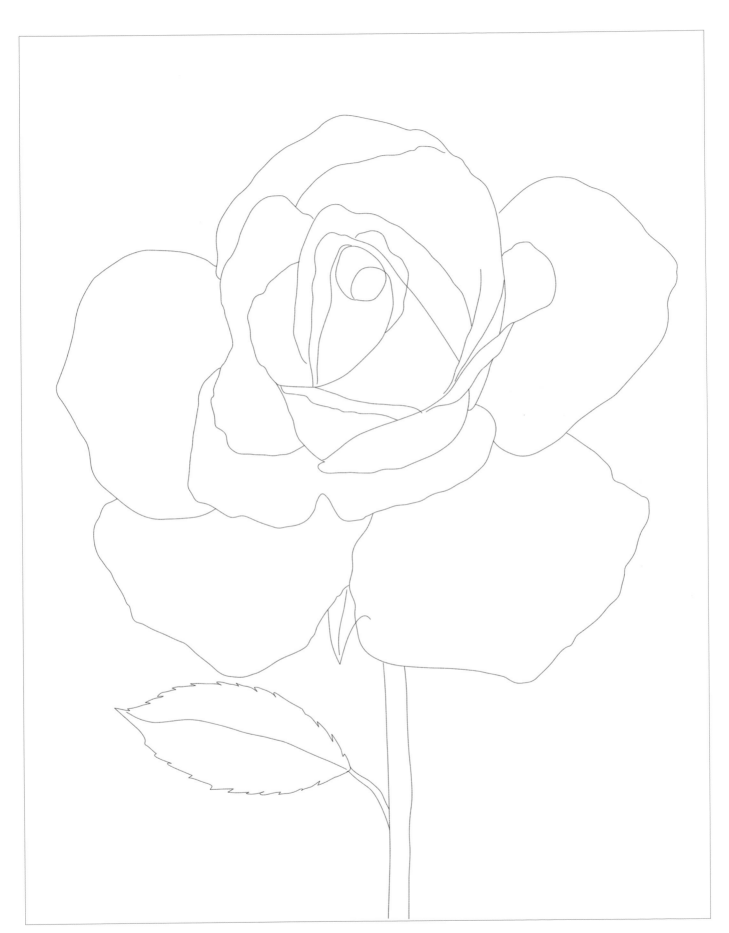

8 Draw the shaft (stem), which should run toward the center of the bud, then a leaf growing out of the shaft that has a jagged edge. If you like, add a sepal (the green leaf-like parts that are underneath the petals) and alternate with them in position.

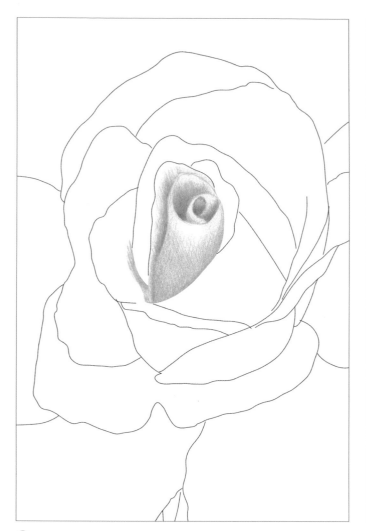

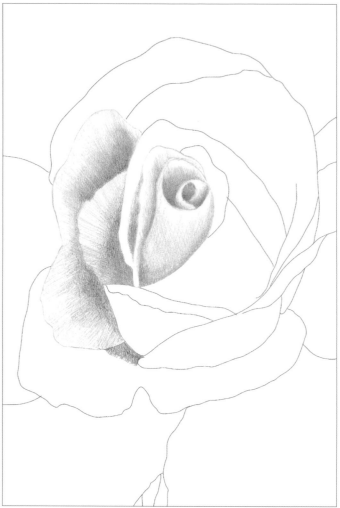

9 With the H lead mechanical pencil, start shading the rose, working outward from the center. Generally speaking, the part of the petals that are closer to the center and the parts that are behind others will be the darkest. As they come up or stick out they will catch more light and become lighter. Our light source will be up and slightly frontal and to the left. For the darkest areas, use the HB or, if needed, the 3B. (The darkest shouldn't be totally black).

10 With linear strokes and following the (vertical) direction of the petals, use the H lead to lightly shade the farther away parts of the next series of petals. Use the HB (or 3B, as needed) to shade the parts of the petals closer to the center, which will be darker.

TIP
As the tips of the petals catch more light, they should generally be lighter. When shading, don't smudge the graphite, because the original mark of the lead will help render the texture of the rose.

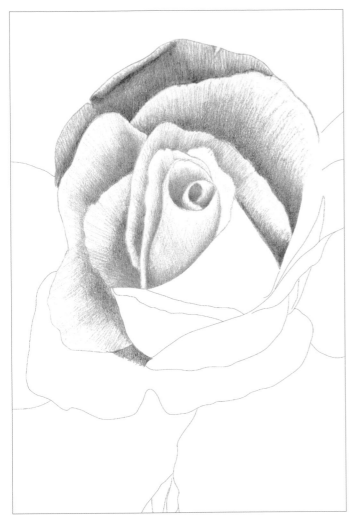

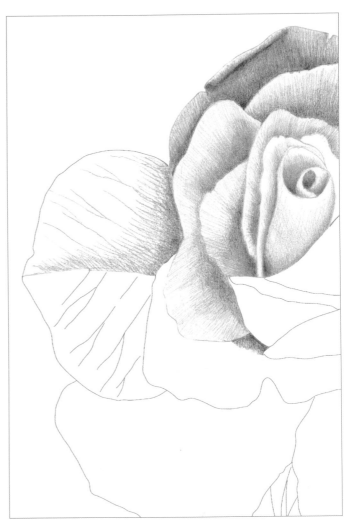

11 As in step 10, shade the rest of the petal at the top. I darkened the one on the back to emphasize the fact that it is behind, and I broke up and curled a section of the edge to give it more movement and realism.

12 On the larger petals you can draw some veins before shading. The main vein runs vertically down the center of the petal and branches out toward the sides. These lines will be hardly perceptible once it is shaded.

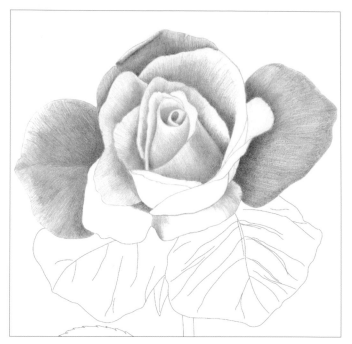

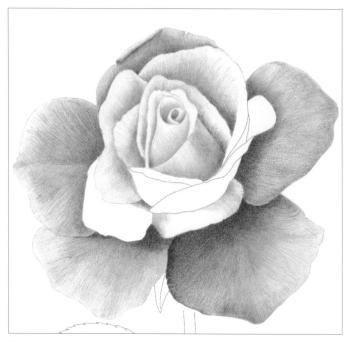

13 Using the H mechanical pencil and continuing with short lines, shade the lighter parts of the petals to the left and right. With the HB, shade the darker areas of these petals, as above. Then, mark some veins for the next lowest petals.

14 Continue shading the larger petals at the bottom following steps 12 and 13, above.

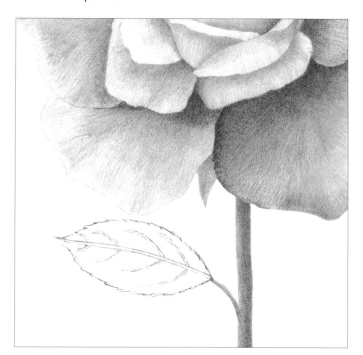

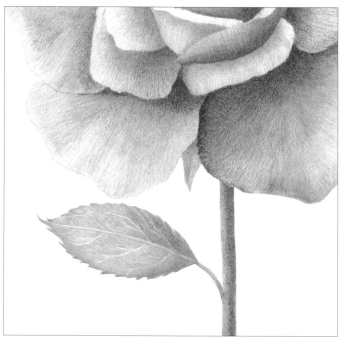

15 Shade the visible section of the sepal between the lower petals. In real life this would be green; if you are drawing a red rose in black and white, then it should remain slightly lighter or of about the same tone as the petals. (If you were drawing a white or yellow or pink rose, the sepal would be darker than the petals).

In regards to the leaf, draw the midrib (the central line) and the veins. Because they will be the lightest part of the leaf, draw them by doing an outline and leaving the "body" of the lines white.

16 With the H and the HB leads, shade the leaf leaving the midrib and veins in a lighter tone.

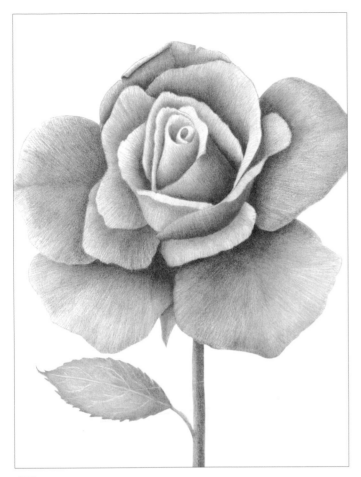

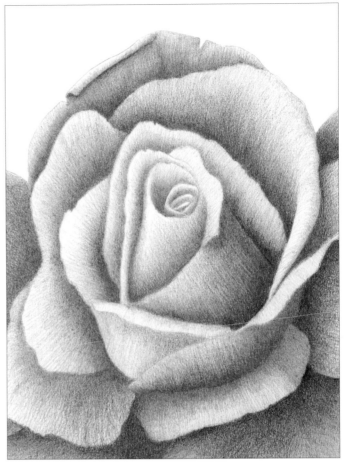

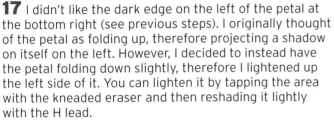

17 I didn't like the dark edge on the left of the petal at the bottom right (see previous steps). I originally thought of the petal as folding up, therefore projecting a shadow on itself on the left. However, I decided to instead have the petal folding down slightly, therefore I lightened up the left side of it. You can lighten it by tapping the area with the kneaded eraser and then reshading it lightly with the H lead.

Additionally, to give more contrast to the drawing, you may further darken some of the areas that are already dark to delineate the petals better as needed (e.g., if the edges look blurry); I did just that on the petal right above the bud.

18 I decided to divide the orifice on top of the central petals to make it more interesting and nicer, as if one saw the tip of very small petals in the bud. For this, erase the dark area by first tapping on it and then rubbing it with the kneaded eraser. Then, divide it horizontally as in the drawing, using the H or HB lead. Shade the darker parts (the lower part of each) with the HB lead and the lighter with the H lead.

137

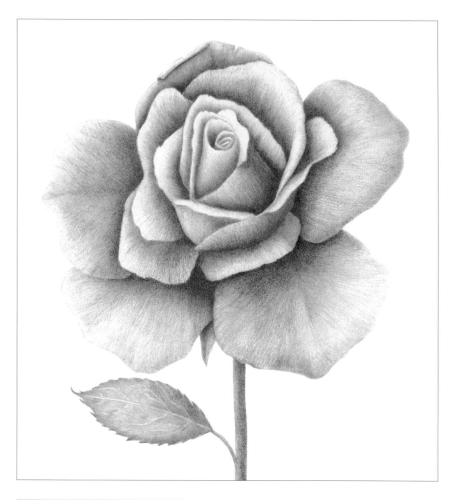

19 It is time for fine-tuning and making small improvements. I saw that the second petal going from the bottom up, (the small horizontal one below the bud), looked too light and flat. I toned it down a bit with the HB lead, particularly the areas that should be in shadow – the upper section nearest the bud (because the petal above it blocks the light) and the area on its right side (which would also be hidden from light by the petal above). Look over the other petals and see which areas should be darker.

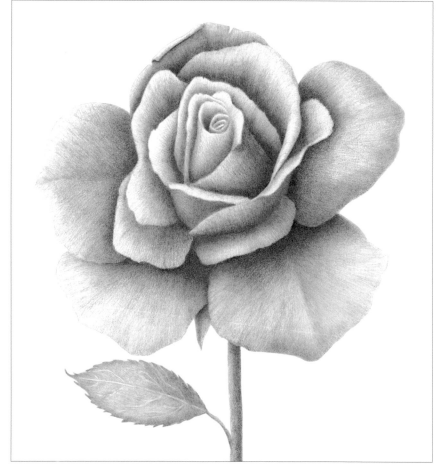

20 I further darkened the lower section of the upper petal on the far right, the upper section of the large petal at the bottom right, and the lower-right area of the petal at the upper far left to give them more dimension and volume. I also slightly lightened the upper or left side of many petals, because this is the area catching the most light. For example, the left side of the two petals at the very left.

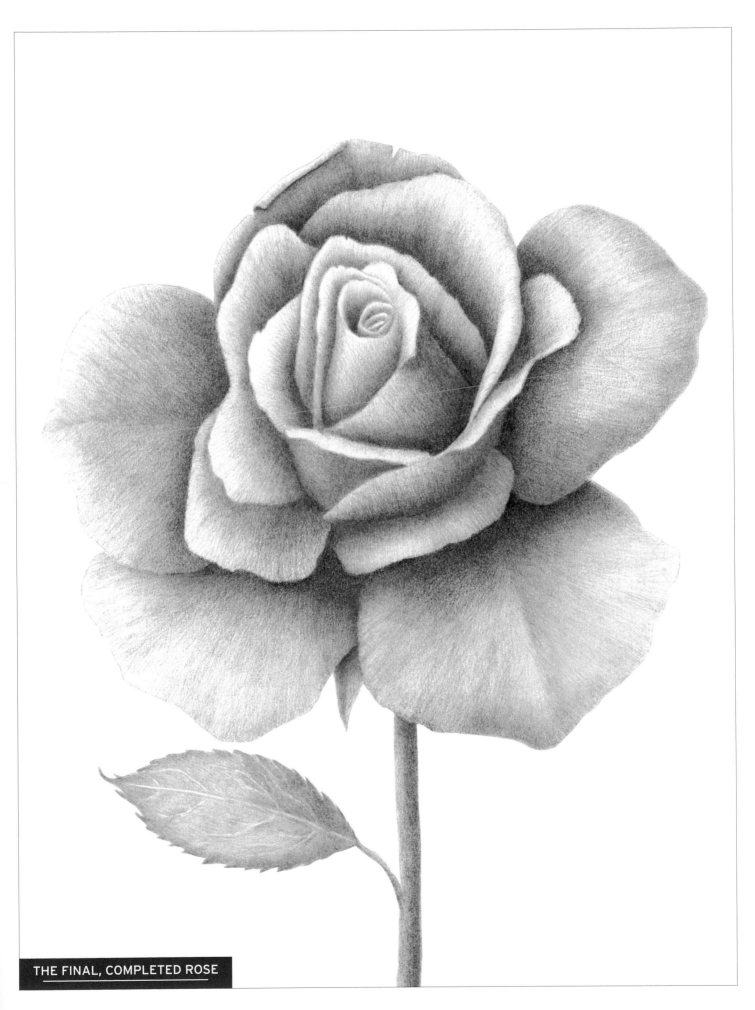

How to Draw a Hibiscus

MATERIALS
5 or 6 Reference photos

Mechanical pencil with 0.7mm, HB lead

Prismacolor Premier color pencils:
Dark Purple
Pink
Magenta
Permanent Red
Chartreuse
Dark Green
Olive Green
Spanish Orange
Deco Pink
Canary Yellow
Crimson Red
Denim Blue

Prismacolor kneaded eraser

Faber-Castell Magic-Rub eraser

Surface: Fabriano sketching paper 56 lb.

The hibiscus is a beautiful and delicate flower that can be found in many different variations and colors. Here, we will draw a red one.
When drawing a hibiscus, it is important to fully reveal its softness and delicacy, and at the same time, reflect the different shades of tones while rendering its bright colors. We can achieve this effect by working patiently, applying layer after layer of color pencils.

Please note that some of the following step-by-step illustrations are closer-up views that have been cropped slightly. The full-page image at the end of the sequence shows the complete drawing.

TO MAKE THIS DRAWING,
YOU MAY FIND IT HELPFUL TO REFER TO THESE BASIC TECHNIQUES:
• blending colors (page 15)
• color pencil techniques (page 22)
• cast shadows (page 27)
• eraser techniques (page 14)
• light source (page 26)
• shade and shadow (pages 27-28)
• pencil points and sharpening (pages 29-31)
• tone, hue, color, tint (pages 24-25)

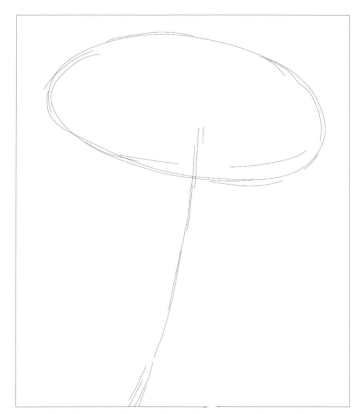

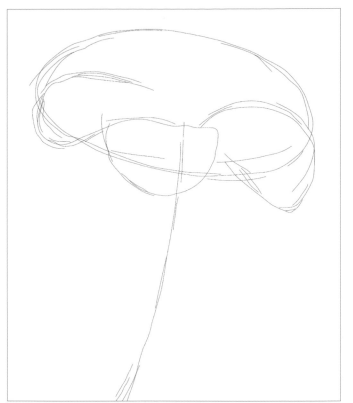

1 With loose strokes and using the 0.7 HB graphite lead mechanical pencil, draw the general shape and size of your flower. The oval will be the overall area for the petals and the stem is a slightly curved vertical. You'll use this pencil in steps 1-5.

2 Begin drawing each petal. I started with the one in front, closer to the viewer, then moved on to the ones to the left and right sides. Continue sketching loosely. If there are any mistakes it is very easy to erase them at this stage (that is why we are sketching with graphite.)

3 Finish the rest of the petals. You will notice that I made the one in the back slightly bigger than the one in front. That is because my back petal is sticking out more and the one in front is seen in perspective (flatter from our point of view.) You can play with the shapes and positions of the petals of your hibiscus.

4 Now that the petals are in place, you can draw the receptacle (the section on the upper part of the stalk where the parts of the flower are attached to it) and the leaves on the stem.

5 At this point, clean up your drawing with the kneaded eraser or the regular eraser and draw some more detail, including the stylus (the thin tube going up from the middle of the petals).

TIP
Please note that when the drawing instructions say: "Use the HB lead for sketching," I'm saying it only as a suggestion. It means that is the lead I used for that particular purpose, but it by no means mandates that you need to use the same one. I give guidance so feel free to adapt it so it is adequate to your style and your own materials.

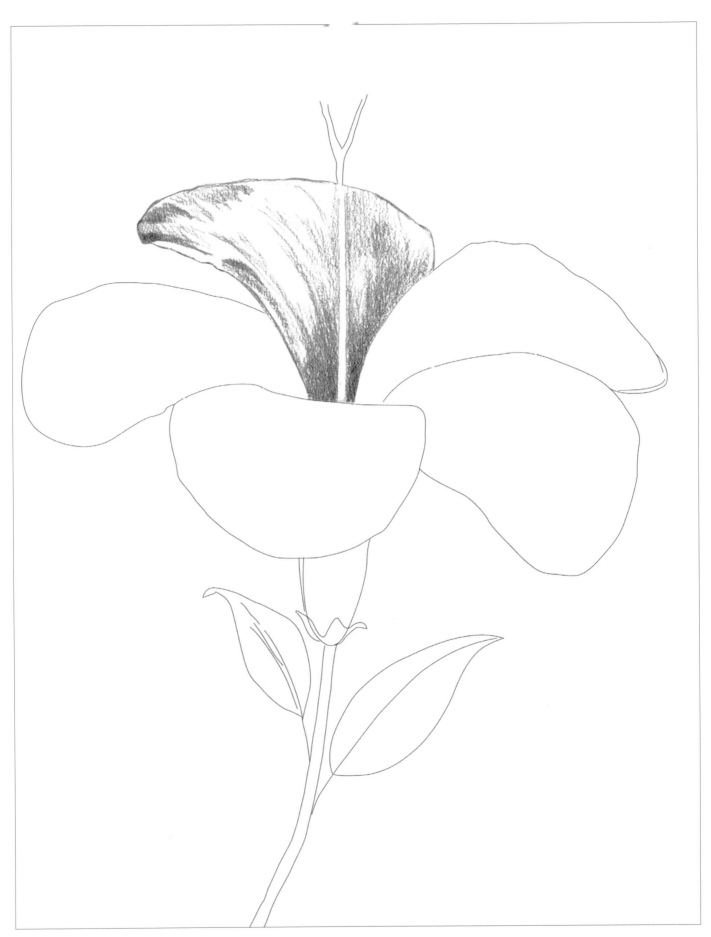

6 Let's start coloring! Begin with the petal that is farthest away. First, give a light tone of Dark Purple to the areas that will be in shade. We will layer other colors on top of it.

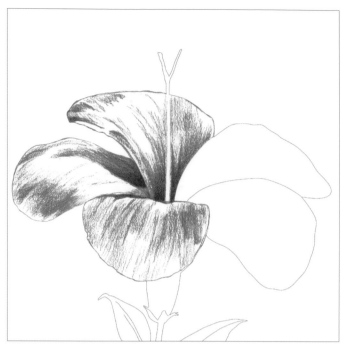

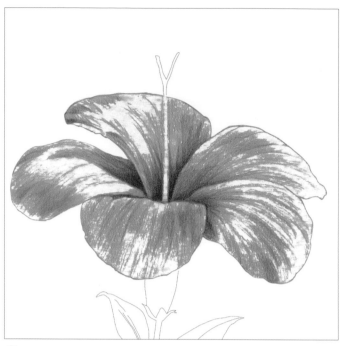

7 Still using Dark Purple, give a light tone as you did in step 6 to additional petals. Press a little harder in the areas that you want darker and give just a light tint of the purple to the areas that will be lighter and softer shades. You can also start producing the texture of the petals by making the different tones stripe-like, as shown, rather than toning evenly and flat.

8 Complete all the petals as you did in step 7. The darkest areas should be the sections that have another petal overlapping them and the area toward the bottom of the style.

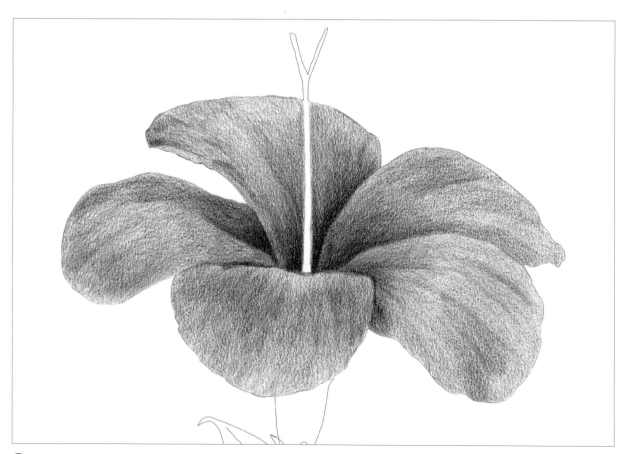

9 Apply a layer of Pink lightly and fairly flat on all the petals. Go over the areas that are shaded and those that are still blank with the Dark Purple.

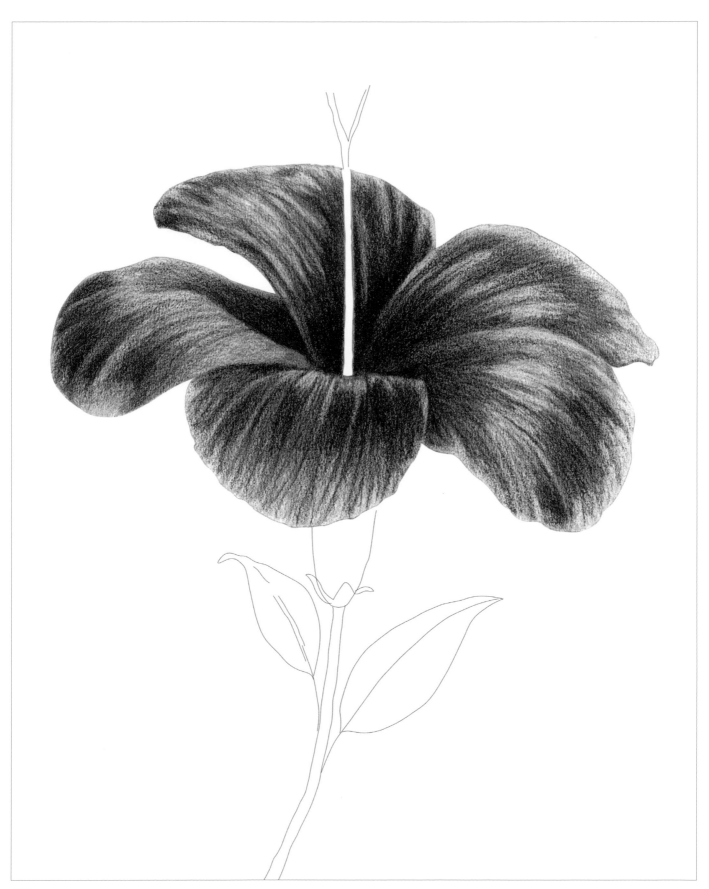

10 Next, go over most of the petals with Magenta. Do not apply Magenta to the areas of the petals that you want to be lighter. As in the steps above, don't press while applying this color. You want to layer it in fairly softly. When you have a solid color, which you achieve by pressing harder, it is more difficult to layer in and mix any other tints afterward. Therefore, apply a light touch.

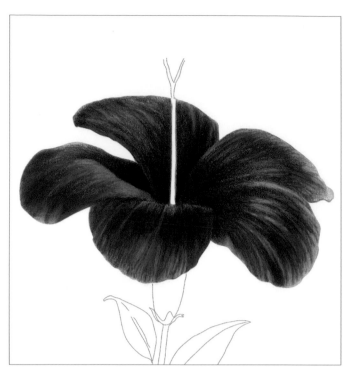

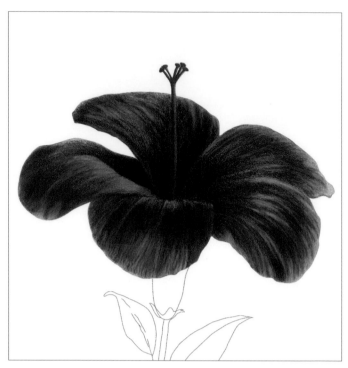

11 Now, layer in the Permanent Red. You can start pressing a bit more now and filling in blank areas, because this will be the main color of the hibiscus. Press softer only on the areas that you want to have a lighter tone.

12 With a light layer of Pink on the right side (closest to the light source), then with the Permanent Red (farther from the light source), fill in the stylus and the five stigma (the little balls at the top.)

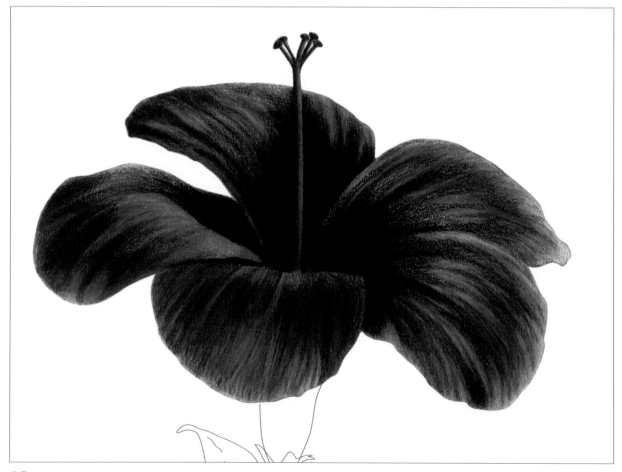

13 Go over the shaded areas of the petals with the Dark Purple again, this time pressing a bit harder (burnishing), so you fill in any white spots left by the texture of the paper.

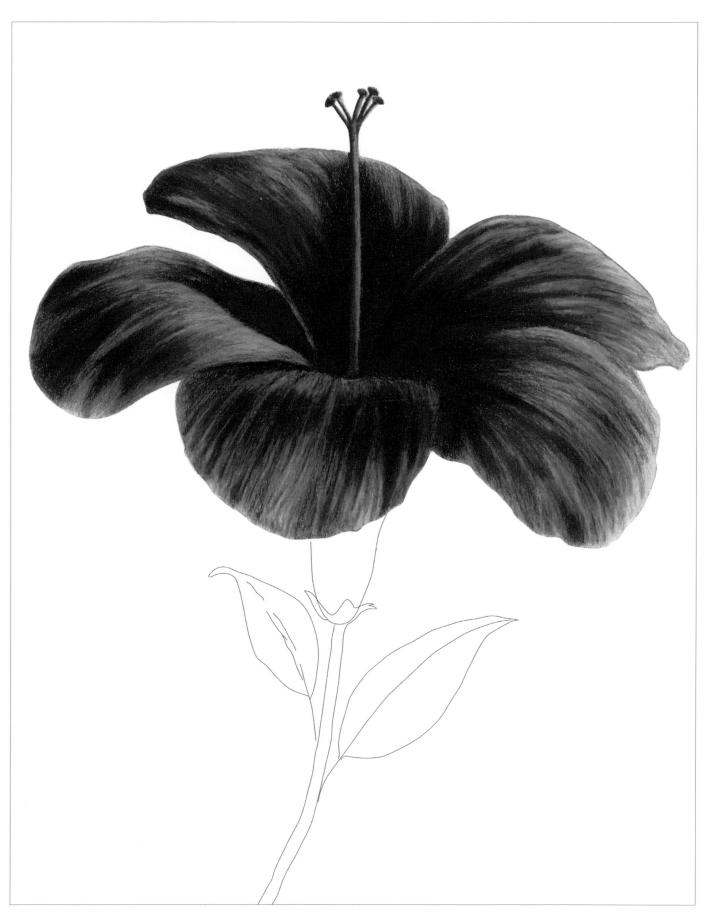

14 Add another layer of Permanent Red on the middle-tone areas (most of the body of the petals), pressing harder this time. Omit only the sections that you want lighter and the areas you just went over with the Dark Purple in step 13.

147

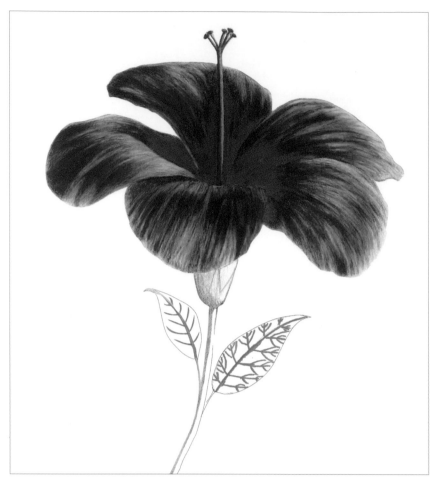

15 Apply a very light layer of Denim Blue on the shaded side (left, farthest from the light source) of the receptacle and the stalk. With the Chartreuse, go over the veins of the leaves. Make sure your pencil has been sharpened to a fine point and press firmly when doing the Chartreuse lines, since we want to be able to see them after we layer other colors on them. You may have to resharpen the pencil after drawing every line.

TIP
Remember to apply light pressure on the first layers of color. It doesn't matter if you don't fill in the area completely, leaving a grainy effect. Increase the pressure on subsequent layers until you achieve the desired effect. If you apply too much pressure on the first layer, it will be very hard to get another layer on it.

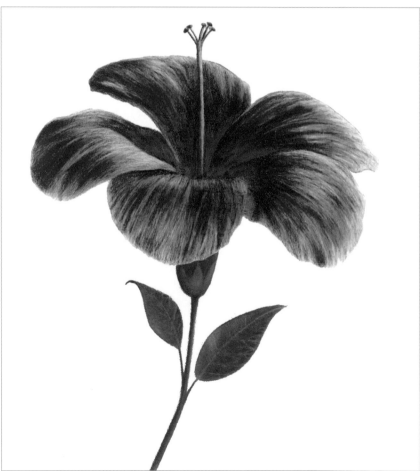

16 With Dark Green and Olive Green, fill in the leaves, the stalk, and the receptacle. Use the Olive Green for the lighter areas and the Dark Green to render the shades. Do a light tone first, not pressing too much, then increase the pressure on subsequent passes.

Now refer to the finished Hibiscus image on the next page. With Spanish Orange, draw the pollen sacs by the stylus. They are located around it, toward its upper part. Since you've already laid in other colors pretty solidly, it may be a bit difficult to get the orange to hold. Press on the paper and make little circles to remove some of the prior color, and then lay in the new one. It may have been a better idea to draw these yellow spots earlier, before we gave the tone to the petals, but drawing them at this stage gives me the opportunity to tell you how to solve this type of problem: Press on the paper with the orange, making round circles; then go over the same spots with Canary Yellow.

Finally, you may want to go over some of the lighter parts of the petals with a Deco Pink. As needed, layer some Crimson Red on the areas that you want to be bright red if, by doing the prior layers, the color seems to have gone a little dull.

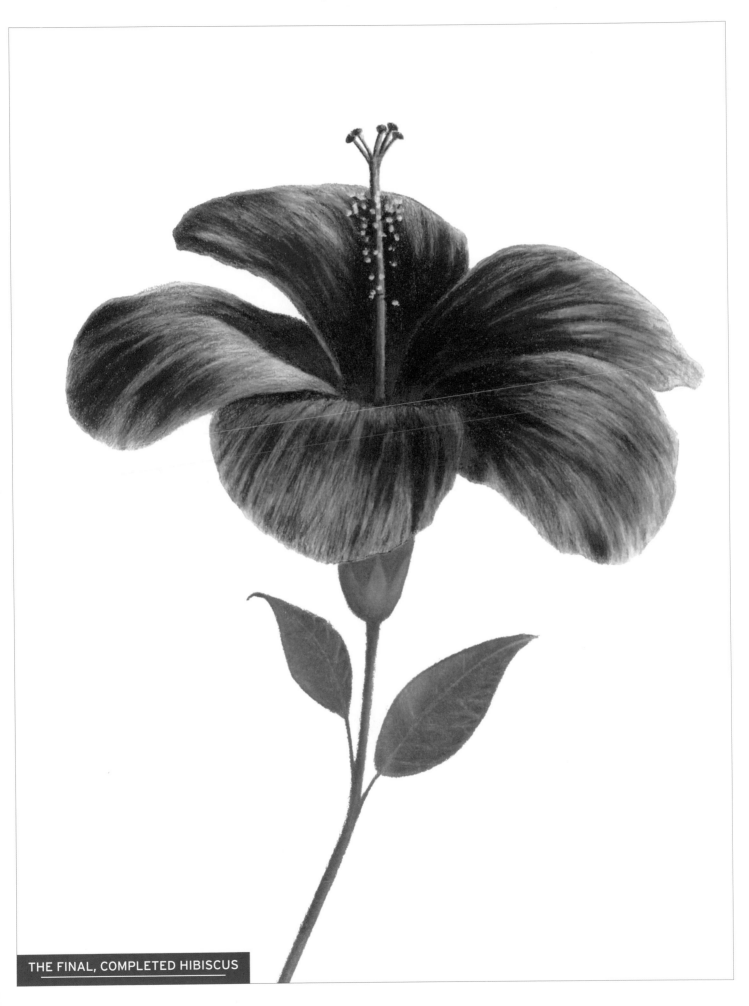

How to Draw a Hydrangea

MATERIALS

5 or 6 reference photos

Mechanical pencil with 0.7mm, HB lead

Prismacolor Premier color pencils:
Cerulean Blue
Violet
Non-Photo Blue
Parma Violet
Limepeel
Olive Green
Dark Green
Cloud Blue
Blue Lake
Grass Green
Indanthrone Blue
Imperial Violet
90% French Grey
Yellowed Orange
Dioxazine Violet
White

Prismacolor kneaded eraser

Faber-Castell Magic-Rub eraser

Synthetic brush - Filbert No. 4

Odorless Mineral Spirits

Surface: Arches watercolor paper 140 lb., hot-press

Drawing a Hydrangea is a challenge and indeed a lot of work, but the result can look awesome!

Hydrangeas have a large flower head that is made up of a round cluster of individual small flowers. To draw a hydrangea, you should start with the general shape of the overall mass of the flower head. Then, choose some small flowers to feature as the most prominent ones (we don't want all the flowers to be on the same plane and with the same value) and draw only those before continuing with the rest. This approach of breaking down the drawing process should make drawing this complex flower fairly simple.

Please note that some of the following step-by-step illustrations are closer-up views that have been cropped slightly. The full-page image at the end of the sequence shows the complete drawing.

TO MAKE THIS DRAWING, YOU MAY FIND IT HELPFUL TO REFER TO THESE BASIC TECHNIQUES:
• blending colors (page 15)
• color pencil techniques (page 22)
• cast shadows (page 27)
• eraser techniques (page 14)
• light source (page 26)
• shade and shadow (pages 27-28)
• pencil points and sharpening (pages 29-31)
• tone, hue, color, tint (pages 24-25)

1 With the HB lead mechanical pencil, draw a nearly circular shape that is slightly more wide than tall. This, of course, will be a guide for the overall shape of the hydrangea. Then, draw the stem, which can be off to one side or the other or in the middle, but in all cases it should point toward the center of your circle. If you want to draw a couple of leaves, sketch these as well. Next, start sketching the flowers with the Cerulean Blue Pencil (use this pencil through step 3). To make it easier you can draw a light square that is turned with the angles on top, bottom, and to the sides. Within this square draw a four-petal flower.

2 In the same manner, draw another flower to the left of the one drawn in step 1, rotating the square so the flowers are at different angles. You may keep drawing the squares as a guide. When you get the hang of it, you may prefer to draw the remaining flowers without the use of the square.

3 Continue sketching flowers in different positions. Choose some, especially toward the center area, which will be seen completely. Then, draw others that will be partially hidden by the ones in front of them. As you get closer to any of the sides, don't draw complete flowers but only petals that stick behind the ones you have made.

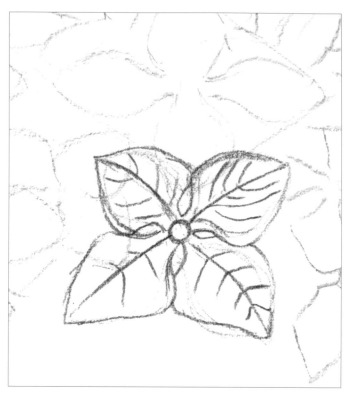

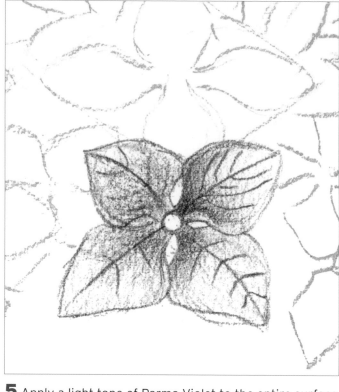

4 With Violet, draw a flower more in detail. Go over the shape of the petals – fairly thin where they attach at the central part, then rapidly widening to their maximum width before they narrow again to a spade-shaped point. You may want to draw some lines along the center of each petal (the primary vein) and from it to the sides (secondary veins), although the idea is that after layering color these will not be very visible. At the center of each flower, make a small circle.

5 Apply a light tone of Parma Violet to the entire surface of the petals and lightly layer some Cerulean Blue on the areas toward the center.

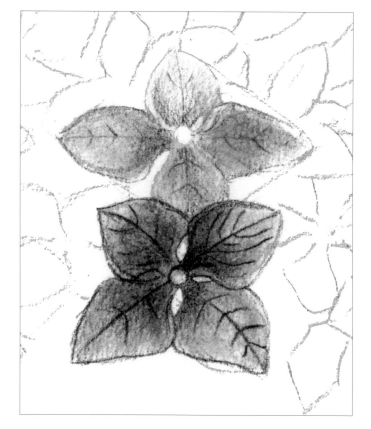

6 You may do more than one petal as in step 5, experimenting with more or less blue on each.

Pour some odorless mineral spirits into a container, dip your brush in it, then wipe the excess off on a tissue or rag. Brush over the petal as if you were painting to melt and extend the color pencil pigment. This will give it a nice painterly effect. The more you "rub it" with the brush, the more you will dissolve the pigment and make it even.

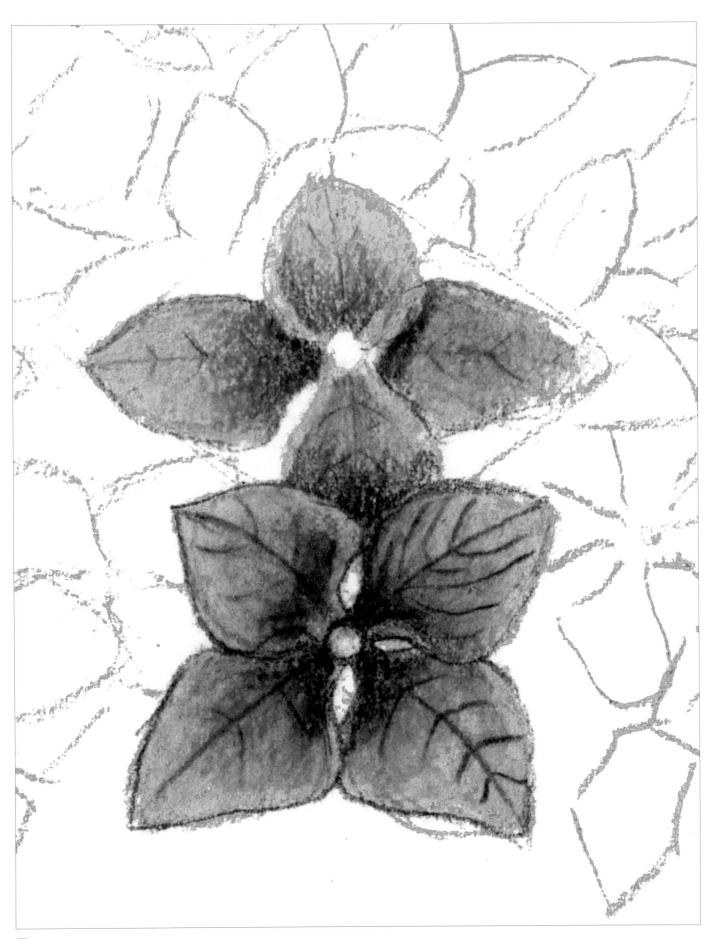

7 Now, layer a lighter blue such as the Non-Photo Blue on the petal and the Cerulean Blue or the Violet (or both) toward the center and dissolve them with the brush and mineral spirits.

153

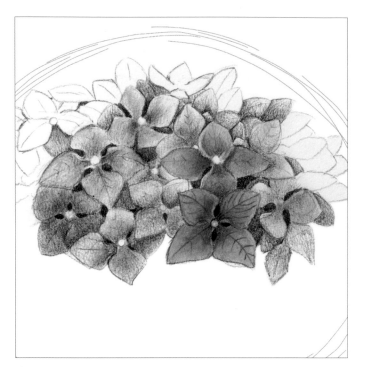

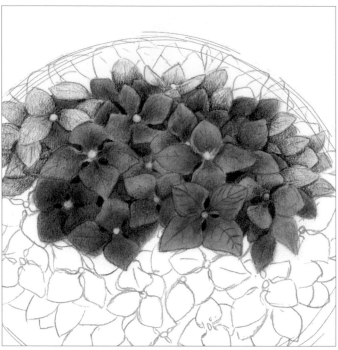

8 Repeat steps 1-7 for the rest of the petals. You may want to pencil-color and brush-dissolve one or two petals at a time before moving to the next. Alternately, you may prefer to first color many and then use the mineral spirits on all. After doing the first two, I colored nine or ten, used the mineral spirit on them, and then went on to color the next group. Don't lay color on the flower's center circle at this point, but you can go over it with the brush and mineral spirits to give it a light tone.

9 After layering with the light Parma Violet and the darker Violet, continue to layer using the Non-Photo Blue and Cerulean Blue. You may choose to layer more intense blue or more intense violet in some rather than others to create a variety (and richness) of hues among petals, rather than doing them all exactly the same.

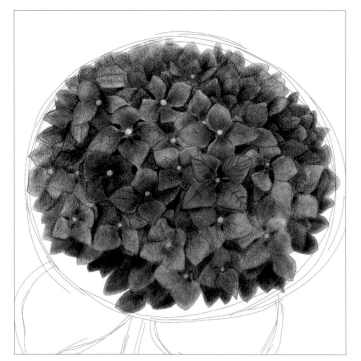

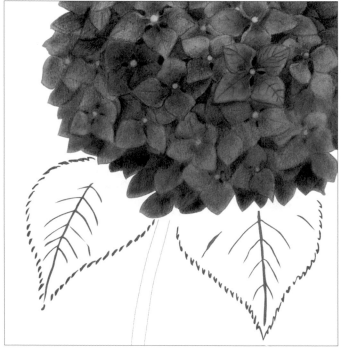

10 Continue to layer violets and blues as in step 9 on the remaining flowers and petals. You may modify the tone and intensity as you go, doing more layers of specific colors as needed so they all look uniform, but not exactly the same.

11 Using the Limepeel, draw the primary vein and lines branching off of it at angles for the secondary veins. Also use the Limepeel to draw the outline of the leaves, which have jagged edges.

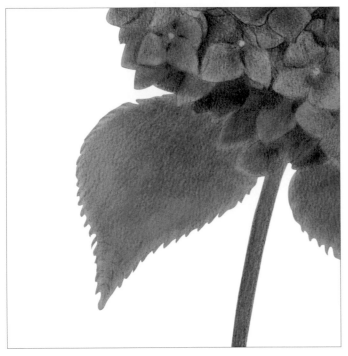

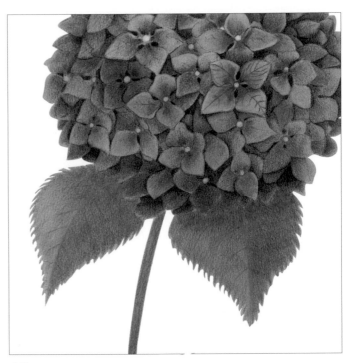

12 With light-to-medium pressure, make a layer of Olive Green on the leaves and stem. Add a light layer of Dark Green on the upper area, dissipating it as you come down to the lower part. Now, smudge it with the brush and odorless mineral spirits.

13 The light source is from the top and slightly to the left of the hydrangea, so the right side of the leaves should be darker. Do another layer of Dark Green on them, as well as on the upper part of the left side of the leaves, since the petals of the flower would be casting a shadow on them.

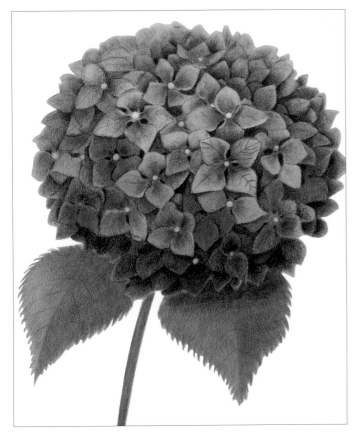

14 This is a good point to stand back a couple of feet and look at your drawing as if you had never seen it before. Stepping back myself, I see that it looks pretty flat. So I darken both the petals in the lower area (using Violet, Indanthrone Blue, and Blue Lake) and the upper area of the leaf on the right (using Dark Green).

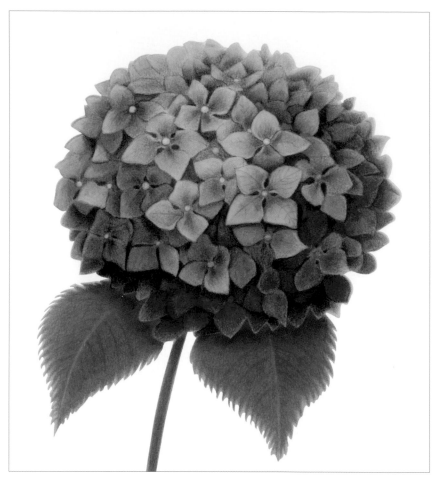

15 It looks better to me, but I still want more volume, so I further darken petals on the lower area using the Indanthrone Blue and Blue Lake. Next, I smudge them with the mineral spirits and brush. I also darken some small spaces between the petals all around the hydrangea; these are spots that are recessed and can't catch light, so they are in a dark shadow.

Layer in Grass Green on the shaft and leaves. Reinforce the dark lines of the veins and texture them with the 90% French Grey, then smudge them with the mineral spirits and brush.

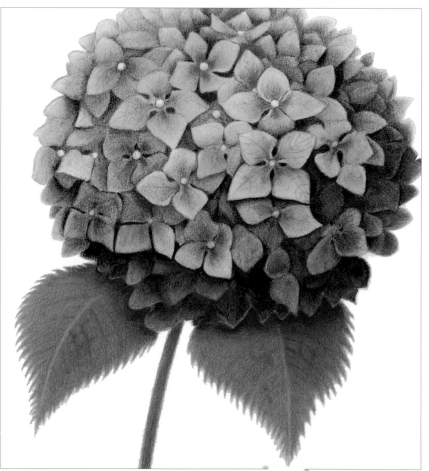

16 I have the volume I want, but the hue at the bottom is too blue. To dim it, layer in some Yellowed Orange. (Because orange is the complementary of blue, you can use it to dull some of the blue's intensity.) Smudge with mineral spirits and brush. Then, go over these petals again, with Imperial Violet on some, and with Dioxazine Violet on others. Smudge them with the spirits and brush.

Finally, to keep these petals from looking too flat, layer in some light hues (like Parma Violet or Cloud Blue) toward the petal tips. Also layer some of these light colors, or even White, on the areas toward the tips of the petals you want to stand out from the rest of the flower head. Then, using sharp pencils, go over and refine the edge of some of the main petals using a color similar to the hue that is already there – a Cerulean Blue, a Violet, a Parma Violet, etc. Excellent!

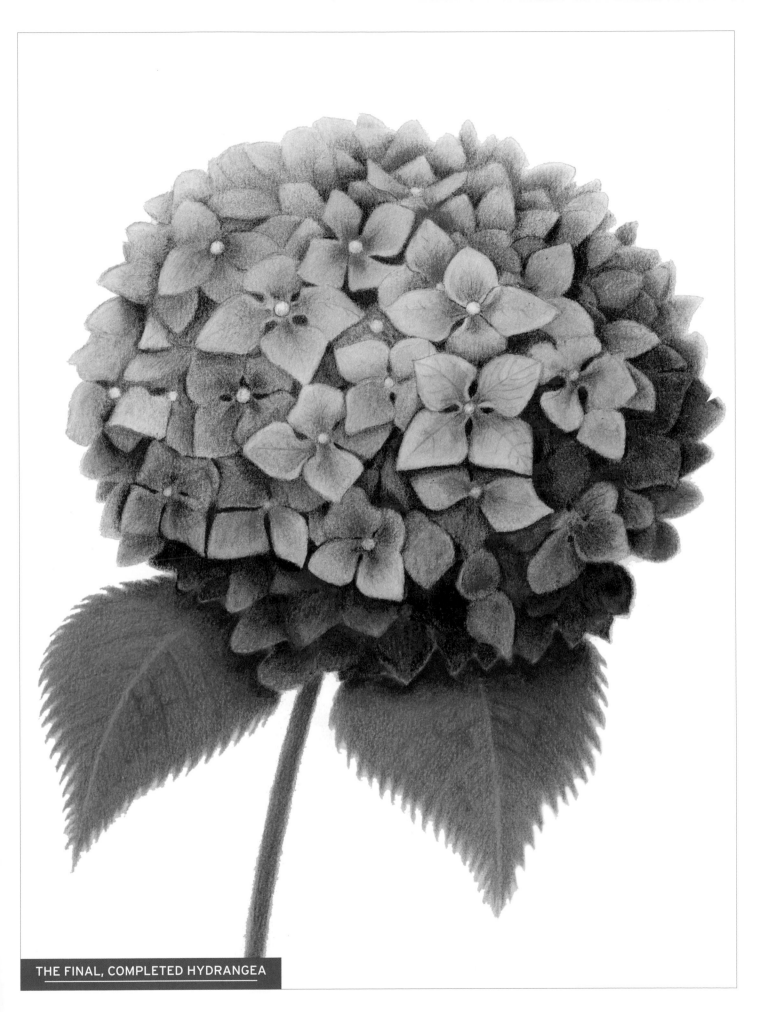

THE FINAL, COMPLETED HYDRANGEA

Final Thoughts

ACKNOWLEDGMENTS
My sincere thanks and appreciation to my publisher Carrie Kilmer, whose idea it was to create this book; for the patience and care of my editor Martha Moran; to Diane Lamphron for the beautiful design; to Laura Cooke for the great coordination of all the parts involved, and to Kevin Moran for his sales and promotion mastery. They all made this project possible.

I want to thank my wife, Gaby, for her love, devotion, and encouragement during this project.

To my sister, Brenda, for her continuous support.

For my students and followers who enthusiastically carry this art to the future and who often teach me more than I teach them.

I want to dedicate this book to my father and mother who from the first moment put me on the path of creativity and who were a never-ending source of patience and love.

I hope this book is truly helpful to you and that by applying the principles contained within it you will create amazing surfaces and textures, add to your drawings, impress your public, and most important, create works of art that fulfill you.

After you have read and applied some of the book's techniques, you may go beyond copying and find your own voice. That is an important step for a creative person, but the first step is having the tools. This book can help with that.

Many aspiring artists tell me that they would love to be an artist but that they do not have "talent." Remember that having the correct techniques, a burning desire, and practicing a lot is much more important than talent. My advice is to always get your hands dirty, to learn some basic tools and techniques, and to practice, practice, practice. And then, lo and behold, talent emerges!

Take your art seriously and seek excellence. Learn and master the techniques by doing exercises and by sketching, as well as creating finished drawings.

I love being an artist because every new work of art is a challenge. It's an adventure. You never really know how it will end up, but one thing is for sure: With every single work you undertake, you want it to be better than the last one. I think that is one of the characteristics that separates artists from others. Can you imagine what the world would be like if every person tried to excel every time he undertook a new piece of work? It would be amazing!

We are very lucky because the time spent creating art is so relaxing, soothing, and joyous. Do more of it. Unleash your mind and enjoy!

Your friend,
Leonardo Pereznieto

Love the process of creation and remember
that masterpieces do not normally appear in a first sitting.
When you enjoy drawing day after day, practicing and creating,
the masterpiece will materialize at last.

– LEONARDO PEREZNIETO

PLEASE VISIT LEONARDO ONLINE AT

artistleonardo.com and youtube.com/user/FineArtEbooks